UNEARTHED

UNEARTHED

Recent Archaeological Discoveries from Northern China

ANNETTE L. JULIANO
with an essay by An Jiayao

Sterling and Francine Clark Art Institute, Williamstown, Massachusetts

Distributed by Yale University Press, New Haven and London

This book is published on the occasion of the exhibition
Unearthed: Recent Archaeological Discoveries from Northern China

Sterling and Francine Clark Art Institute
Williamstown, Massachusetts
June 16–October 21, 2012

The exhibition was organized by the Sterling and Francine Clark Art Institute
in association with Art Exhibitions China and is supported by an award from
the National Endowment for the Arts.

Published by the Sterling and Francine Clark Art Institute
225 South Street
Williamstown, Massachusetts 01267
www.clarkart.edu
Curtis R. Scott, Director of Publishing and Information Resources
Sarah Hammond, Special Projects Assistant

Distributed by Yale University Press
P.O. Box 209040
New Haven, CT 06520-9040
www.yalebooks.com/art

Produced by Vern Associates, Inc., Newburyport, Massachusetts
www.vernassoc.com
Edited by Brian Hotchkiss
Designed by Peter M. Blaiwas
Maps by XNR Productions, Madison, Wisconsin
Page composition by Glenna Collett
Chinese translation by Ling Tang
Production by Susan McNally
Printed and bound by Capital Offset Company, Concord, New Hampshire

Library of Congress Control Number: 2012932336

ISBN 978-0-875772-25-7 (Clark)
ISBN 978-0-300-17967-5 (Yale)

Pages ii–iii: Detail of mortuary bed from sarcophagus of Song Shaozu, dated
477 C.E. (Caofulou Village, Datong, Shanxi province)

Page xvi: Detail of stone tiger-headed door support of sarcophagus of Song
Shaozu, dated 477 C.E. (Caofulou Village, Datong, Shanxi province)

Page 4: Detail of a *dougong* bracket supporting roof ridge of porch on sar-
cophagus of Song Shaozu, dated 477 C.E. (Caofulou Village, Datong, Shanxi
province)

Page 26: Detail of painting from ceiling in tomb of Lou Rui, dated 570 C.E.
(Wangguo Village, Taiyuan, Shanxi province)

Page 140: Wooden chariots from fourth century B.C.E., unearthed in Hui
county, Henan province

中方展览主办单位：
中国文物交流中心

协办单位：
山西省文物局、甘肃省文物局

参展单位：
山西博物院、甘肃省博物馆、灵台县博物馆

展览统筹：王军 姚安 赵古山
展览策划：钱卫
展览筹备：冯雪 戴鹏伦
摄影：厉晋春
(甘肃省展品照片由收藏单位提供)

Exhibition Organizer in China
Art Exhibitions China

Co-organizers
Bureau of Cultural Relics of Shanxi Province
Bureau of Cultural Relics of Gansu Province

Exhibitors
Shanxi Museum
Gansu Provincial Museum
Lingtai County Museum

Exhibition Coordinators: Wang Jun, Yao An, Zhao Gushan
Exhibition Planner: Qian Wei
Exhibition Preparation: Feng Xue, Dai Penglun
Photographer: Li Jinchun
Exhibition photos from Gansu Province are provided by the exhibitors.

CONTENTS

FOREWORD

Seemingly every month news from China tells of yet another major archaeological discovery. After centuries of accidental finds and nearly a century of systematic inquiry, the state of archaeology in China continues to provide clues and challenges to understanding past cultures, their rituals and practices, and the fabric of society. What comes out of the earth often refines our understanding of early cultures on the Chinese subcontinent, while groundbreaking discoveries find their way into popular publications and exhibitions and, eventually, the cultural consciousness of the general public. As with cultural archaeology in many parts of the globe, the situation in China today is one of excitement, innovation, and progress toward a fuller, more nuanced view of its cultural heritage.

Unearthed: Recent Archaeological Discoveries from Northern China contributes to our understanding of Chinese archaeology and to China's collective sense of history and introduces to the American public a number of exceptional objects from the Northern Wei through Tang dynasties recovered from tombs in Shanxi and Gansu provinces in recent years. Many of the pieces on loan to the Clark have never been exhibited before, even within China, and all of them reveal aspects of China's ancient past that surprised specialists and the public upon discovery. The tomb of court official Song Shaozu (died 477), discovered in 2004 near Datong in northern Shanxi, contained a massive stone sarcophagus in the form of a traditional Chinese house, and this provides the centerpiece of the exhibition. A selection of objects from the tomb of Lou Rui (died 570), discovered on the outskirts of modern-day Taiyuan in central Shanxi in 1979 and recently published, exemplify a fine, well-appointed Northern Qi-dynasty tomb belonging to an accomplished and powerful tribesman. A set of large, polychrome figures from an early-Tang-dynasty tomb that was found completely intact just three years ago near Fujiagou Village, in Lingtai county, Gansu province, demonstrates the persistence, continuity, and adaptation of foreign influences in ancient Chinese burial practices. Drawing on recent excavation records and publications, the exhibition conveys both the aesthetic and intellectual value of the finds and the stories of each of these archaeological contexts.

A most particular set of circumstances have led to the conception and realization of this exhibition project. *Unearthed* is the culmination of the Clark Art

Institute's commemoration of Sterling Clark's 1908–1909 scientific exploration of northern China and his publication in 1912 of *Through Shên-kan,* a travelogue and a discussion of the expedition's findings. The commemoration began in 2008 with a series of celebrations in Taiyuan, Xi'an, and Lanzhou—provincial capitals situated along the original route of the expedition—in which the Clark presented those communities with copies of the book and mounted exhibitions of the photographs made by the expedition team. Our institution's founder was curious about China's culture, and there are numerous descriptions of the sites of cultural interest that the expedition team encountered in what are now Shanxi, Shaanxi, Ningxia, and Gansu provinces. Yet the team took away nothing but taxonomic samples of the wildlife they found along the Loess Plateau as they charted that terrain to create a modern map and collected scientific data about its weather, botany, and geology. These samples, together with more than a hundred archival photographs from the expedition, are now in the collections of the Smithsonian Institution in Washington. In his 2010 critical edition and Mandarin translation of *Through Shên-kan,* historian Shi Hongshuai writes, "the Clark expedition offers more comprehensive context than any single disciplinary exploration done by Western expedition teams in the Loess plateau regions. An objective evaluation of the Clark expedition in terms of its academic contribution during a historical period of transition validates its significance . . . [and] the overall value of its scientific and academic research was positive." Indeed, Sterling Clark's exploration of these regions inspired this exhibition project, and a series of cultural exchanges in those provinces over the past five years—including Professor Shi's edition—have enabled it. Just as that early-twentieth-century expedition significantly advanced contemporary understanding of the region's topography and wildlife, so too this twenty-first-century exhibition seeks to expand and enrich today's public's understanding of aspects of its cultural heritage.

The planning for this exhibition has been extensive and intense, led by Annette Juliano, our guest curator, professor at Rutgers University, and a specialist on the region and the periods under examination. In this, its first Chinese exhibition, the Clark could not have asked for a more steadfast leader, one who brought to bear her extensive knowledge and professional network to make these loans and this excellent catalogue possible. Her work has been augmented not only by our team in Williamstown but also by the talents of exhibition designer Perry Hu and the skills of our colleague Zhou Xiuqin. It is our great honor to publish a seminal essay by the esteemed archaeologist An Jiayao in this volume as well, giving a perspective on

the history and state of Chinese archaeology over the past century. The exhibition has been developed and articulated with great care by our devoted staff at the Clark led by Tom Loughman, Kathleen Morris, and Richard Rand, and I especially wish to thank Paul Dion, Sarah Hammond, Jennifer Harr, Mattie Kelley, Forbes Litcoff, Teresa O'Toole, Paul Richardson, Anne Roecklein, and Curtis Scott for their contributions to realizing the exhibition and this catalogue. Zhou Zhicong, our friend in Shanghai and special assistant on the Clark's China initiative, has been a constant resource and limitless help. The collective work of those mentioned here has been, in turn, supported by numerous Clark colleagues and interns over the past three years and a host of talented and sensitive specialists in graphic design, rigging and art logistics, and educators in the Berkshires and far beyond.

In China the project has been organized by Art Exhibitions China under the leadership of Director Wang Jun and through the dedicated work of his fine staff and the support of numerous officials at the State Administration of Cultural Heritage in Beijing—particularly Deputy Director Song Xinchao—and at the provincial cultural-heritage bureaus. I want to recognize not only the principal lenders to the project—particularly the Shanxi Museum, under the direction of Shi Jinming, and the Gansu Museum—but also the more than forty archaeologists, curators, and officials who showed every professional courtesy to Professor Juliano and our team as they investigated and prepared the exhibition. Without their trust and partnership, this project would not have been possible.

Neither could the show be realized without the support of the National Endowment for the Arts, an essential part of so many of our exhibitions of this magnitude; we deeply appreciate the NEA's commitment to the nation's cultural programs.

Foremost among my hopes is that the relationships begun by this endeavor—from professional ties uniting specialists from our two nations to a new relationship between the Clark and its audiences—will thrive and provide the basis for greater understanding and future exchanges. Our goal has always been to understand better the role archaeology plays in the evolving sense of Chinese national identity and world heritage. Much as Sterling Clark's expedition helped spawn this newly relevant investigation into Chinese archaeology today, perhaps this exhibition will excite the imaginations and curiosity of many to continue the search for, and the delight in, the discovery of the ancient past.

Michael Conforti
Director, Sterling and Francine Clark Art Institute

前言

　　地处黄河流域核心地带的黄土高原是哺育中华文明的摇篮之一,也是中国历史上不同文化频繁交融碰撞的重要区域。灿烂悠长的文明史给黄土高原留下了丰富的考古遗存。随着我国考古事业的飞速发展，这些极具历史价值及艺术价值的古代遗存愈加为国内乃至世界人民所欣赏，也使得黄土高原成为研究中国古代文明的焦点区域。

　　一百年前，美国探险家罗伯特·斯特林·克拉克带领他的探险队深入中国西北，对山西、甘肃等省份的自然、人文情况进行了为期480余天的科学考察。面对晚清时西方国家对于中国文物珍宝的掠夺风潮，老克拉克先生显示了他对于中国的情谊与尊重，除了亲笔记录的文字和亲手拍摄的照片，他从未带走属于中国的任何一件文物。一百年后的今天，由克拉克先生建立的克拉克艺术中心依旧保持着对中国文化的浓厚兴趣以及与中国文博界的友好关系。为纪念老克拉克先生的中国科考之行一百周年，克拉克艺术中心与中国文物交流中心合作精心策划了《黄土高原的考古发现》展览，通过文化的视角和文物的语言展示黄土高原的绵厚文明和独特魅力。展览精选16件来自山西及甘肃两省重要考古遗址的出土文物，反映了1300年前当地丰富精彩的历史面貌，并重点释读这一时期黄土高原多种文化的激烈碰撞与交融。

　　希望藉由这次展览，使世人进一步了解中国黄土高原的历史风貌，延续并深化中美两国文化交往，在交往中相互接纳学习，从而一同发展、共促和谐。

王军　主任　中国文物交流中心

PREFACE

Lying in the middle reaches of the Yellow River region, the Loess Plateau is known as the cradle of Chinese civilization. But it also is known for its geographical importance for the cultural exchanges and conflicts that occurred there throughout centuries of Chinese history. For thousands of years, civilizations have nurtured and preserved a wealth of archaeological remains in this region. With the rapid growth of archaeological research in China, the historical and artistic values embodied in these ancient remains will be increasingly well recognized and appreciated by the Chinese people as well as the rest of the world. The rich culture and heritage of the Loess Plateau has made it the focal point for research and studies on ancient Chinese civilization.

More than a century ago, American adventurer Robert Sterling Clark led a scientific expedition across northern China. For a total of 480 days, his team traversed the provinces of Shanxi, Shaanxi, and Gansu, where they explored and studied nature and regional social life. In contrast to other explorers during the late Qing dynasty, who were looting Chinese cultural relics, Clark demonstrated his love and respect for Chinese culture. He removed nothing from China besides his own journals and photographs.

Clark later founded the Sterling and Francine Clark Art Institute, and one hundred years after his extensive sojourn in northern China the museum still maintains an avid interest in Chinese culture and a close relationship with the country's museums. In memory of the one-hundredth anniversary of the Clark expedition, the Clark Art Institute and Art Exhibitions China jointly have organized a major exhibition—*Unearthed: Recent Archaeological Discoveries from Northern China*—a showcase of lavish objects reflecting civilizations and distinctive attractions of the region from a cultural perspective and in the "language" of its cultural relics. The sixteen objects featured were selected from important relics unearthed in Shanxi and Gansu provinces. They demonstrate the rich, exciting history of this region as it was 1,300 years ago as well as emphasize northern China's multicultural exchanges and conflicts.

It is hoped that the opening of this exhibition will help people all over the world understand the Loess Plateau's history and culture, continue to deepen Sino-American cultural exchanges, and foster a *cultural* atmosphere through which to learn from each other and to work together, thus promoting harmony.

Wang Jun, Director, Art Exhibitions China

ACKNOWLEDGMENTS

As noted in the opening essay, Sterling Clark's experience of China elicited a complex and conflicted response often reflected in his own words and phrases scattered throughout *Through Shên-kan: The Account of the Clark Expedition in North China, 1908–9.* He wrote of China as a land of mystery, one that was enigmatic, perhaps inscrutable, and he referred to his sojourn in the "unknown east." Like many of his comments, these sound surprisingly contemporary. Despite China's increasingly powerful and highly visible global presence, the Western world's perception of the Far East still includes this aura of the mysterious; even rampant tourism has not dispelled this sense of differentness. And China's extraordinary economic expansion and building boom, seemingly prosaic, have themselves contributed to the glamour, as bulldozers and construction workers continue to unearth the most amazing and quite unprecedented archaeological discoveries, including the life-size warriors in the vast terracotta army surrounding the still-unopened mausoleum of China's first emperor, the bodies of imperial princes sheathed in garments of jade plaques sewn together with gold wire, and the famous "pickled lady" of Mawangdui, her body preserved for thousands of years. Although these finds have, on the one hand, increased our knowledge of the world's most ancient continuous culture, on the other hand they ironically have also deepened its mystique.

Despite having spent my academic life studying the history and art of ancient China, I find that every visit inspires even greater awe and appreciation. The Clark project presented a marvelous opportunity to explore the intersection among the past, the 1908–1909 expedition, and the present in Shanxi, Shaanxi, Ningxia, and Gansu, the four provinces traversed by the Clark expedition. Because of Chinese beliefs in the afterlife and burial practices that endured for centuries, a significant part of this ancient culture remains hidden underground. As described in Professor An Jiayao's essay, the science of archaeology has been rapidly evolving since the revolution in China. At the same time, China's transformation has underscored the challenges facing its government and society in attempting to reconcile the conflicting demands of a burgeoning economy with the need to recognize and preserve the past.

The preparations for the exhibition required several trips to the northern Chinese regions traversed by Sterling Clark. Like him, I was fortunate to have a superbly competent travel companion and colleague, Dr. Xiuqin Zhou, Senior Registrar at the University of Pennsylvania Museum of Archaeology and Anthropology, who had worked at the Shanghai Museum before coming to the United States. Her network of contacts, negotiating skills, and experience were all invaluable in assisting me to secure a selection of exceptional objects, especially the stone sarcophagus of Song Shaozu, which since its excavation in 2000 had been disassembled, stored in pieces, and never exhibited outside of China. The sarcophagus and other marvelous Shanxi artifacts would not have been shown without the assistance of my Shanxi colleagues, to whom I am very grateful: from the Shanxi Provincial Museum, Shi Jinming, Director; Li Yong, Deputy Director; and Liang Yujun, Deputy Chief of Development; from the Shanxi Provincial Cultural Relics Bureau, Liu Zhenghui, Deputy Director; and Hao Xiaowei, Director, External Affairs. My deepest appreciation to my Gansu colleagues, who agreed to loan magnificent painted and gilded clay Tang tomb guardians, unearthed in 2009 but not yet officially published: from the Gansu Provincial Museum, E Jun, Director; and Jia Jianwei, Deputy Director; from the Gansu Provincial Cultural Relics Bureau, Ma Yuping, Director; and Bai Jian, Deputy Director, Museum Section. During initial planning stages, the exhibition also included a number of superb objects from the provinces of Ningxia and Shaanxi, and I want to thank the many scholars, museum professionals, and archaeologists who provided gracious hospitality, time, and the opportunity to examine many exceptional pieces. A special acknowledgment goes to two consummate professionals—Zhou Zhicong, Deputy Director, Museum of Contemporary Art, Shanghai; and Chen Tianji, China Travel Service, Gansu—who always resolved the problems at hand.

International exhibitions require considerable cooperation at the highest administrative levels. I am most grateful to have met and gained the support of Song Xinchao, Deputy Director General of the State Administration for Cultural Heritage, Beijing. Without the tireless efforts at coordination from the provincial to the national levels through the auspices of Art Exhibitions China under the able leadership of Wang Jun, Director; Yin Jia and Yao An, Deputy Directors; Qian Wei, Deputy Director, Curator Section; Feng Xue, Project Assistant; and Dai Penglun, Curatorial Section, this exhibition could not have been realized.

My engagement with the Clark began more than two years ago with a series of conversations in New York with Tom Loughman, Assistant Deputy Director; he has

remained my interface with the Clark throughout, capably and energetically grappling "head on" with all the challenges, both the predictable and the unexpected, that emerged. Any guest curator would be fortunate to work with such an effective senior executive team during what often became a stressful and challenging process: Kathleen Morris, Sylvia and Leonard Marx Director of Collections and Exhibitions; and Richard Rand, Robert and Martha Berman Lipp Senior Curator, not only remained intensely focused, creative, and attentive to detail but also were remarkably good-humored facilitators. Of course, little could be accomplished without the enormous contribution of the support staff. I had the pleasure of working with Paul M. Richardson, Assistant Exhibitions Manager; and Maria Gamari, Audience and Engagement Coordinator, who also expertly arranged to have me whisked off to Williamstown and back to New York regularly. Chief Preparator Paul Dion's trip to Taiyuan to participate in the trial assembly of the stone sarcophagus assured its central role in the exhibition, while Director of Collections Management and Senior Registrar Mattie Kelley's keen attention to detail and expert oversight guaranteed the safe arrival of all objects in Williamstown from China. Finally, but not least, I must thank Michael Conforti, Director of the Clark, a remarkable leader who saw in the Sterling Clark centennial celebration an unusual opportunity to expand the museum's interests into the art and culture of China.

The catalogue for *Unearthed* required the skills and dedication of many, and I am particularly pleased by the honor of having An Jiayao, Research Professor at the Institute of Archaeology, Chinese Academy of Social Sciences, in Beijing, a prominent archaeologist, scholar, and friend, write a highly informative essay about the development of Chinese archaeology and the challenges it faces in light of today's rapid economic development. I also want to extend a special appreciation to several scholars who contributed their time and expertise to the catalogue and the research for the exhibition: Elinor Pearlstein, Associate Curator of Chinese Art, Art Institute of Chicago; Sarah Laursen, Research Fellow, ISAW, New York University; and Suzanne G. Valenstein, Research Curator Emerita at the Metropolitan Museum of Art, New York.

I am grateful to Curtis Scott, Director of Publishing and Information Resources at the Clark, for his close supervision of the catalogue-production process, for his thoughtful guidance, constant problem solving, and selection of Vern Associates to implement the editing and design of the catalogue. I cannot adequately thank Peter Blaiwas and Brian Hotchkiss of Vern Associates for

their meticulous attention to the text, photographs, maps, design, and layout of the catalogue. Brian's sensitive editing skills never failed to improve the text and bring greater clarity, consistency, and accuracy. Sarah Hammond, Special Projects Assistant in the Publications Department at the Clark was a pleasure, always helpful and supportive. In addition I wish to thank the following individuals who helped in numerous ways with other aspects of the exhibition and catalogue: from the Clark staff, John Carson, Michael Cassin, Lara Ehrlich, Laurie Glover, Sally Morse Majewski, Tom Merrill, Teresa O'Toole, Victoria Saltzman, and Viktorya Vilk; also Harry Blake, Francesca Calabretta, Charleen Du, Brian Eseppi, Frank Gregory, Heidi Humphrey, Tim Johnson, Emma Laukitis, Tim Naughton, Christopher Nugent, Derek Parker, Hannah Pickwell, Michael Rousseau, Robert Salmon, Nicole Sullivan, Li Tiankai, Greg Van Houten, Brian Waldren, Linna Wei, Carrie Zhang, and Cathy Zhu.

Having worked successfully on other projects with the exhibition's designer, Perry Hu, I was delighted that he was able to bring his superb talent and sensitivity to the design and installation of this small but challenging exhibition. In addition, he was an excellent travel companion on several of our excursions in north China, and I am grateful for his friendship and support.

After fifteen years as Department Chair, Associate Dean for Academic Affairs, and Professor of Art at Rutgers University, Newark Campus, I feel very fortunate to be at an institution so committed to supporting both faculty research and teaching. I want to acknowledge my Department Chair, Professor Ian Watson, and the staff at Rutgers who, over the years, helped make it possible for me to manage my teaching, my research commitments, and my administrative responsibilities. In particular, I want to thank former Dean of the Faculty Philip Yeagle, now Acting Chancellor, for approving my leave to travel and write the catalogue for the exhibition. I also owe special thanks to Dr. Jan Lewis, Acting Dean, Newark Faculty of Arts and Sciences; Professor Ned Kirby, former Dean, Newark Faculty of Arts and Sciences; and former Chancellor and now Professor Steven J. Diner, who has always been supportive of my research.

In conclusion, the entire undertaking would not have been possible without the loving support of Joanna and Joseph Geneve. Their patience, encouragement, and good humor helped immeasurably.

Annette L. Juliano

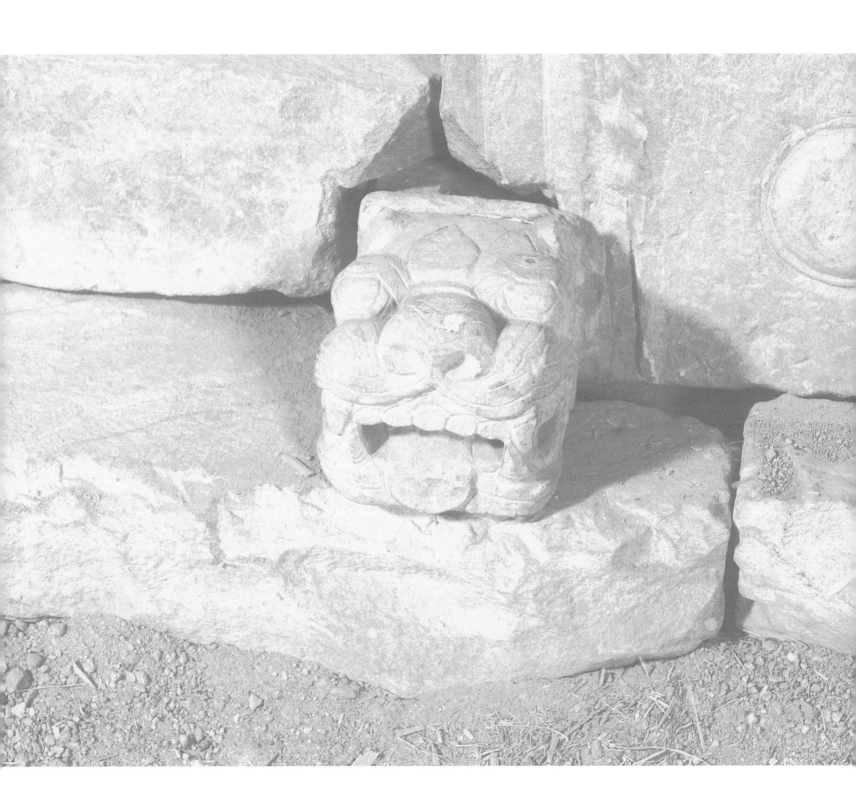

CHRONOLOGY

Han dynasty founded	206 B.C.E.	
	27 B.C.E.	Roman Empire founded
Fall of Han dynasty	220 C.E.	
China splits into Northern and Southern Dynasties	317	
Northern China unified under Wei	386	
Northern Wei dynasty founded		
	476	Fall of Roman Empire
Song Shaozu dies	477	
Northern Qi dynasty founded	550	
Lou Rui dies	570	
Sui dynasty reunifies China	589	
Sui dynasty ends	618	
Tang dynasty founded	618	
Fujiagou tomb	Late 7th–early 8th century	
Tang dynasty falls and splits into Five dynasties	907	
Five dynasties period ends	960	

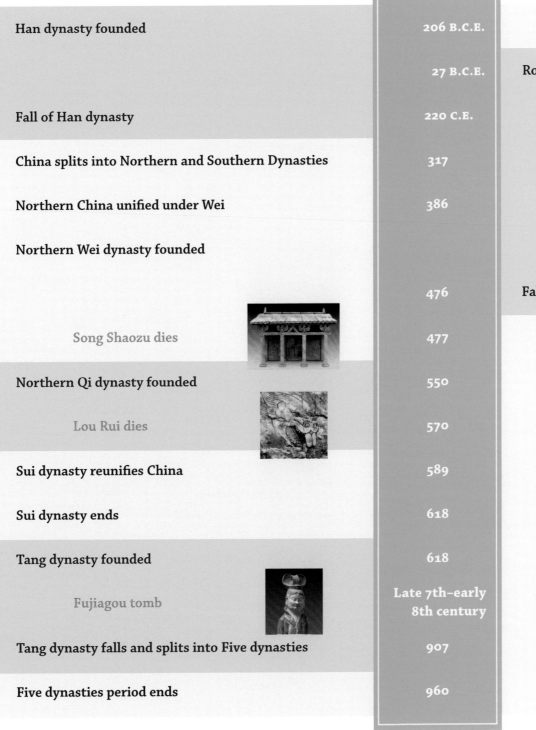

THE SILK ROAD AND CLARK EXPEDITION ROUTES

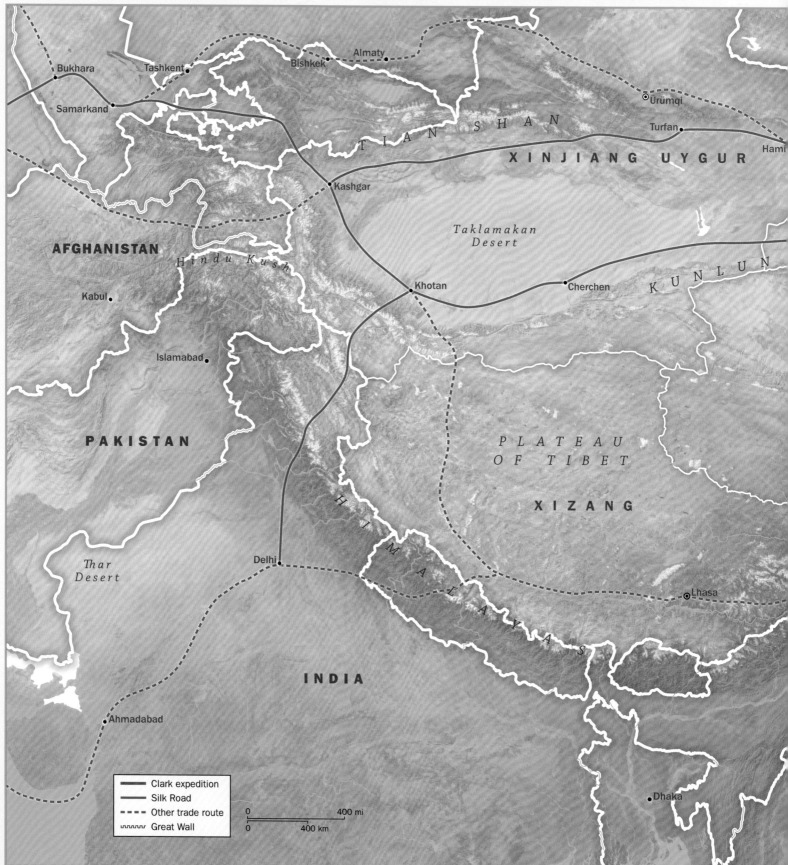

Bukhara

Tashkent

Samarkand

Bishkek

Almaty

Ürümqi

Turfan

Hami

TIAN SHAN

XINJIANG UYGUR

Kashgar

Taklamakan
Desert

AFGHANISTAN

Hindu Kush

KUNLUN

Kabul

Khotan

Cherchen

Islamabad

PAKISTAN

PLATEAU
OF TIBET

XIZANG

Thar
Desert

Delhi

H I M A L A Y A S

Lhasa

INDIA

Ahmadabad

Dhaka

	Clark expedition
	Silk Road
- - -	Other trade route
⌄⌄⌄	Great Wall

0 400 mi

0 400 km

Gobi
Desert

INNER MONGOLIA

LIAONING

Shenyang

Hohhot

Yellow River

BEIJING
Beijing

TIANJIN

Tianjin

HEBEI

Shijiazhuang

Dunhuang

M O U N T A I N S

Yinchuan

Taiyuan

SHANXI

Yellow River

SHANDONG

Jinan

Xining

NINGXIA

Lanzhou

QINGHAI

GANSU

SHAANXI

Kaifeng
Zhengzhou

HENAN

JIANGSU

Xi'an

Nanjing

Shanghai
SHANGHAI

Hefei

ANHUI

SICHUAN

HUBEI

Wuhan

Hangzhou

Yangtzi River

Chengdu

ZHEJIANG

CHONGQING
Chongqing

Nanchang

Changsha

JIANGXI

HUNAN

FUJIAN

Fuzhou

GUIZHOU

Guiyang

Quanzhou

Kunming

YUNNAN

GUANGXI

GUANGDONG

TAIWAN

Guangzhou

Nanning

CROSSING NORTHERN CHINA

In 1899, after graduating from Yale University with a degree in civil engineering, Robert Sterling Clark (1877–1956), heir to the Singer sewing machine fortune, joined the United States Army. He was posted in the Philippines first and the following year in China, where he and an international force fought to defeat the Boxers in their siege of Tianjin and of the eleven foreign diplomatic legations in Beijing.[1] After returning to Washington, D.C., for two years, Clark went back to Beijing, where he stayed from 1903 to 1905. Two years later, he began preparing to lead an ambitious eighteen-month-long scientific expedition across northern China. His intent was to complete a detailed geographical survey; record meteorological observations; photograph people, places, and landscapes; and collect specimens of flora and fauna.[2] Clark hoped his comprehensive approach would "form a solid foundation for the future explorer in North China."[3] In pursuit of these scientific goals, he invited the British naturalist Arthur de Carle Sowerby (1885–1954), who had been born and raised in Shanxi province, to join the expedition (fig. 1).[4]

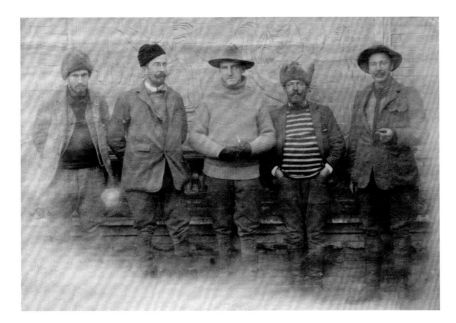

Figure 1 Members of Sterling Clark's expedition through northern China (*left to right*): Arthur de C. Sowerby, naturalist; Robert Sterling Clark, expedition leader; Nathaniel Haviland Cobb, artist; George A. Grant, interpreter and general manager; and Captain H. E. M. Douglas, doctor and meteorologist

Even though Clark experienced a disintegrating China in the years just before the final unraveling and collapse of its last dynasty, the Qing (1644–1911), the Celestial Empire still fascinated him. He described not only the teeming millions of poor farmers tilling the yellow earth with crude implements, but also "its mighty rivers and mountain ranges, its rich mineral deposits, its ancient tombs, and its relics of a bygone prosperity [Yet, for him, it was] still a land of mystery—enigmatic, perhaps inscrutable."[5] Clark's intense and conflicted response to this paradoxical culture places him firmly within a centuries-old tradition of adventurers, merchants, missionaries, scholars, monks, scientists, and diplomats. Driven by diverse and powerful passions, these travelers left their homelands and traversed thousands of miles, often in exceedingly hostile and life-threatening environments, to reach the "mysterious East." Clark follows in the ephemeral footsteps of these ancient travelers. As a scientist and a man of the twentieth century, however, he also was part of the phenomenon of foreign explorers of the late nineteenth and early twentieth centuries from Sweden, Great Britain, France, Russia, Japan, Germany, and the United States who led expeditions and conducted excavations of historical sites in northern China and in Chinese Turkestan, modern-day Xinjiang.

These intrepid foreigners, who continued their explorations until the 1940s, can be divided into two distinct groups that often shared some overlapping goals. One group, undoubtedly the more familiar to Westerners, was comprised of those who reached China by following the fabled "Silk Road" in pursuit of treasure, lost oases, and, along the edges of the formidable Taklamakan desert of Xinjiang, the hidden cities that had crumbled and vanished under its sands. Although commonly known by this late-nineteenth-century term, *Silk Road* (see map, pages 2–3) actually refers to a network of overland trade routes populated with cities and oases scattered like beads along a vast necklace stretching from the ancient city of Antioch (modern Antakya, in southeast Turkey) to the city of Chang'an (modern Xi'an in north central China).[6] It emerged during China's first great empire, the Han dynasty (206 B.C.E.–220 C.E.), then flourished through China's second vast empire, the Tang (618–907), when it reached its peak. This highway between East and West transferred by camel and donkey caravans not only luxury goods, but also ideas, philosophies, and religions; it was certainly the main conduit through which Buddhism reached China from India and Central Asia.

Particularly compelling to the Western explorers in the late 1890s into the 1940s were the remains of the Buddhist civilization that once thrived near the abandoned oasis towns bordering the Taklamakan desert.[7] The interior walls of

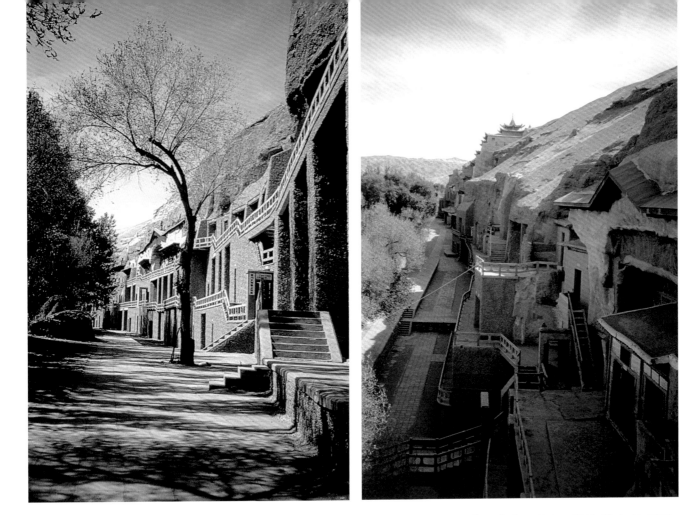

damaged Buddhist cave temples carved into cliffs still bore traces of extraordinary paintings or remnants of stucco-sculpted images, some life size, others colossal. In 1907 the renowned archaeologist Sir Aurel Stein (1862–1943), a contemporary of Clark's, visited the Mogao Buddhist caves (fig. 2)—known variously as the Dunhuang Mogao Caves and the Thousand Buddha Caves—just outside the town of Dunhuang in the far northwestern corner of Gansu province.[8] His uncovering of the hidden sutra-storage cave stands as one of the most famous of many such discoveries (fig. 3). Accompanied by the Daoist monk Wang Yuanlu (about 1849–1931), self-appointed caretaker of the isolated caves, Stein peered into the secret chamber that had been walled up centuries before. By the light of a primitive oil lamp, he saw layer upon layer of bundled manuscripts rising nearly 10 feet (3 meters) in height and filling some 500 cubic feet (14 cubic meters). Stein and his Chinese assistant, Qiang Siya, systematically examined countless manuscripts in Chinese, Sanskrit, Tibetan, Sogdian, Runic-Turkic, Uighur, and other languages unknown to them. He settled for removing just fifty compact bundles of Chinese manuscripts and five from Tibet. Another 230 bundles were acquired from Monk Wang four weeks later. In December 1907, Stein shipped nearly one

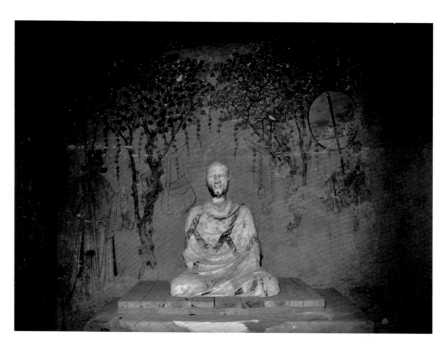

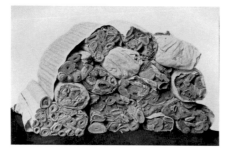

Figure 3 When opened by archaeologists, sealed Cave 17 of the Mogao Buddhist Caves was packed with thousands of manuscripts. At left, one of the 280 bundles of manuscripts Sir Aurel Stein selected, purchased, and shipped back to the British Museum; a statue of the monk Hong Bian that was removed to make room for the hidden library, was returned in the late 1970s (*right*)

hundred cases of documents and artifacts via India to the British Museum in London, where they arrived in 1909.[9] Stein's acquisitions included the *Diamond Sutra,* which dates to 868 C.E., making it the world's earliest dated and complete woodblock-printed book.[10] In her essay in this catalogue, noted archaeologist An Jiayao points out that the hidden cave was one of the two extraordinary discoveries that both foreshadowed and spurred the development of Chinese archaeology as a science.

At the beginning of the twentieth century, during what is sometimes referred to almost ironically as the "Golden Age" of archaeology in Central Asia or Chinese Turkestan, others also were gaining recognition for their dramatic adventures in pursuit of scientific purposes.[11] Among those who wrote fascinating narratives were the German, Albert von Le Coq (1860–1930), Paul Pelliot (1878–1945) of France,[12] and somewhat later the American Langdon Warner (1881–1955) and the elusive Count Ōtani Kōzui (1876–1948) of Japan.[13] All returned home with rich archaeological collections. As a result, during the first third of the twentieth century literally tons of wall paintings, manuscripts, sculptures, and treasures were removed from lost cities and Buddhist sites in Xinjiang and northwestern China and scattered through museums and institutions in at least a dozen countries (fig. 4).[14]

Although almost contemporaneous with Stein's, Clark's expedition falls into the second group of explorations, which were smaller, less well known, and took

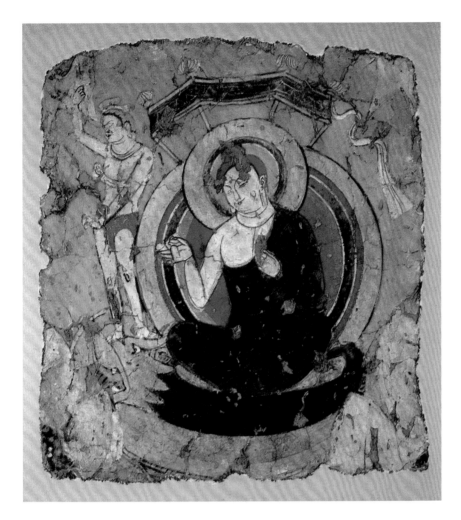

place mostly during the early twentieth century. These explorers worked primarily within northern China, where they conducted investigations of the geography and geology of the region and collected plant and animal specimens in the Loess Plateau.[15] Clark chose a somewhat uncommon route that few others would follow, from northern Shanxi province (Taiyuan), into Shaanxi province, near the Great Wall, through what is now called the Ningxia Hui Autonomous Region, and ending in Gansu province (see map, pages 2–3). At the time, this area was described not only as the hinterland of the Loess Plateau, but also as one of the "unknown or blank regions" on the map of China.[16]

The thoroughly comprehensive approach Clark conceived entailed data collection, observation, drawing and painting, photography, and documentation meticulously executed by an expert team using the best equipment then available. Although his primary goals were scientific—including a plane-table survey

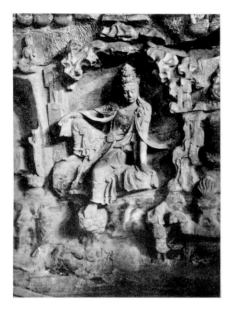

Figure 5 Carved-stone bodhisattva from the eleventh to twelfth century seated in a niche (*left*) and a central altar with an image of the Buddha flanked by bodhisattvas seated on lotus flowers (*right*); both from one of the three Buddhist caves in Qingliang Mountain near Yan'an, Shaanxi

of the entire route and the gathering of astronomical, meteorological, and geological information—*Through Shên-kan* also revealed other aspects of Clark's keen intelligence and acute observations in the manner in which he made photographs and described living conditions, agriculture, and cultural monuments in the towns and villages along the route. Among the cultural sites he visited were the Jinci ancestral temple just outside of Taiyuan as well as the Buddhist cave temples outside of Yan'an and the Xi'an Beilin Museum—the Forest of Steles—both in Shaanxi (fig. 5).[17] While Clark's expedition has been considered one of the most comprehensive of the time, it also earned another exceptional distinction: one of the few, perhaps the only one, that did not acquire archaeological treasures from China's soil to bring home.[18]

After spending six months assembling their supplies and collecting data in and around the city of Taiyuan, the thirty-six-man expedition team departed in September 1908, traveling westward on horse and mule through Shaanxi province, the southern part of what now is Ningxia Hui Autonomous Region, and into the eastern portion of Gansu province, before returning to Taiyuan—a journey of some 2,000 miles (3,200 kilometers) in all. En route they crossed the famous Loess—or Yellow Earth (Huangtu)—Plateau.[19] Loess consists of fine silt deposits built up by the windstorms that have swept across the plateau since ancient times. These homogeneous and nonstratified deposits cover some 247,100 square miles (640,000 sq. km) along the upper and middle reaches of the Yellow River

(Huanghe). They typically reach 1,000 feet (305 m) in depth, making them the thickest such accumulations in the world. Although very fertile, the yellow soil is also subject to severe erosion. Clark commented on the loess landscape outside of Taiyuan, which was "cut and hollowed by many rains into fantastic shapes, weird grottoes, deep chasms, narrow ridges and isolated columns,"[20] breathtaking scenery still visible today (fig. 6). Because it is easy to farm, the Loess Plateau provided ideal conditions for the development of the earliest Chinese Neolithic cultures. Loess deposits can also bury existing topography, thus concealing and preserving the remains of past structures. These remains, coupled with longstanding Chinese practices of interring the dead in underground tombs furnished with material goods for the afterlife, make the Loess Plateau—in particular Shanxi, Shaanxi, Henan, and Gansu provinces—incredibly rich in cultural relics.

Figure 6 Eroded and terraced landscape of the Loess Plateau

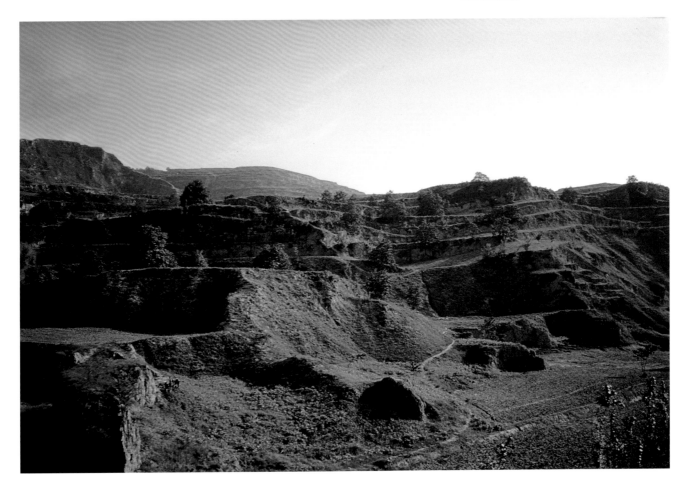

UNEARTHED: THE EXHIBITION

The year 2012 marks the centennial of the publication of Clark and Sowerby's detailed, lively narrative, *Through Shên-kan*. During this past century, China literally has been transformed in almost every respect. Fortuitously, the building and development that has taken place since the founding of the People's Republic of China in 1949 has led to extraordinary archaeological finds.[21] The discoveries have emerged largely as the result of what is called "salvage archaeology": the chance discovery of elaborate tombs filled with grave goods, ancient architectural foundations, and sculpture from lost temples. Today, treasures continue to appear when fields are plowed and bulldozers clear construction sites. Unprecedented and previously inconceivable archaeological finds have rewritten significant aspects of the history of China's ancient culture, particularly in the north. One such example—the mausoleum and terracotta army (fig. 7) of Emperor Qin Shihuangdi (died 201 B.C.E.)—has unquestionably achieved global recognition.[22]

Unearthed was conceived as an exhibition that would resonate with the physical journey as well as the cultural context of Sterling Clark's travels by focusing primarily on very recent developments in northern-Chinese archaeology. More than half of the objects on display have been uncovered since 2000. Organized chronologically for the most part, the principal objects presented were excavated in one of two provinces, with the earlier, fifth- and sixth-century examples

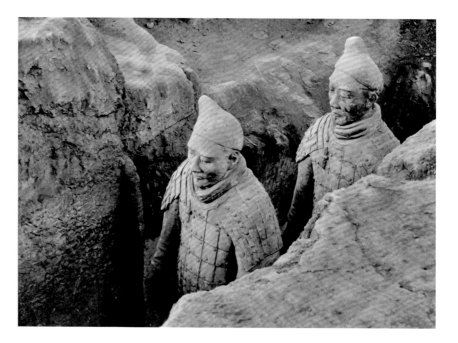

Figure 7 Two terracotta soldiers standing in Pit I, which was excavated as part of the Emperor Qin Shihuangdi's mausoleum complex at Lintong, Shaanxi

coming from Shanxi in the northeast, where the expedition began, and the later, seventh- to tenth-century objects from Gansu province in the northwest, where the trek ended. The material drawn directly from tombs is complemented by a Buddhist stone stele (Shanxi) and a reliquary (Gansu), both of which were found in what had been temple foundations. All these remarkable objects date between the fifth and tenth centuries, an interval described by Chinese and Western scholars alike as truly transformative for China's art and visual culture.[23]

During these centuries, China experienced dramatic political changes, and its boundaries shifted as the first true empire, the Han dynasty, slowly collapsed. Not only had the Han created a great empire, its era was one of unprecedented peace and prosperity conferred by internal economic and administrative reforms. A strong military successfully expanded China's external reach into the Western Regions and sheltered the beginnings of the trade routes later known collectively as the Silk Road. These accomplishments inspired such pride that even today the Chinese define themselves as "men of Han."[24] In the aftermath of empire, however, China became embroiled in political disunity, internecine warfare, and nomadic invasions that lasted for almost four hundred years. By the fourth century, the Tuoba Xianbei, a confederation among competing nomadic tribes, emerged victorious, conquering the north, which it ruled for 150 years as the Northern Wei dynasty (386–535; fig. 8). They drove remnants of the Han imperial house to South China, leaving the country divided into the nomad-ruled north and the traditional Han-ruled south.[25] The Northern Dynasties of this period of divided rule (known as the Northern and Southern Dynasties) encompassed five regimes of nomadic origin, which provide the focus for *Unearthed*.

Within two generations of ascending to power, the character of the Northern Wei regime began to change. Seduced by China's traditional culture, the ruling house eagerly sought to adopt the bureaucratic model of the Han and also began a conscious policy of Sinification. During 493 and 494, Emperor Xiao Wendi moved the capital from Datong to Luoyang, the ancient capital of previous Chinese dynasties, located near the Yellow River in the heart of northern China. Here, Tuoba Xianbei aristocrats were ordered to adopt Chinese dress and speak only Chinese at court; they also were encouraged to change their surnames and intermarry with the surviving Chinese gentry.[26] This policy led to serious internal struggles between the ruling house and opposing tribal aristocracy, who resented relinquishing their Tuoba heritage. The north was plunged into chaos and bloodletting

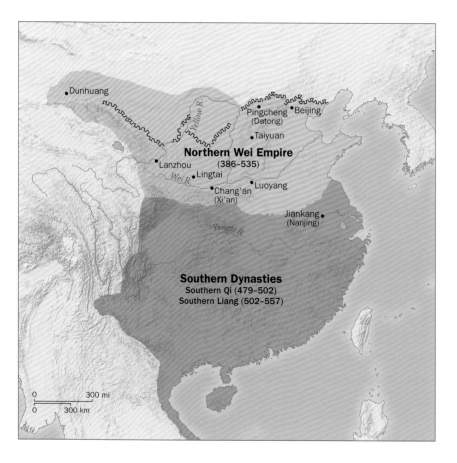

in 535 as the Northern Wei split into two rival dynasties (fig. 9): the Western Wei (535–557), which became the Northern Zhou (557–581), and the Eastern Wei (534–550), which soon was succeeded by the Northern Qi (550–577; fig. 10).

Against this backdrop of disruption, trade along the Silk Road continued to flourish, as foreigners, merchants, diplomats, Buddhist monks, and artisans carried a wealth of goods as varied as grapes, gold, silver, and Roman and Persian glass (fig. 11) to Chinese cities, such as Luoyang in Henan, Lanzhou in Gansu, and Xi'an in Shaanxi. Luoyang itself fostered a large community of foreigners, mostly merchants, who numbered some forty to fifty thousand. They were restricted to a special district in the southern part of the city that was divided into four wards,[27] where their special market was known as the Four Directions Market in reference to the foreign visitors or new immigrants arriving from each of the four directions.[28] As new ideas and religions, particularly Buddhism from India and Central Asia, arrived and took root, China's landscape began to be transformed with pagodas and temples (fig. 12), and its philosophical discourse, imagery, sculptural styles, and floral vocabulary were likewise enriched. Decorative elements such as classical palmettes borrowed from Mediterranean cultures, and the lotus flower, a symbol of the Buddha, became ubiquitous. The mid-sixth-century Northern Qi

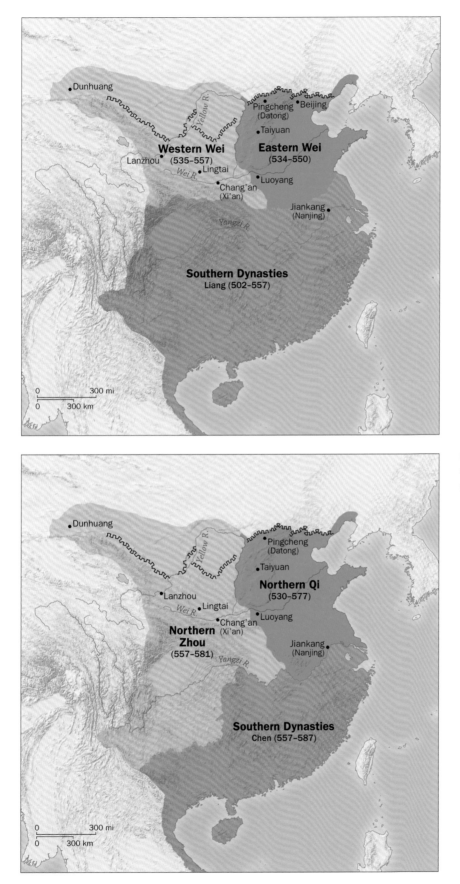

Figure 9　Map showing the division of the Northern Wei Empire into the Western and Eastern Wei dynasties

Figure 10　Map showing the overthrow of the Western Wei dynasty by the Northern Zhou and the Eastern Wei dynasty by the Northern Qi

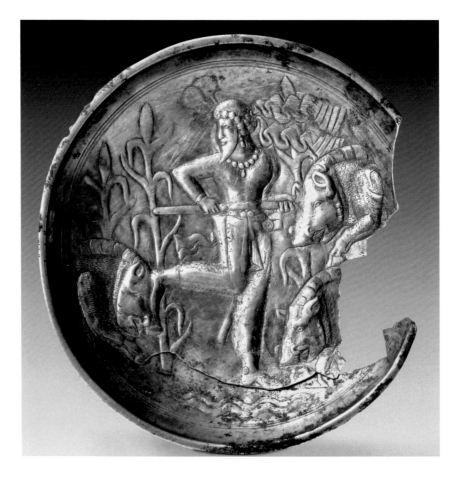

Figure 11 Plate of gilt silver, probably of provincial Sasanian manufacture (late third to early fourth century), showing a hunting scene; excavated from a tomb near Datong, Shanxi province, burial place of Feng Hetu (died 504), commander of cavalry and a garrison located along China's northern border in an area where merchants, nomads, and exotic goods from western Central Asia all mingled

stone stele that shows remains of extensive pigment and gilding (**pl. 10**) exemplifies the profound effect of Buddhism in China's visual culture.

By the fifth century, visual arts revealed the growing intersection of influences coming into the north, a blending visible in the exhibition in Song Shaozu's stone sarcophagus (pl. 1).[29] After centuries of disorder, China's second great empire, the Tang, arose in 618 and endured until 907. Tang became not only the most powerful culture in East Asia, but also its most cosmopolitan. The Silk Road trade reached its apogee during the Tang, which facilitated the flow of exotic goods and foreigners into the capital city of Chang'an in Shaanxi province, as well as other northern cities, and it created a dynamic, multiethnic society and culture.[30]

Rather than strive for a purely chronological survey of the artistic and cultural achievements during this complex time, *Unearthed* presents a small, select group of objects anchored by a central theme: the transformation in northern Chinese art and visual culture spurred by the dynamic interaction among the

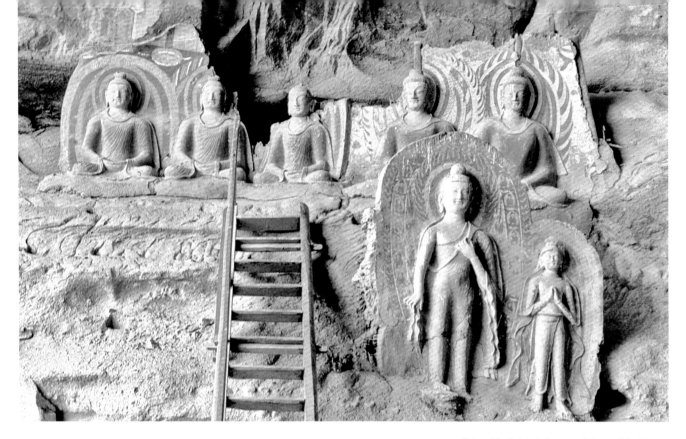

Figure 12 Painted stucco sculptures of Buddhas from the upper levels of Cave 169 (dated 420) at Binglingsi, Yongjing, Gansu province, one of the earliest dated Buddhist cave temple sites in China

"Han" Chinese, their nomadic northern neighbors and conquerors, and the outside world of foreigners, particularly Buddhist monks, who traveled the Silk Road. This theme of transformation is explored through discussion of evolving traditional-Chinese burial practices as exemplified by a late-fifth-century Northern Wei tomb from Datong (pls. 1–4) juxtaposed with a recently discovered, undisturbed, eighth-century Tang tomb from Fujiagou Village, Lingtai county, in Gansu province (pls. 10–16). Overall, the objects selected for this exhibition reveal important changes, from a shift in subject matter that now incorporates a new vocabulary of animal and military imagery, to adaptation of typically Buddhist iconographic forms, such as the guardians of the Buddhist realms or *tianwang* (heavenly kings; pls. 11–12), into the pantheon of Chinese tomb guardians. The inclusion of the two magnificent examples of Buddhist sculpture—a mid-sixth-century stele from Shanxi (pl. 10) and a tenth-century reliquary from Gansu (pl. 18)—underlines the importance of Buddhism and foreign-inspired sculpture and painting in the formation of China's decorative vocabulary and aesthetic sensibilities.

The discussion of the impact of nomadic art and culture on northern China further challenges a longstanding ambivalence on the part of the Chinese toward their northern neighbors, whom they tended to perceive as uncultured barbarians to be either civilized or dismissed. As far back as the Zhou dynasty, Mencius (about 371–about 289 B.C.E.), perhaps the most famous disciple of Confucius, pointedly observed: "I have heard of men using doctrines of our great land to

change barbarians, but I have never heard of any being changed by barbarians."[31] For centuries, the "men of Han" scorned the northern nomadic lifestyle, which they characterized in their derogatory descriptions of men with loose-hanging hair, who ate cheese and consumed horsemeat with their hands. Today, many Chinese are unaware of their multiethnic heritage. Of the two-dozen imperial dynasties in China's history, most founding rulers were non-Han or only partly Han. Most Chinese would be surprised to learn that the surname of their leader, Hu Jintao, is multiethnic in origin, *hu* meaning "foreign, barbarian," the term once used to designate northern nomads and foreigners.[32]

The definition of *Chinese* long had been an issue for those dwelling within the *Middle Kingdom,* the term by which the Chinese came to call their country and is indicative of their distinctly Sinocentric view of the world. From ancient times, China's view of itself was based on cultural and political, rather than ethnic, criteria. It involved a complex set of usages, sometimes known as *li,* which are defined as "what the former Kings received from Heaven and Earth, in order to govern their people."[33] By the Han dynasty, the notion of what it meant to be Chinese was firmly established, so that those who considered themselves Chinese called themselves *Han* and termed all others *not Han.* To be considered Han, one had to live according to specific political and cultural norms, so it came to be an ethno-cultural designation, regardless of a person's actual origins. As noted above, the Tuoba Xianbei elites who established the Northern Wei dynasty took steps to acculturate themselves to Han customs and practices at the same time as they maintained aspects of their own distinctive culture.

Some ambivalence toward the "nomads" and "foreigners" remains in China today, but the negative connotation began to fade beginning in the 1970s with the accumulation of impressive archaeological finds that resulted in recognition that from about 1300 B.C.E. and even earlier through the tenth century C.E., nomadic tribes in northern China played a pivotal role in facilitating trans-Asian trade. The nomads often acted as intermediaries, transmitting to China important technologies, such as wheeled transport, chariotry, cavalry, and metalworking techniques for granulation, twisted wire, cloisonné, and lost-wax casting, which they in turn had learned from tribes further west in Central and West Asia.[34]

Since the 1990s, truly extraordinary tombs have been unearthed in Shanxi and Gansu provinces, and these finds have allowed for the rigorous, revealing

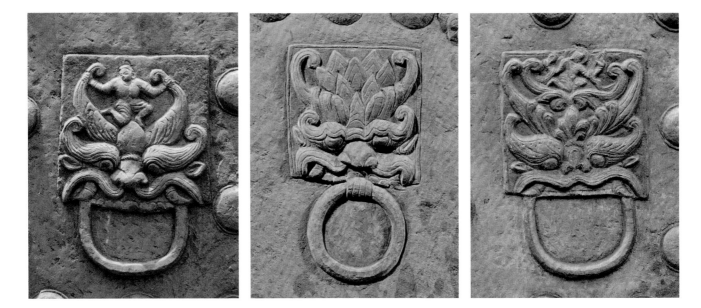

Figure 13 Three carved *pushou* (ring handles) embellishing the exterior front wall of the stone sarcophagus excavated from the tomb of Song Shaozu, Datong, Shanxi province (details of pl. 1)

study of exciting, previously unknown and unexpected material. The uniquely large, detailed stone sarcophagus and coffin platform from the tomb of Song Shaozu (died 477; pls. 1, 4), a magistrate who served in the Northern Wei court, is the centerpiece of *Unearthed*. His sarcophagus, found in 2000 outside the city of Datong in northern Shanxi province, is comprised of more than a hundred individual carved-stone pieces and is constructed to imitate a wooden building with roof brackets and tiles, unmistakably emulating Chinese architectural features and resembling a traditional ceremonial hall. The exterior walls of the sarcophagus have twenty-two *pushou*—beastlike masks clearly non-Chinese in origin (fig. 13)—carved on them. This sarcophagus has remained virtually untouched since the tomb was excavated in 2000, and it has never before traveled outside of China. Datong City, located at the northern border of Shanxi province, just south of Inner Mongolia, is on the site that was known as Pingcheng when it served as the first capital of the Xianbei nomads after they conquered north China and established the Northern Wei dynasty. The grave goods from Song Shaozu's tomb include 117 pottery sculptures, or *mingqi,* made specifically to accompany him into the afterlife.[35] Nearly all were military figures adorned with distinctive cockscomb headgear and wearing typical nomadic dress of long tunics over trousers and boots (pl. 2).

This late-fifth-century material is supplemented with magnificent sculptures of camels and oxen, ceramics, and jewelry excavated from the mid-sixth-century tomb of the Xianbei tribesman Lou Rui (died 570), a member of one of the most

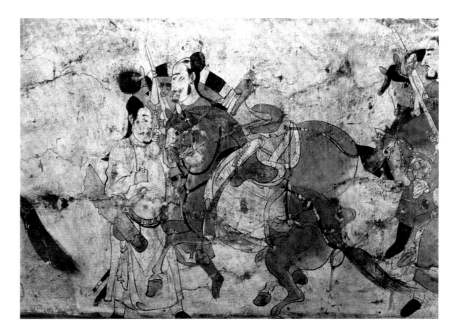

influential nomadic ruling families of the Northern Qi dynasty (fig. 14). His tomb was uncovered in Taiyuan, the modern-day capital of Shanxi, which also served as the Northern Qi emperor's alternate capital to Ye (or Jinyang).[36] Unearthed from what had been the location of a famous monastery in the Taiyuan area, the mid-sixth-century Northern Qi stone stele with remains of extensive pigment and gilding exemplifies the profound impact of Buddhism on China's visual culture (pl. 10). The style, iconography, and exquisite sculptural quality draw from a complex of sources—India, Central Asia, and Southeast Asia—and blend with Chinese aesthetic values.

The recently discovered, eighth-century, Tang-dynasty tomb from Fujiagou Village, Lingtai county in southern Gansu province demonstrates the continuing assimilation of foreign influences and new artistic imagery.[37] Unlike so many others, this tomb was uncovered intact, its undisturbed contents in excellent condition and occupying their original positions. From this tomb, six clay *mingqi;* a pair of door guardians, or *tianwang* (fig. 15; pls. 11–12); a pair of *zhenmushou* (pls. 13–14), coffin guardians depicting composite monsters or earth spirits; and a camel with attending groom (pls. 15–16) provide insights into the role of the burial as a symbolic microcosm through which the deceased traverses into the afterlife. The connection with Buddhist imagery and the penetration of that imagery into Chinese visual culture is further underscored by the tenth-century stone Buddhist reliquary (pl. 18), the form of which follows the shape of the stone

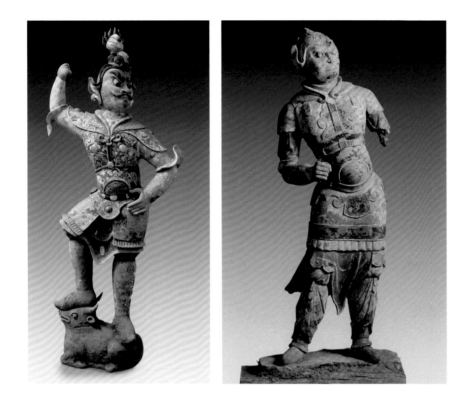

Figure 15 Two Tang-dynasty *tianwang* (heavenly kings)—painted and gilded clay tomb-guardian sculptures: (*right*) *tianwang* from a cave temple at Mogao Buddhist Caves that originally was positioned to protect the Buddhist realm within; (*left*) one excavated from a tomb at Fujiagou, Lingtai, Gansu (pl. 11), was adapted from Buddhist precursors into the pantheon of Chinese tomb guardians

sarcophagi that were commonly found in sixth-century graves across northern China. The false door carved into the south end of the reliquary is flanked by a pair of *tianwang* carved in relief that protect the now-lost sacred or sanctified relics associated with the Buddha and the Buddhist realm.

The Song Shaozu stone sarcophagus and the clay tomb sculptures from Fujiagou Village form the focus of *Unearthed,* and they are key to understanding the role and importance of burial practices in ancient Chinese culture. Together with the accompanying photographs and diagrams documenting the tomb plans and excavations, they offer tangible engagement with the concepts of the afterlife and the connections between life and death. Tomb decor and objects demonstrate the interweaving of popular beliefs with Buddhism as well as Confucianism and Daoism, the three philosophies that underpin China's ancient culture. By focusing first on the north during its period of disunity, then on the reunification achieved by the Tang Empire, it becomes possible to glimpse the threads of influence from popular beliefs and from nomads, other foreigners, and Buddhism. These influences eventually amalgamate with elements of traditional Han and Tang cultures to shape the dynamic that not only contributed to the formation of China's multiethnic civilization but also sustained it over millennia.

ENDNOTES

1. *Rebellion,* the commonly used term for the Boxer's uprising, is historically inaccurate; *movement* is more correct. This violent reaction to foreign encroachments was provoked by the complex events and conditions of the late nineteenth century. Poverty and starvation among the Chinese peasantry led to the emergence of the Boxer movement, a direct response to the deepening crisis in their lives. The diverse forces and events that led to destruction in the countryside, the burning of missionaries, the slaughter of Chinese Christians, and the siege of the foreign legations are lucidly discussed and analyzed by John K. Fairbank, Edwin O. Reischauer, and Albert M. Craig in *East Asia: The Modern Transformation* (Boston: Houghton Mifflin, 1965), 394–407.

2. See *Sterling Clark in China* (Williamstown, MA: Sterling and Francine Clark Art Institute, 2012), a catalogue accompanying an exhibition at the Clark Art Institute in summer 2012, which presents the story of the Clark expedition and is illustrated with archival photography.

3. Robert Sterling Clark and Arthur de C. Sowerby, *Through Shên-kan: The Account of the Clark Expedition in North China, 1908–9,* ed. Major C. H. Chepmell (London: T. Fisher Unwin, 1912), [i].

4. Some thirty-two years later Sowerby published an important reference book, *Nature in Chinese Art* (New York: John Day, 1940), which has helped several generations of scholars, collectors, and students of Chinese art identify birds, wild and domestic animals, reptiles, fishes, and flora depicted in ancient paintings, porcelain, lacquer, sculpture, roof tiles, and other media. Sowerby eventually became president of the North China Branch of the Royal Asiatic Society and honorary director of the Shanghai Museum.

5. Clark and Sowerby, *Through Shên-kan,* 1.

6. Since the 1990s, Silk Road literature has expanded exponentially as archaeologists and others uncovered more tombs and lost cities, gripping the world's imagination. The political thaw during this time also made it possible for increasing numbers of foreign scholars and tourists to visit these sites in Xinjiang and West Asia. A continuing stream of exhibitions in the United States, Europe, and Japan has also fueled Silk Road fever. Suggested readings include Denis Sinor, ed., *The Cambridge History of Inner Asia* (Cambridge, UK: Cambridge University Press, 1990); Richard C. Foltz, *Religions along the Silk Road* (New York: St. Martin's Press, 1999); Susan Whitfield, *Life along the Silk Road* (Berkeley: University of California Press, 1999); Annette L. Juliano and Judith A. Lerner, *Monks and Merchants: Silk Road Treasures from Northwest China* (New York: Asia Society; Abrams, 2001); Li Jian, ed., *The Glory of the Silk Road: Art from Ancient China* (Dayton, Ohio: Dayton Art Institute, 2003); Susan Whitfield, ed. *The Silk Road: Trade, Travel, War, and Faith* (Chicago: Serindia, 2004); and Luce Boulnois, *Silk Road: Monks, Warriors, and Merchants on the Silk Road* (Hong Kong: Odyssey, reprinted 2008).

7. Surrounded on three sides by ranges of some of the highest mountains in the world and blocked by the Gobi desert on the fourth side, the Taklamakan desert in Xinjiang was so dreaded that it was called the "Land of Death." Travelers feared the *kara-buran,* the black hurricane described by Albert von Le Coq: "It unleashes appalling violence upon the caravan. Enormous masses of sand mixed with pebbles The whole happening is like hell let loose." (Quoted in Peter Hopkirk, *Foreign Devils on the Silk Road* [London: John Murray, 1980], 10–11.) Darkness mixed with howling, roaring, and strange clashing noises could easily panic the horsemen, because the Chinese believed such happenings were caused by demons.

8. The Mogao Caves of Dunhuang comprise the most famous site in Gansu province. Positioned in the northwestern corner, where the province borders Xinjiang and Qinghai, the caves and the town are situated where the northern and southern Silk Roads met before the caravans continued through the Hexi corridor (Gansu) into the heartland of China. Recognition of the site's importance has been accompanied by efforts to address the challenges of conserving a location that is constantly encroached upon by the desert. In 1961 the Chinese government included Mogao in the first group of sites designated as Protected Important National Cultural Properties, and UNESCO approved it as a World Heritage Site in 1987.

 These caves have been wrapped in an aura of mystery and drama ever since Stein discovered Cave 17—the secret-library cave filled with manuscripts and paintings. Since then, Dunhuang's rich and complex iconography, architecture, sculpture, and wall paintings located in 492 caves that stretch along a mile-long (1,700-meter) cliff, have been the focus of worldwide scholarly attention. Hundreds of books, scholarly articles, and popular magazine pieces have been published on this astonishing site and its dramatic setting. *The Caves of Dunhuang* (Hong Kong: London Editions, 2010) by Fan Jinshi, director of the Dunhuang Academy, provides an excellent overview and gorgeous photographs. Another helpful English-language publication that describes some of the challenges faced by conservators is Roderick Whitfield, Susan Whitfield, and Neville Agnew's *Cave Temples of Mogao: Art and History on the Silk Road* (Los Angeles: Getty Conservation Institute and J. Paul Getty Museum, 2000).

9. In the *Times Literary Supplement,* Sir Leonard Woolley, discoverer of Ur, hailed the discovery of the hidden sutra cave as "an unparalleled archaeological scoop" (quoted in Hopkirk, *Foreign Devils,* 165). Sir Aurel Stein's archaeological explorations were followed avidly by his contemporaries and first announced in the *Times,* the British Empire's most important broadsheet, which carried well over one hundred articles on the subject between 1901 to 1943; see Helen Wang, *Sir Aurel Stein in* the Times: *A Collection of over 100 References to Sir Aurel Stein and His Extraordinary Expeditions to Chinese Central Asia, India, Iran, Iraq and Jordan in the Times Newspaper, 1901–1943* (London:

Eastern Art, 2002). For Stein's first-hand account of this expedition to the Mogao Caves, see Aurel Stein, *Ruins of Desert Cathay: Personal Narrative of Explorations in Central Asia and Westernmost China,* 2 vols. (London: Macmillan, 1912).

According to the Dunhuang Academy, almost 80 percent of the contents of the hidden library cave (manuscripts and silk, painted banners) were removed to the West and India; see the International Dunhuang Project at the British Museum Library for their holdings and information about the library's collaboration with other sites and the Dunhuang Institute, http://idp.bl.uk

10. S. Whitfield, *The Silk Road: Trade, Travel, War, and Faith,* 301.

11. These scientific and archaeological expeditions were played out against a background of intense political rivalry in what is sometimes referred to as the "Great Game," which was "played," or fought, between the British and the Russians struggling to maintain their influence in Central Asia; see Imre Galambos, "Japanese 'Spies' along the Silk Road: British Suspicions Regarding the Second Otani Expedition (1908–1909)," *Japanese Religions* 35, nos. 1/2: 33–61; and Peter Hopkirk, *The Great Game: The Struggle for Empire in Central Asia* (New York: Kodansha International, 1992).

12. Paul Pelliot, one of the greatest Sinologists of his time, arrived "hard on Stein's heels" at the Mogao Caves in Dunhuang, and persuaded Wang, the caretaker, to part with more cartloads. After this, the Chinese authorities ordered the removal of the remaining contents of the cave to Beijing. In spite of this, manuscripts were still for sale when Russian and Japanese expeditions arrived several years later. Stein bought another six hundred scrolls in a nearby town in 1913; see S. Whitfield, *Life along the Silk Road,* 5.

13. There is an extensive body of documentary narratives written by these "Silk Road" explorers, including one by the Swedish traveler, Sven Anders Hedin (1865–1952). His discovery of the ruins of once-rich oases near Khotan in Xinjiang and the two-volume *Through Asia* (New York: Harper and Brothers, 1898), the account he published, fired the imaginations of scientists and explorers, and the "Great Race" began. See Albert von Le Coq, *Chotscho: Königlich-Preußische Turfan-Expedition* (Berlin: D. Reimer, 1913) and, in English, *Buried Treasures of Chinese Turkestan* (London: George Allen & Unwin, 1928; reprinted, with new introduction by Peter Hopkirk, Hong Kong: Oxford University Press, 1985); Paul Pelliot, *Les grottes de Touen-Houang: Peintures et sculptures bouddhiques des époques des Wei, des T'ang, et des Song,* 6 vols. (Paris: Paul Guethner, 1914–24); Langdon Warner, *The Long Old Road in China* (London: Arrowsmith, 1927) and *Buddhist Wall-Paintings: A Study of a Ninth-Century Grotto at Wan Fo Hsia* (Cambridge, MA: Harvard University Press, 1938).

14. Some of the paintings, manuscripts, and fabric fragments Sir Aurel Stein collected from Dunhuang's Cave 17 and sent to the British Mu-

seum are included in Roderick Whitfield and Anne Farrer, *Caves of the Thousand Buddhas: Chinese Art from the Silk Route* (New York: Braziller, 1990); a selection of the sculpture, wall paintings cut out of walls, and manuscripts from the ruins of Buddhist temples and other monuments that were taken back to Germany by Albert Grünwedel and Albert von Le Coq for the Museum für Indische Kunst in Dahlem and Staatliche Museen Preußischer Kulturbesitz, Berlin, were exhibited at the Metropolitan Museum of Art in 1982; see Herbert Härtel and Marianne Yaldiz, *Along the Ancient Silk Routes: Central Asian Art from the West Berlin State Museums* (New York: Metropolitan Museum of Art, 1982).

15. The word *loess* was coined in 1823 by German mineralogist Karl Cäsar von Leonhard (1779–1862) to describe the unstratified deposits of soil in this region of North China. It is related to the German word *los* (loose).

16. William Churchill, "Review of *Through Shên-kan,*" in *Bulletin of the American Geographical Society* 47, no. 1 (1915): 62.

17. Clark includes one photograph of the Jinci temple compound and the pagoda near Taiyuan along with three others of surviving Buddhist caves carved out of a sandstone cliff, during the Song dynasty (960–1279), in Yan'an, Shaanxi; see Clark and Sowerby, *Through Shên-kan,* 29, pls. 18, 19, 20 (Yan'an) and pl. 4 (Jinci). Clark also visited one of the oldest museums in China, the Xi'an Beilin Museum, often referred to as the Forest of Steles, a veritable stone forest made up of 1,095 steles that range in date from the third to the twentieth century. Some of these stone slabs and tablets rise as tall as 10 feet (3 meters), and they preserve ancient classical texts, historical events, epitaphs, and famous calligraphy. In 1087 the stones were moved into a former Confucian temple compound, which became the Beilin's permanent home. For a discussion of Beilin's history and its holdings of Buddhist sculpture, see Annette L. Juliano, *Buddhist Sculpture from China: Selections from the Xi'an Beilin Museum, Fifth through Ninth Centuries* (New York: China Institute Gallery, 2007); for one of the rubbings made from a stele and purchased by Clark at the Beilin, see Clark and Sowerby, *Through Shên-kan,* pl. 26.

18. Shi Hongshuai at Shaanxi Normal University has evaluated the Clark expedition's scientific goals and compared them to those of other explorers traversing the Loess Plateau. In notes on his translation of *Through Shên-kan,* Shi concluded that Clark offered more "comprehensive content than any single disciplinary exploration done by Western expedition teams in the Loess Plateau regions. . . . They did not rob cultural relics or hunt rare species—activities that were common among other Western expedition teams." The original text by Shi Hongshuai was published in *A Collection of Theories on Chinese History and Geography* (Beijing: Chinese Social Sciences Press, 2008), 4.

In a letter to Clark dated 16 November 1930 (now at the Clark Art Institute), Sowerby lamented that they had missed the opportunity to acquire archaeological treasures: "Since the Chinese have discovered that there is good money to be made from things they find in ancient tombs, they have begun to open them up over Honan [Henan] and Shanse [Shanxi] and Shensi [Shaanxi] with marvelous results. As I knew it would be that country is turning out to be a veritable treasure house of ancient Chinese art. . . . Just think of it . . . we didn't know anything about this when we were there. What a sensation we could have made if we had stumbled on some of it."

19. Chiao-min Hsieh, *Atlas of China* (New York: McGraw Hill, 1973), 16. Another helpful book about loess silt and its use in constructing cave dwellings in northern China is Gideon S. Golany's *Chinese Earth-Sheltered Dwellings: Indigenous Lessons for Modern Urban Design* (Honolulu: University of Hawai'i Press, 1992).

20. Clark and Sowerby, *Through Shên-kan,* 14.

21. In her essay for this catalogue, An Jiayao poignantly describes current conditions, in particular the insufficiency of Chinese archaeologists qualified to lead fieldwork. Every year, thousands of new construction projects begin, but a very small fraction of them include any archaeological assessment before building begins, which has resulted in untold numbers of ancient sites and cultural relics being bulldozed.

22. For a fascinating discussion of the production process for the thousands of terracotta soldiers guarding Qin Shihuangdi's eternal residence, see Lothar Ledderose, *Ten Thousand Things: Module and Mass Production in Chinese Art* (Princeton, NJ: Princeton University Press, 1998), 67–73; for an overview, see *The Terracotta Warriors: The Most Significant Archaeological Find in the 20th Century* (Beijing: People's China Publishing House, 1997).

23. Between the fall of the Han and rise of the Tang dynasties, China succumbed to four hundred years of turmoil. This hiatus from 220 to 589 C.E. has been known by various names: Three Kingdoms–Six Dynasties, Three Kingdoms and Northern and Southern Dynasties, or simply the Six Dynasties period. Except for a few scholars' interest in the development of Buddhist art, calligraphy, and ceramics, a tendency prevailed to ignore or minimize this period's contributions to the development of Chinese art and culture. Among the early attempts to analyze its important contributions of this period was an exhibition drawn from Western collections curated by Annette L. Juliano, *Art of the Six Dynasties* (New York: China Institute in America, 1975). But the outpouring of extraordinary archaeological finds since then has changed this perspective, and the eminent scholar Wu Hung refers to this hiatus as a time of broad cultural interaction and a transformative period. Between 2000 and 2003, he organized three international conferences and edited three volumes on the subject (all published by the Cultural Relics Publishing House in Beijing): *Between Han and Tang: Religious Art and Archaeology in a Transformative Period* (2000);

Between Han and Tang: Visual and Material Culture in a Transformative Period (2001); and *Between Han and Tang: Cultural and Artistic Interaction in a Transformative Period* (2003).

24. A valuable overview of Han history and culture is Michele Pirazzoli-t'Serstevens' *The Han Dynasty,* trans. Janet Seligman (New York: Rizzoli, 1982).

25. Mark Edward Lewis has written two excellent books that cover the Northern and Southern Dynasties and the Tang: *China between the Empires: The Northern and Southern Dynasties* (Cambridge, MA: Harvard University Press, 2009); and *China's Cosmopolitan Empire: The Tang Dynasty* (Cambridge, MA: Harvard University Press, 2009). For a summary of the material culture and archaeological finds up to 2007, see Albert E. Dien, *The Six Dynasties Civilization* (New Haven, CT: Yale University Press, 2007).

26. Lewis, *China between the Empires,* 81–82.

27. Ibid., 115.

28. Ibid.

29. The sarcophagus and tomb of Song Shaozu (died 477) was first published in Chinese by the Shanxi Provincial Institute of Archaeology and the Datong Municipal Institute of Archaeology, "Datong Bei Wei Song Shaozu mu fajue qianbao" (A brief report on the discovery of the Northern Wei Tomb of Song Shaozu near Datong City), *Wenwu* 7 (2001): 39. A comprehensive monograph on the entire eleven-tomb site, including No. 5 (that of Song Shaozu), is Datong City Archaeological Research Institute, *Datong Yanbei Shizhang Bei Wei mu qun* (Tombs of the Northern Wei period in Yanbei Teachers College at Datong), ed. Liu Junxi (Beijing: Cultural Relics Publishing House, 2009).

30. A sense of this exotic, multiethnic life in the Tang court and the bustling streets and markets of the capital city is conveyed in *The Golden Peaches of Samarkand: A Study of Tang Exotics* (Berkeley: University of California Press, 1963), a wonderful book by Edward H. Schafer, who discusses the important resources camels provided in addition to excellent transport across deserts. Camel hair, for example, could be woven into a soft cloth, which Marco Polo admired, and the hump, considered a delicacy, could be stewed or broiled (p. 72).

31. Quoted in Jenny F. So and Emma C. Bunker, *Traders and Raiders on China's Northern Frontiers* (Washington, D.C.: Arthur M. Sackler Gallery, Smithsonian Institution, 1995), 86; and Tao Jing-shen, *Two Sons of Heaven: Studies in Sung and Liao Relations* (Tucson: University of Arizona Press, 1988), 2.

32. Comments drawn from a *New York Times* blog: http://roomfordebate.blogs.nytimes.com/2009/12/13chinas-changing-views-on-race, particularly those of Yan Sun, a political science professor at Queens College of the City University of New York, who is cowriting a book about ethnic relations in contemporary China.

33. Herrlee G. Creel, *The Origins of Statecraft in China,* vol. 1: *The Western Chou Empire* (Chicago: University of Chicago Press, 1970), 197. As early as the late second millennium B.C.E., with the invasion of the Zhou peoples, the issue of who is and who is not "Chinese" arose. The already settled Shang viewed the invaders as "uncultivated intruders," although as soon as the Zhou established themselves as rulers, their non-Chinese origins became moot as they adopted existing Chinese cultural values.

34. So and Bunker, *Traders and Raiders,* 26–27 and 73–74.

35. Short Report of Song Shaozu, *Wenwu* 7 (2001): 26–36.

36. The tomb of Lou Rui was first published by the Shanxi Provincial Institute of Archaeology and Taiyuan Municipal Institute of Cultural Relics and Archaeology Committee, "Taiyuan Shi Lou Rui mu fajue jianbao." Also see the brief report of the discovery of the Northern Qi tomb of Lou Rui, Taiyuan City, *Wenwu* 10 (1983): 1–23. The Shanxi Provincial Institute of Archaeology and Taiyuan Municipal Institute of Cultural Relics and Archaeology published a comprehensive monograph, *Bei Qi Dong'an Wang Lou Rui Mu* (Northern Qi Tomb of Lou Rui, Prince Dong'an) (Beijing: Cultural Relics Publishing House, 2006).

37. The archaeologists have not completed their report on the excavation of the Tang tomb found in Fengjia loess hill, near Fujiagou Village. All information about this undisturbed tomb has been drawn from the Gansu archaeologists' preliminary draft report, presently in preparation, "Ling tai xian Liangyuan Xiang Fujiagou cun Yaoziji-anshe Fengjia Shan Tangmuqiangjiu xingqing liji ben qingguang" (Basic Description of the Emergency Rescue Excavation for the Tang tomb at Fengjia Hill, Taozijian Cooperative at Fujiagou Village in the Liangyuan District of Lingtai County, Gansu), which was generously provided to the Clark Art Institute.

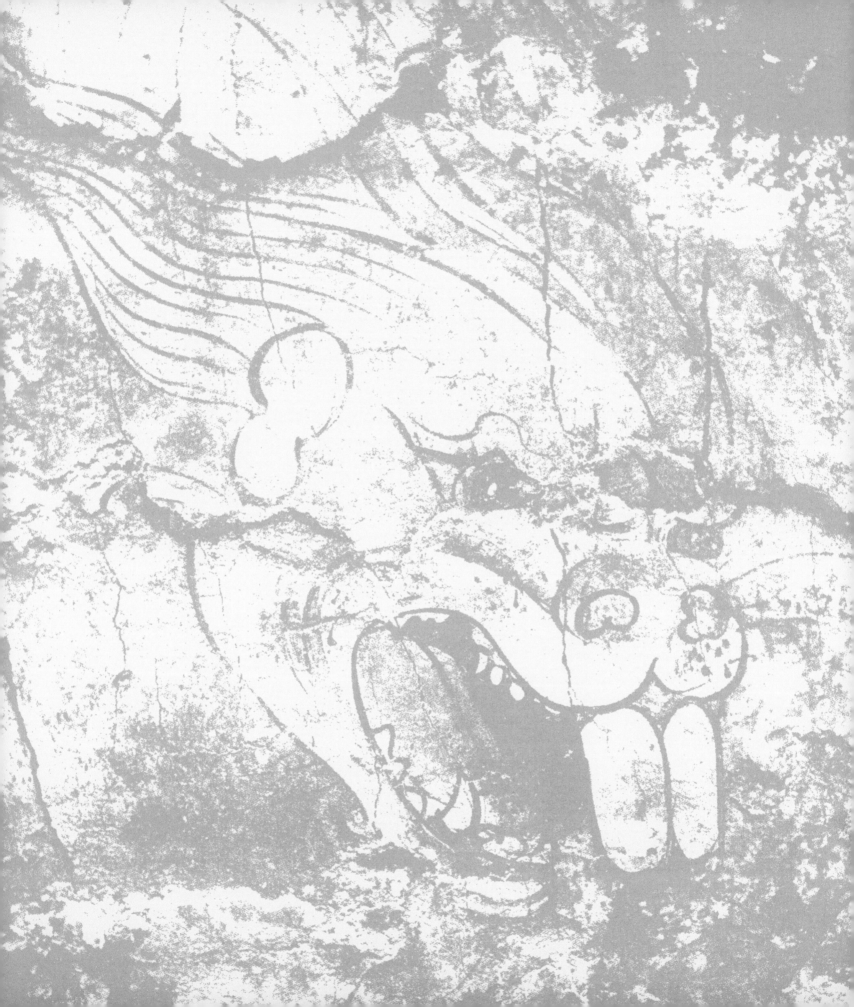

BURYING THE DEAD IN CHINA

or thousands of years, beginning as early as the Neolithic period or the sixth millennium B.C.E., the Chinese buried their dead by surrounding them with meaningful objects—some beautiful, others mundane, and a few terrifying. Most of these objects were created especially for burial and often were selected from the everyday surroundings of the deceased and reproduced in miniature form as *mingqi*. Early Chinese graves evolved from simple vertical shafts to horizontal pits and finally to rooms constructed with both hollow and solid bricks and slabs of stone. By the second century B.C.E., tombs of the wealthy and aristocratic became multichambered spaces arranged along a horizontal axis and entered through a long passageway in imitation of the houses and palaces of the living.[1] Underground residences for the dead often were staffed with clay servants; protected by painted-pottery guardians, sometimes whole armies of them; filled with models of horses, dogs, pigs, and other animals; and provisioned with food and drink, including storage jars filled with grain and wine. Chinese life and social organization thereby crossed the threshold into the place of the dead. The injunction of Xun Zi, the fourth-century Chinese philosopher, was simple—treat the dead like the living: "They are treated as though dead and yet are still alive, as though gone and yet are still present."[2]

These burial practices stemmed from the belief that death was not oblivion but rather a change in status that transported one into a new sphere of existence characterized by a definite continuity and even dialogue with the old life. Chinese views of the afterlife varied somewhat, as they were informed by a mixture of complex, sometimes contradictory Chinese folk religions of the distant past coupled with influences from the "three teachings"—Confucianism, Daoism, and later, Buddhism. However, filial piety and ancestor worship provided the consistent foundation for the conception of the afterlife. As early as the Western Zhou dynasty (1050–771 B.C.E.), the growth of ancestral cults inspired temple building,

elaborate rituals, and ornate burials.[3] The extended family or clan included not only the living but also the whole line of deceased relatives. Filial piety, a fundamental tenet of Confucianism, prescribed much of the behavior within the traditional family and reached beyond the grave to delineate obligations the living owed to the spirits of the dead.[4] Confucius taught that filial piety meant that parents must be served in death just as they were in life. Reverence was bestowed not only by child to parent, but also by survivor to deceased. Complex ceremonies and burial customs that prepared the deceased for the next world also were designed to honor, placate, and nourish them. Well-cared-for ancestor spirits bestowed good fortune on the living, while neglected spirits turned into malevolent, implacable ghosts, who would harass the living. Even during times when the society was transforming rapidly, the Chinese have always believed in the existence of the spirits of the dead, and they continue to do so today.[5]

As the concept of spirits or the soul in China and the mystery of what happens after death coalesced from many sources, over centuries, new ideas merged with old practices resulting in an aggregate of unsystematic beliefs that were inherently elusive and often illogical. In pre-Buddhist China, the soul traditionally was perceived to comprise two different elements sometimes described as two distinct "souls"—the *hun* and the *po*.[6] When these two aspects maintained harmony in the material body, their balance served to keep the human being alive; death occurred when the *hun* and the *po* separated from each other and left the body. The *hun* represents the emanation of intelligence and spark of life, or *qi* (breath), which after death ascends to the heavens or travels to the afterlife as a spirit. The *po*, the more material or earthly part, animates the movement of the body in life and remains in the grave with the body as the deceased's ghost. Grave goods nurture the *po*, enticing it to stay in the tomb and not become a wandering ghost, while celestial symbols painted, carved, or stamped on the tomb's walls and ceiling safely guide the journey of the *hun* to the realm of the immortals (fig. 16).[7] Only if the buried *po* is satisfied and at peace can the *hun* journey to the afterlife to shower blessings on the surviving family. Tradition dictated three years of mourning, including yearly sacrificial offerings to the *hun*, at the end of which time the body was thought to have disintegrated, thus permitting the *po* to sink harmlessly into the earth or into an elusive underworld called the Yellow Springs. This netherworld, identified as the final destination of the body after death, became the imagined location of the occupants of the "innumerable graves constructed over several thousands of years."[8]

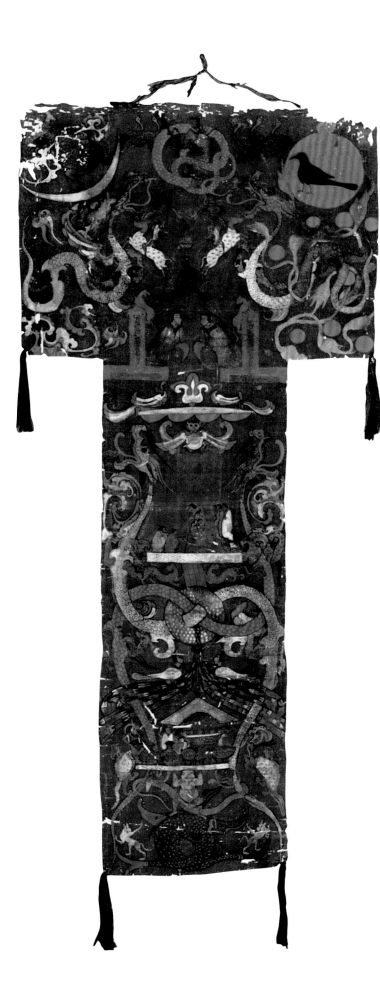

Figure 16 T-shaped silk banner from Western Han tomb of Lady Dai (died about 168 B.C.E.) at Mawangdui, Changsha, Hunan province; scholars generally interpret this imagery as depicting the journey of the *hun* soul upward from the worldly realm to the heavenly

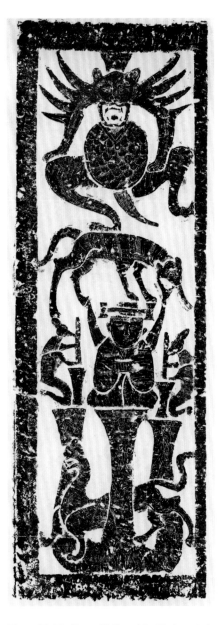

Figure 17 The Queen Mother of the West, seated atop the central peak of her tripartite mountain paradise, is depicted in this rubbing of a low-relief carving from the stone entrance of the Han-dynasty tomb at I-nan, Shandong province (about third century C.E.)

After death, if the journey was successful, the *hun* could reach one of three immortal spirit realms, all envisioned as mountains.[9] One, the Blessed Isles of the East, better known as Mount Penglai, offered a taste of the elixir of immortality or a route to existence beyond in the realm of the Di, supreme ruler of nature and man.[10] The second was the vividly described magical kingdom ruled by Xi Wang Mu, Queen Mother of the West, from her perch atop the "mountains of jade" or "mountains of turtles," which were inhabited by fantastic hybrid creatures (fig. 17).[11] The last of these realms was the sacred Mount Tai, or Taishan (eastern peak), in Shandong province, where the god of Taishan, believed to be the master of life and death, resided. As the god of Taishan acquired more human characteristics, he took on the attributes of a Chinese-style bureaucrat, the lord of Taishan, who managed not only a large administrative staff to record all births and deaths but also "runners," who summoned the spirits of the recently deceased.[12]

The tenacity of these Chinese concepts of the afterlife is evidenced by the arrival, spread, and challenge of the Buddhist religion during the fourth century C.E. Aspects of the original teachings of this Indian religion conflicted directly with Chinese beliefs. For example, according to Buddhist teachings, there is no soul to survive after death; the customary practice in India involved cremation of human remains, and this post-mortem practice clashed with those in China, where the transition to the afterlife required preservation of the material body for a period of time. The original Buddhist conception of Nirvāṇa considered it to be a state an enlightened believer achieved after death, when he moved beyond both existence and nonexistence and became free from suffering. This Buddhist emphasis on obtaining release from suffering by attaining Nirvāṇa gave way to an intense interest in a more concrete vision of rebirth in a favorable realm more consistent with the Chinese conception of the afterlife. The Mahayana sect of Buddhism, which was dominant in China, presents a well-defined vision of Sukhāvatī or the Pure Land of Amitābha Buddha situated in the West. The deceased soul metamorphoses into a new being born into the Pure Land or Western Paradise in a precious lotus flower blessed with miraculous power.[13]

Another shift involved the introduction of moral judgment that stemmed directly or indirectly from the basic Buddhist teaching of the existence of karma. The word *karma* means action, and based on the cumulative impact of wholesome, unwholesome, and neutral acts performed during one's lifetime, it brings

about repeated rebirths into the human world of suffering. The total effect of a person's actions and conduct during successive lifetimes determine the fate of the deceased's soul. Arriving at Mount Tai, souls were judged on their lives on earth, and the unwholesome ones were consigned to the hells of damnation. Yama, the god of Hell, governed the elaborate, systematic underworld bureaucracy of ten hells or prisons, each with its own king. Buddhist teachings gradually reshaped to become more consistent with a culture that revered the family and filial behavior, believed in ancestor worship, and was committed to the continuity of the generations. These modifications helped Buddhism gain widespread popularity. As often occurs, the cultural desire for an afterlife or immortality in China led to the simultaneous practice of more than one belief system.

TOMB FORM AND FUNCTION: LATE FIFTH TO EARLY TENTH CENTURY

Within the context of Chinese beliefs about death, the soul, and the afterlife, how were these concepts tangibly manifested in the relic-rich legacy of tomb structures and furnishings left underground for thousands of years and now unearthed? To explore this, several objects from Shanxi province that are included in *Unearthed* will be discussed: first, the magnificent stone sarcophagus from the tomb of Song Shaozu (died 477; pl. 1); then, the furnishings from the nomadic burial of Lou Rui (died 570), one of the Xianbei elite (pls. 5–9); and finally, the exquisite mid-sixth-century Buddhist stele, with its representation of the Pure Land or Western Paradise (pl. 10). All of these examples are from the dynamic period of disunity in the nomad-controlled north that followed the Han dynasty (206 B.C.E.–220 C.E.). In contrast, the third, later tomb with its clay sculptures from Fujiagou Village in Lingtai county, Gansu province, dating to the Tang dynasty (618–907), had remained undisturbed since the early eighth century (pls. 11–16). These grave goods and the tenth-century Buddhist reliquary reflect the establishment of China's second great empire, a period of unity during which elaborate burial practices and the popularity of Buddhism both reached their apogees.

Traditional Chinese tombs comprise two physically unconnected complexes—one above ground and the other beneath. Although each complex has its own separate physical environment and architectural design and accommodates different ritual functions, the structures maintained a psychic connection.[14]

The above-ground structures often reveal only minimal surviving traces of the original shrines, statues, steles, and tumuli established for ongoing performance of ritual offerings that are associated primarily with elite burials. Some stone ancestral shrines were dismantled or cut apart and sold abroad. One lasting feature, which usually marks imperial burial grounds, such as the tombs of emperors, their relatives, and meritorious ministers or distinguished generals, was a *shendao* (spirit road), a grand avenue along which the deceased was carried to the tomb as part of the funeral rites (fig. 18). This spirit road was lined with stone monoliths, including auspicious beasts and larger-than-life statues of generals, foreign dignitaries, and civilian and military officials, all standing as silent sentinels in a permanent honor guard (fig. 19). These statues, which formed two parallel lines facing each other and led north to the tumulus, were viewed by whomever came to perform memorial rites.[15] Stone endured forever, and the impressive giants of the *shendao* served to deter human wrongdoers and evil spirits for eternity.

The belowground complex was the focus of the burial rites until the interment and final sealing of the tomb. The deceased's body first would be carefully prepared, washed, dressed, and "fed." Coffins and objects created for the tomb would be displayed publicly prior to burial, and a brief ceremony might be performed inside the tomb to allow relatives to say farewell. Once the tomb was sealed, however, it became solely the domain of the departed. The often lavishly decorated and furnished interior space served to conceal the deceased from the living world, and it would be revealed again only when the grave was penetrated by robbers or unearthed by archaeologists.[16]

Because digging into the earth for burials meant trespassing into the underworld of the Yellow Springs, the family of the deceased attempted to protect him or her in many ways. For example, from the Han dynasty onward, land contracts or deeds were purchased and placed in the tomb certifying that the deceased was legally occupying the land. Before the burial, shamans or exorcists sometimes descended into the tomb to expel malevolent spirits, a ritual occasionally depicted on the tomb walls or indicated by the presence of a clay *mingqi* figure of an exorcist among the grave goods in order to provide eternal protection. This practice of using a *fangshi,* a shaman's image meant to repel evil, flourished in the Han and early Six Dynasties (220–386) periods.[17] Human and supernatural guards, fierce in expression, painted on walls or fashioned of clay, as well as other fantastic,

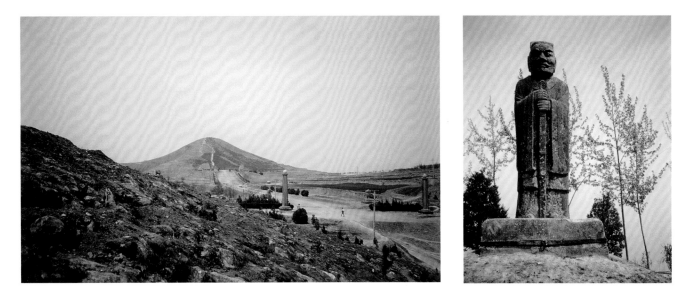

Figure 18 The *shendao,* or spirit road, outside Xi'an {*left*} leads to the Qianling burial mound of the third Tang emperor, Gaozong (reigned 650–683), and is lined with a retinue of carved-stone officials—civil (*right*) and military—as well as massive animals, all standing in silent vigil

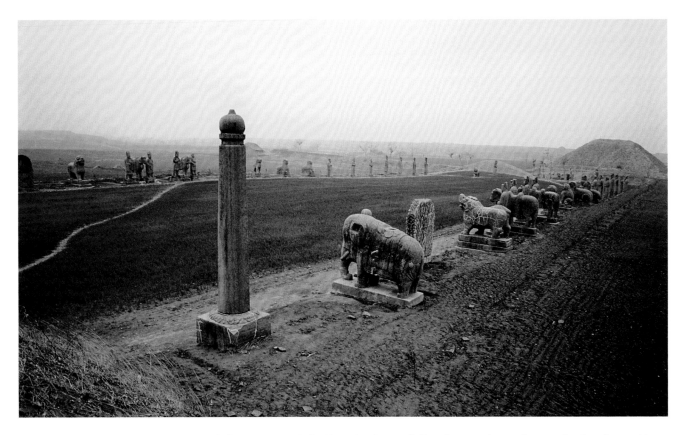

Figure 19 Carved-stone pillars begin the line of officials and animals flanking a *shendao* near Kaifeng, Henan province, as it approaches Song Emperor Zhenzong's (reigned 997–1022) tomb

apotropaic hybrid beasts—even unicorns (fig. 20)—were positioned strategically at the entrance of the burial chamber. In addition, the grave goods included funerary texts, sometimes inscribed in red ink on the outside of ceramic "grave or demon-quelling jars," as a cautionary measure intended to blunt potential damage if the deceased became a dangerous spirit.[18] Clearly, the afterlife possessed a bureaucracy that functioned like one in the world of the living, as the inclusion of coins—real or clay imitations—inside the tombs to pay taxes or bribes also makes evident.[19]

Besides protecting the physical remains of the deceased, however, perhaps the most important function of a tomb was to provide a support system in the Yellow Springs for her or him. Furnishings, both those selected from everyday life and those made specifically for burial, such as clay or wood *mingqi* ("bright, spirit or numenous objects"), were essential to this pattern of funeral rites as a means to offer signs of respect and concern (see pls. 3–7, 11–17).[20] Gathering objects from everyday life and placing them in the tomb symbolized that the deceased had changed dwellings.[21] These grave goods overtly proclaimed and

Figure 20 Bronze unicorn from the late third or early fourth century found in a tomb excavated at Xiaheqing, Jiuquan, Gansu province, where it stood guard before the burial chamber

demonstrated the dead person's status and mirrored his or her social and ceremonial rank. The subjects chosen to decorate the tomb walls also expressed in pictorial form the deceased's status, accomplishments, and filial devotion, and they also supplied a set of standard symbolic representations designed to reinforce the notion of the tomb being a microcosm of the universe, the space where life meets death, and a portal into the heavenly realms.

THE NORTHERN WEI TOMB OF SONG SHAOZU, SHANXI PROVINCE

The Tuoba, a tribe within the Xianbei confederation, founded the Wei kingdom in the northern corner of Shanxi province in 386. In 398, the Tuoba Xianbei chose Pingcheng (modern-day Datong) as their dynastic capital (see fig. 8 and maps, pages 36 and 37). This city, just inside the Great Wall, was closer to their homeland, Inner Mongolia. The Wei kingdom expanded steadily, completing its conquest of the north with the defeat of the kingdom of the Northern Liang, which had been founded in 439–440 in Gansu province by the Xiongnu, another powerful nomadic tribe, and this ushered in a century and a half of stability in China. More walls were built along the northern border, and garrisons of tribesmen were established to keep out other nomadic groups. Details concerning the construction of Pingcheng were recorded in the *Weishu* (History of the Wei dynasty), including the forced migrations from Gansu province of elites, peasants, Buddhist monks, and craftsmen in order to provide the workforce to build and maintain the new capital city.[22] The *Weishu* recounts that many monks came eastward, bringing with them their Buddhist paraphernalia. Other accounts suggest that this migration may have involved tens—or even hundreds—of thousands of households and three thousand monks. As a result, Wei Buddhism accelerated its growth. Yungang, the earliest major Buddhist cave-temple complex, was excavated in a sandstone cliff on a mountain just outside Datong.[23] The first phase of the site's cave construction during the 460s and 470s reflects "overwhelmingly western iconography and style."[24] This forced migration underscores the special historical relationship between Gansu and Shanxi provinces during the formative years of the Northern Wei dynasty (386–535) and its capital city at Pingcheng.

During the last three decades, numerous important tombs dating from the mid- to late fifth century have been unearthed in northern China, many in or near Datong. These new discoveries have deepened our understanding of the cultural and political interactions between the Chinese Han population and their

SHANXI PROVINCE

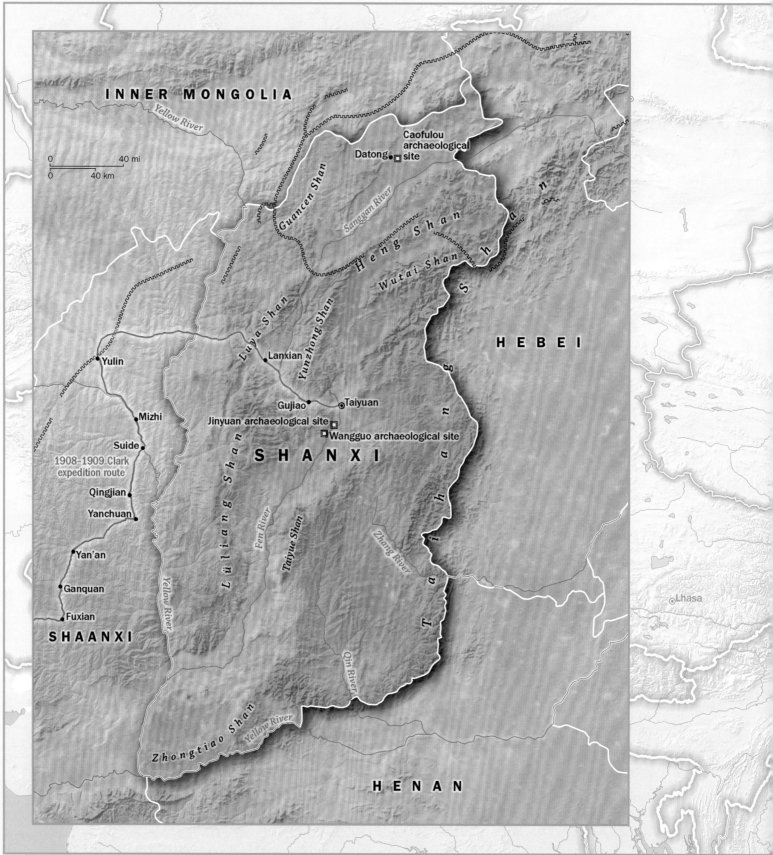

INNER MONGOLIA

Yellow River

0 40 mi
0 40 km

Guancen Shan

Caofulou
archaeological
Datong ◻ site

Sanggan River

Heng Shan

Wutai Shan

Luya Shan

Yunzhong Shan

HEBEI

Yulin

Lanxian

Gujiao ◉ Taiyuan

Mizhi

Jinyuan archaeological site ◻
◻ Wangguo archaeological site

Suide

SHANXI

1908–1909 Clark
expedition route

Lüliang Shan

Fen River

Taiyue Shan

Qingjian

Yanchuan

Yellow River

Zhang River

Yan'an

Ganquan

Fuxian

Qin River

T a i h a n g S h a n

SHAANXI

Lhasa

Zhongtiao Shan

Yellow River

HENAN

nomadic conquerors.[25] In 2000, during construction at Yanbei Teachers College (now known as Datong University), the tomb of Song Shaozu was discovered in Datong's southern suburbs. This tomb yielded an exceptional architectural treasure—a stone sarcophagus assembled like a puzzle out of more than one hundred interlocking pieces (pl. 1).[26] Two inscriptions inside the tomb record the deceased's name, position, and date of burial and provide information about the tomb's construction. The longer inscription—twenty-five characters carved into an ordinary brick—was found in an alcove in the northern passage. It reads: "The coffin of Song Shaozu of Dunhuang prefecture, regional inspector of Youzhou and duke of Dunhuang, buried in . . . the first year of the Taihe reign [477] of the Great [Northern Wei] Dynasty."[27] Apparently, the Song were an established, powerful clan in Dunhuang in the northwestern end of Gansu, site of the famous Buddhist cave temples (see fig. 2), when the Northern Wei Emperor Taiwu (Tuoba Tao, reigned 424–452) conquered the province. The clan including Song Shaozu was probably forced to migrate to Pingcheng, where he attained a high position in the Northern Wei court (see fig. 8).[28] The smaller (fifteen-character) inscription provides a very rare glimpse into the details of the tomb's construction, which Chinese archaeologists estimate to have taken sixty days of work by fifty artisans.[29]

Song's tomb is part of a cemetery that contains eleven Northern Wei tombs; six are earthen, cave-style burials of commoners or poor tribesmen, and the remaining five are brick-chambered structures built for members of the elite or aristocracy. Each of the modest earthen tombs consists of a narrow, sloping passage leading to a cave, the entrance to which was blocked by piled-up lumps of clay mixed with straw, similar to adobe. Each cave held one or two coffins accompanied by very few funerary objects of a relatively poor quality.

The five brick-chambered tombs all share the same basic three-part plan and structure: A sloping earthen tomb path (*xiepo mudao*) and a level corridor (*yongdao*) with a barrel- or tunnel-vault ceiling leads to a square-domed burial chamber with slightly curved east and west walls (fig. 21). Holes in the domed roof of each burial chamber and the disarray of skeletons and tomb furnishings indicate that all five had been rifled prior to excavation. Three of them were also furnished with different combinations of clay *mingqi,* including male and female figures dressed in nomadic garments, cavalry, and entertainers; pack mules and other animals, mostly oxen, and horses and ox carts, well heads, stoves, jars, and bronze Chinese

coins, or *wushu* (pls. 2, 3). Many of the human and animal figures assume very animated postures and retain brightly colored, painted clothing; horses' saddle blankets even display decorative patterns. Of the five, Song Shaozu's tomb alone can be dated by inscription, and it also is the only one with a magnificent stone sarcophagus incorporating a stone coffin platform (figs. 23, 30).

These brick tombs in Datong fall into a transitional period in mortuary architecture. Before about the third century C.E., multichambered tombs arranged along a horizontal axis resembled almost literally underground palaces. Often extravagantly embellished and furnished, they reflected the status of the deceased and the filial piety of his or her living relatives. Tombs of lavish scale and concept eventually became popular among lesser elites as well. Preparations for such a tomb had to begin well in advance of the individual's death, and in the case of the emperor they would have begun by the second year of his reign. Because such extravagance could bankrupt surviving families, sumptuary laws were formulated that specified the types and quantities of grave goods that were permissible according to the individual's social rank.[30] Amidst increasing turmoil in the north, by the fourth century multichambered tombs were simplified, and the single-chamber format gained popularity.[31] This tomb plan—the single-coffin chamber—had become the most common plan in the north by the sixth century, and it endured into the Tang dynasty. Early-eighth-century *mingqi* (pls. 11–16) unearthed from one such tomb in Fujiagou Village, Lingtai county, Gansu province, are representative of grave goods from such a tomb.

Although Song Shaozu's ethnic origin is uncertain, his tomb reflects not only the popularity of the single-coffin-chamber plan but also the Tuoba Xianbei's growing receptiveness to Chinese cultural values and political structure.[32] Tuoba Xianbei burials in Inner Mongolia, their homeland, compared to those in the new capital in China, reveal successive and increasing levels of adaptation. By 496, when the capital moved from Pingcheng to Luoyang in the heartland of China, there no longer was much difference between the tombs of Han Chinese and their Tuoba Xianbei rulers (see fig. 8). Song Shaozu's sarcophagus—its architectural forms, iconography, and decor as well as its *mingqi*—captures the cultural dynamic of the north in the way that traditional Chinese artistic elements intertwine with nomadic, foreign, and Buddhist ones.

With its entrance facing the auspicious south, the overall horizontal length of the tomb is close to 117 feet (35.57 m), and the sloping ramp plunges into the

earth to a depth of nearly 25 feet, or 7.53 meters (fig. 21).[33] The entrance ramp to Song's tomb is another indication it was built during a transitional stage in the development of mortuary architecture: It has two airshafts (*tianjing*), and the arched doorway was bricked over to block entrance to the burial chamber, both features that generally are considered markers of high status, although in Northern Wei tombs around Pingcheng this is not always consistent. These features became standardized symbols of rank after the end of the Northern Wei dynasty, particularly in Tang tombs. The Chinese monograph about this cemetery shows that four of the brick tombs have elegantly pointed and arched entrances leading to the burial chambers (fig 22, center). All the doors were bricked over (fig. 22 left), and the marks of the molds used to manufacture the solid bricks remain visible, as do those made by the tools used to fashion the airshafts in Song's tomb.

Finally, the greatest treasure in Song's tomb was the central 172-square-foot (16-sq.-m) sarcophagus fashioned of sandstone (fig. 23; pl. 1). Measuring close to 8 feet (2.4 m) in height and 11 1/2 feet (3.48 m) in width, it clearly resembles the three-bay, wooden ceremonial hall of traditional Chinese architecture, but with wooden walls and clay roof tiles translated into stone. The raised, circular bosses carved on all the outer walls of the sarcophagus are decorative, and resemble the metal ones found on the doors of ceremonial halls, temples, and palaces, the number of which apparently was associated with status and rank. Although some scholarly debate persists about the actual function of this stone house, the reporting archaeologists refer to this sarcophagus as a *shiguo,* or outer coffin, that

Figure 21 Plan (*left, top*), elevation (*left, bottom*), and detail elevation (*right*) of burial chamber containing the stone sarcophagus of Song Shaozu

contains the remains of the deceased.[34] Coupled with the larger structure of the tomb, this sarcophagus created an appropriate dwelling for the afterlife.[35]

The sarcophagus was constructed from more than one hundred pieces of meticulously carved stone: Twelve stone slabs formed the four walls and doors (see fig. 26); four gable-shaped tie (transverse) beams were notched to hold the five rows of horizontal beams and support the roof slabs, which were carved to replicate a single-eave, gable-end roof resembling clay tiles (fig. 24; pl. 1).

Figure 22 At the bottom of the sloping entrance ramp, archaeologists encountered a bricked-up entrance (*left*) to the burial chamber. Removal of the bricks revealed a pointed-arch doorway opening into a barrel-vaulted passage (*center*), at the end of which were seen the columns, crossbeams, and U-shaped *dougong* bracket supports (*right*) for the porch roof that extends out from the front of the house-shaped sarcophagus filling the burial chamber

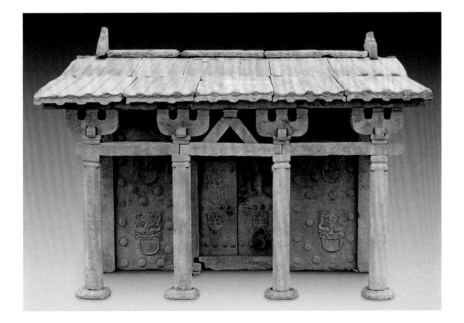

Figure 23 Song Shaozu's house-shaped sarcophagus (pl. 1) is made of more than 100 stone pieces that were reassembled outside the burial chamber; this more-complete view of the porch structure shows its four columns on plinths, crossbeams, *dougong* brackets centered on the man-shaped (inverted-V) one, and the roof ridge

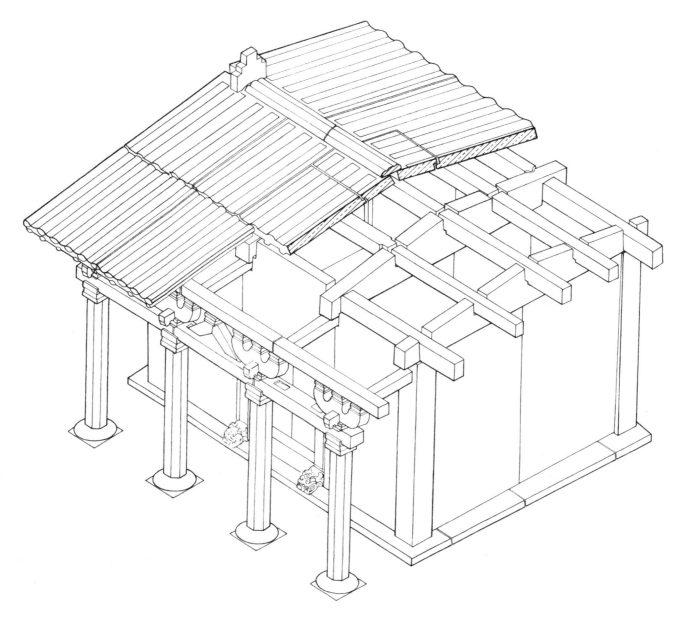

Figure 24 Isometric drawing of the sarcophagus with parts of its roof removed to reveal the structural support system with interlocking tie and horizontal beams and exterior wall slabs; the stone roof has been laid in sections to mimic the ridges of a clay-tile roof

The outer wall surfaces have been embellished with twenty-five ring-handled *pushou* (beastlike-mask doorknockers; figs. 26, 27) that retain evidence of color, one similar monster without a ring above the door, and 239 raised, circular bosses that imitate the bronze, sometimes gilded versions common to ceremonial halls, temples, and palaces. The stone bosses carefully replicate the details of their metal counterparts and capture the rounded raised bosses with thin flat ridges around the edges. Inside the sarcophagus, the inner surfaces of the

eastern, western, and northern walls show remains of once-vivid scenes of dancers and musicians, painted with fluent expressive lines, but now so faded they are barely visible.

The front door, composed of two decorated stone slabs facing south, is sheltered by a porch: Four octagonal columns rise from carved column bases and support a horizontal beam with four sets of U-shaped brackets (*dougong*), which in turn support the roof extension over the porch (see fig. 23). The bases have square plinths with rounded doughnut shapes on top and are carved with four dragons chasing each other, and a central, inverted lotus flower encircles the lower portion of the column (pl. 1). Perpendicular to the columns, four tie beams support the large U-shaped brackets and connect to the wall slabs of the house. Decorating this span of tie beams are undulating single-stem vines with flowers—possibly honeysuckle or a palmettelike leaf shape—that once were brightly painted, but now are faded.[36] Barely visible, similar vines occur on the front surface of the tripartite U-shaped brackets. The one "man-shaped" strut—so-described because it incorporates the Chinese character *ren* (人), for man—occurs directly in the center of the crossbeam (see fig. 22); it also displays faded, painted, and curled tendrils in a repeated pattern. This strut, which provides added support to the cross beam, is "the largest early example" of that type of strut.[37] The *ren*-shaped bracket also appears in mid-fifth- and early-sixth-century Buddhist stone cave temples, such as Cave 10 at Yungang. These, too, have architectural details derived from wooden temple buildings.[38]

The two center columns frame the door; the joints carved at their top and bottom corners and resembling wooden mortise and tenon joinery allow the doors to pivot open and closed (fig. 25). On the floor on either side of the threshold, heads of fanged felines or fantastic lions, both with open mouths and one with a large protruding tongue, protect this entrance. Such heads with curled horns are associated with other tomb entrances from the late fifth century in the Datong area as well as with other sixth-century stone sarcophagi. While similar Chinese concepts of the feline extend back one thousand years, distinctive parallels suggest its ultimate source may be Persia's Achaemenid period (fifth century B.C.E.) at Persepolis.[39]

On all four exterior walls, the *pushou* share the same basic form—a monster mask, framed in a square, with bulging eyes and almond-shaped ears protruding above a gaping, fanged mouth that grasps the semicircular ring hanging below

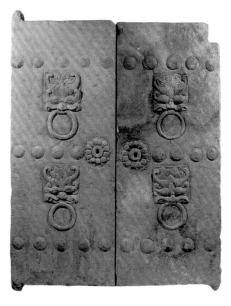

Figure 25 The entrance to Song Shaozu's house sarcophagus comprises two stone slabs in the south wall, a benevolent direction; at three of the corners, tenon-like elements were inserted into holes in the door frame, allowing the doors to pivot open and closed

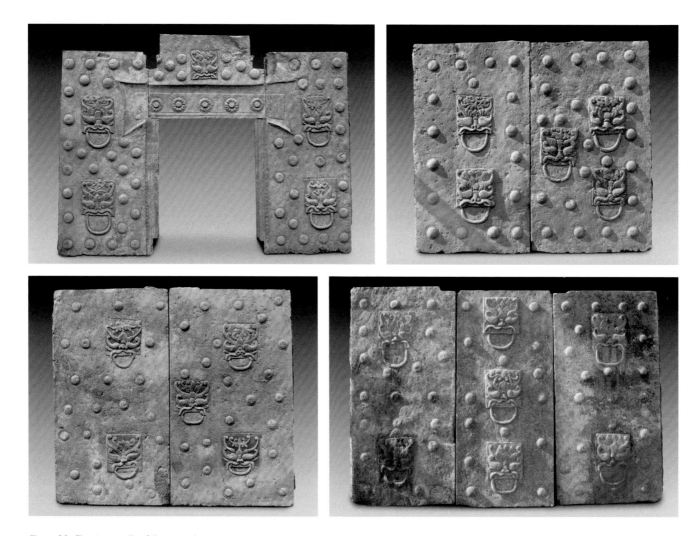

Figure 26 The stone walls of the sarcophagus (*clockwise from top, left*): the south façade with framing walls and doors removed; the east wall; the west wall; and the north wall or back; all had *pushou* carved in relief and raised bosses

the square (fig. 27). Above the eyes seem to be upswept bushy eyebrows that curl at the ends; just below, two large, curved horns twist to the top of the square frame. The spaces between the horns are filled with three different types of motif: Eight display a mountain made up of overlapping triangles; two have human figures, one a haloed celestial being and the other a kneeling female figure grasping the monster's horns; and the remaining fifteen show curling, half-palmette scrolls. One unique monster mask decorated with floral vines is situated just above the door, but since it does not hold a ring in its fanged mouth, it is not considered a *pushou* (fig. 26, top left, and fig. 28, top).

In China such monster masks in numerous variations have a long history reaching back to the ferocious animal-like creatures that dominated the decor of early ritual bronzes from about 1650 to about 1050 B.C.E.[40] Single large monster

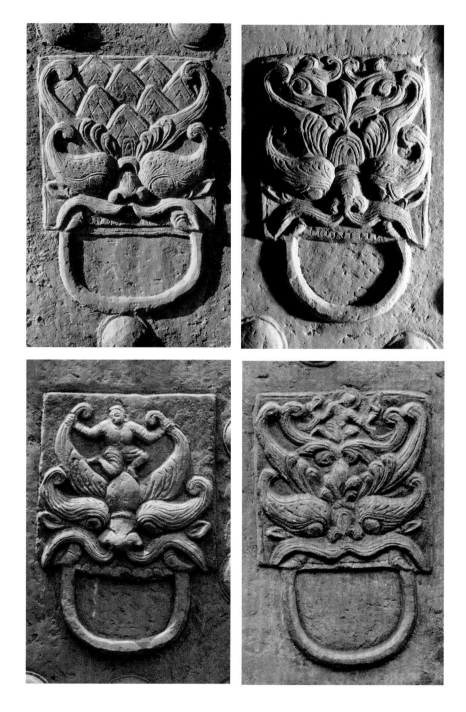

Figure 27 Four *pushou*—monster masks framed in squares, with rings clenched in their fangs—from the sarcophagus; almost all the spans between pairs of curled horns are filled either with overlapping triangles that symbolize mountains (*top, left*) or floral vines and half palmettes (*top, right*). Each of the two exceptions from the front wall has a human figure seated between the horns (*bottom, left and right*)

masks located above the entrance to burial chambers appear in tomb decor of the fifth and sixth centuries, or, as in two Northern Qi (550–577) tombs of influential figures from Taiyuan, Lou Rui (died 570) and Xu Xianxiu (died 571), the lunettes over the entrances depict single large demonic masks flanked by pairs of

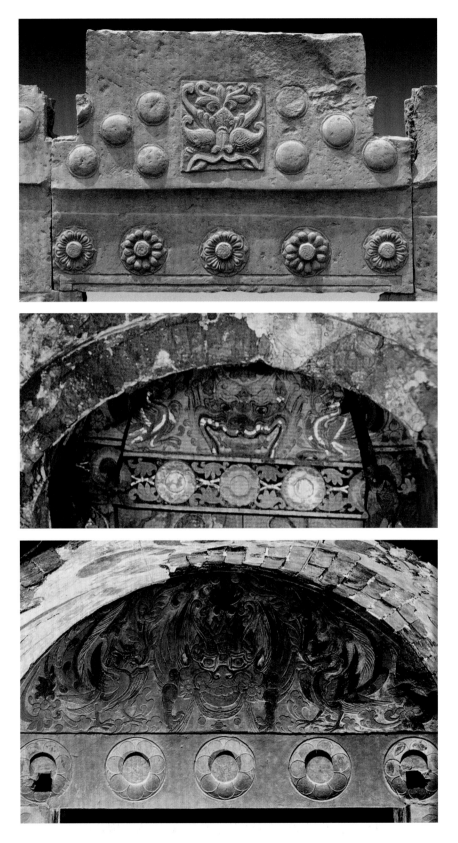

Figure 28 Three versions of decoration on stone lunettes over tomb doors leading to burial chambers (*top to bottom*): with no separate stone door, the space over the entrance to Song Shaozu's burial chamber serves as the lunette, filled with a central monster mask flanked by raised bosses above five lotus roundels; over the door to Lou Rui's tomb, the monster mask filling the center of the lunette is flanked by the Red Bird of the South above five circular bosses; similarly, the lunette above the door to the tomb in Taiyuan of Xu Xianxiu (died 571) also has a monster mask flanked by Red Birds of the South above five lotus roundels

red birds (fig. 28). *Pushou* most commonly are carved on the stone doors of tombs and rarely, if ever, have occurred in such large numbers distributed over an entire tomb structure, as is the case on Song Shaozu's sarcophagus.

A distinctive type of monster mask also occurs on the shields of a pair of sixth-century *mingqi* in Lou Rui's tomb. These armor-clad warriors or guardians were the largest *mingqi* in the tomb and would have been placed at the entrance of the burial chamber. On the warrior-guardian in *Unearthed* (pl. 7), the mask appears more like a lion's head than a fantastic monster. Masks on shields can be seen in Central Asian art found along the northern branch of the Silk Road and also can be "traced as far back as ancient Greece."[41] By the early seventh century, guardian masks on warrior shields had disappeared. All of the carefully carved masks on Song Shaozu's sarcophagus, those placed above doorways, and those on warrior guardians' shields served an apotropaic function: to protect the deceased by warding off malevolent spirits and unwanted intruders for eternity.

The mountain images suggested by overlapping triangles between the horns on eight *pushou* are allusions to the residences of the immortals: Mount Penglai in the Eastern Sea or Mount Tai in Shanxi (see fig. 27, top left). On the sarcophagus, three sides of which display these images, the mountains function to offer auspicious wishes for the safe journey of the deceased's *hun* to the afterlife and immortality. One such image is on the east wall, two are on the south wall flanking the door, and five show on the north wall, again suggesting their protective role against the malevolent spirits of the north.

Preparing the tomb properly and anticipating the needs of the deceased were crucial steps in paving the way for the successful journey to the afterlife. Putting in place the protective functions that would ward off both seen and unseen perils the deceased might encounter was paramount. In addition to the monster masks and mountain images, *zhenmushou* (tomb-guardian beasts) in the form of hybrid animals also protected the tomb. Those in Song Shaozu's tomb are known to be earlier versions of the more fully developed models preserved in the tomb at Fujiagou Village, Lingtai county, in Gansu, which dates to the earlier eighth century (pls. 13, 14).[42] Typically, the two earthenware animal figures, one with a human head and the other a more leonine or monsterlike face, were positioned at either side of the entryway to the burial chamber. In Song Shaozu's tomb, the seated, lion-headed guardian was paired with a human warrior with an exaggeratedly ferocious face, bulging eyes, and large teeth.[43] Some 170 funerary objects accompanied Song Shaozu, most of which were placed in the space between the brick tomb

walls and the sarcophagus on the west and east sides; very few objects occupied the north space. Although they had been somewhat disturbed, the pottery *mingqi* on the west side still formed a re-creation of Song's funerary procession that included some ninety representations of standing or mounted military figures and twelve riderless horses, one larger than the rest, for this retinue; of the riders, thirty-two wear typical black-felt, hooded hats topped with cockscomb-shaped

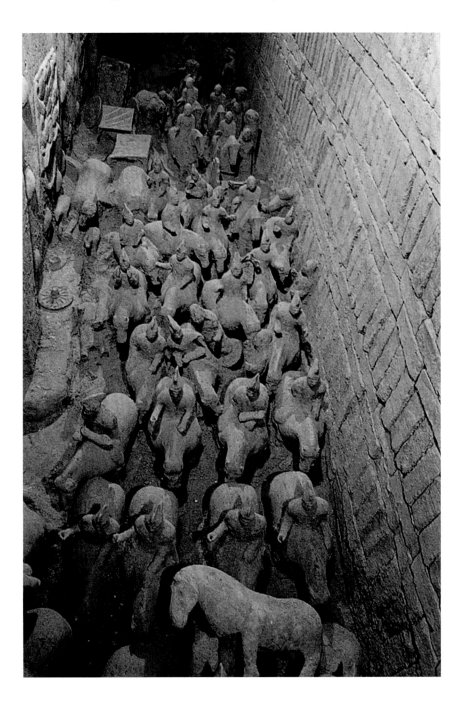

Figure 29 The space between the tomb wall and the west side of Song Shaozu's sarcophagus was filled with a procession of *mingqi* that probably was disturbed by tomb robbers

headgear (fig. 29). The riders with cockscomb headgear wear no military clothing, armor, or weapons, and the raised position of their hands suggests they may have been playing musical instruments (pl. 2).[44] The procession clusters around six ox-drawn carts, four of which include awnings (pl. 3), which symbolize the vehicle the deceased would have used in life.[45]

With their heads resting on two oval, grayish-white stone pillows, Song Shaozu and his wife were laid directly on a raised, squared, U-shaped stone platform—an unusual form of mortuary couch or bed[46]—that filled the interior space of the sarcophagus (fig. 30). The excavators found no evidence of wooden

Figure 30 A view from above into the sarcophagus with its roof removed: stone slabs create a raised platform that occupy almost the entire sarcophagus floor and form a stone funerary platform on which the bodies of Song and his wife were laid; lack of evidence of rotted or disintegrated wooden coffins suggests the bodies were placed directly on the stone. A tent, canopy, or screenlike structure may have been arranged over and around the bodies. Decorated stone slabs cover the vertical surfaces of the open U-shaped space just inside the door

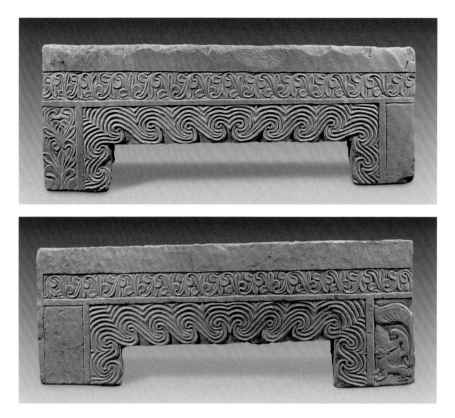

Figure 31 Two of the four stone slabs that covered the vertical surface of the mortuary bed (pl. 4) inside the sarcophagus

coffins ever having been there. The vertical edges of the platform that were visible through the front door were faced with standing carved slabs that had low, rectangular feet and surfaces exquisitely carved with floral vines and undulating, scrolling patterns.⁴⁷ Two stone slabs, one with two rectangular feet and the other just one, fit together to stand across the base of the U-shape that runs parallel to the north wall, which is 94 inches (239 cm) long, 10 ¼ (26 cm) thick, and 9 ¾ (25 cm) high (fig. 31; pl. 4). Each of the two shorter slabs, which run parallel to the east and west walls, measure 37 inches (94 cm) in length, 6 ¾ (17 cm) in thickness, and 9 ¾ (25 cm) in height. On the center slab a large monster mask with curled horns, half-palmettes, and no ring commands immediate attention, as the bodies of the deceased would have lain just above that place. A thin, raised-ridged border frames the monster mask and divides the decoration, and only on the larger central slab is the border beaded or pearled (see pl. 4, second from bottom).

The slab decoration divides horizontally into three bands: The plain, undecorated top one is followed by a central band filled with an exquisitely executed, half-palmette scroll that reveals a very high level of craftsmanship in the variety of

depths used in the undercutting, which conveys with lively elegance the structure of the bending leaves (fig. 31). The bottom and widest band contains a hypnotic, undulating, scrolled pattern composed of deeply undercut parallel ridges. Clearly both the palmettes and the beaded borders arrived via the Silk Road, brought from the west with Buddhism and trade goods, particularly textiles and metalwork. Although at this time Buddhist elements were becoming assimilated into the visual language and culture throughout the north, it is possible that the stone carvers who created the Yungang caves also decorated Song Shaozu's sarcophagus.

As mentioned earlier, the first phase of Buddhist cave building at Yungang in the 460s and 470s would have occurred at approximately the same time as Song Shaozu's sarcophagus was constructed. Without question, the decor on the sarcophagus and coffin platform displays some of the same, or similar, floral elements that make up the rich and diverse decorative vocabulary employed to cover the walls of the Yungang caves, and both evidence other specifically Buddhist symbols as well. For example, the use of the five circular lotus-flower discs carved in high relief across the lintel above the door of the sarcophagus parallel the applied-clay lotuses spaced across the door lintel of Cave 10 at Yungang (fig. 32). Floral motifs, flowering vines, and half-palmettes emerge from the tops of the monsters' heads to bifurcate and fill the spaces between the two curled horns on fifteen of the *pushou* on the sarcophagus. Some of these floral configurations vary, reflecting the enormous richness of the floral patterns carried into China with Buddhism, which certainly is visible in paired Caves 9/10 and 11/12 at Yungang (see fig. 32). The palmette motif was not indigenous to China, but rather an import from the west that had reached China by the fifth century.[48]

Figure 32 The lintel above the doors into Song Shaozu's sarcophagus (*top*) shows five lotus roundels very similar in form and placement to the clay roundels over the entrances to Buddhist Caves 9 and 10 at Yungang (*bottom*) built in the 460s and 470s; the motifs on the later Northern Qi tombs of Lou Rui and Xu Xianxiu follow the same format (see fig. 28)

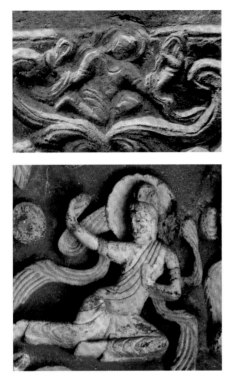

Figure 33 Detail of the celestial being (*tianren*) between the curled horns of the {pushou} to the east of the lower-level front door of the sarcophagus (*top*) compared with one of the numerous *tianren* found on the ceiling and around the doors of Yungang Caves 9 and 10 (*bottom*)

Figure 34 On the west side of the front door of Song Shaozu's sarcophagus, opposite the *tianren*, a voluptuous female figure is shown grasping the horns on a monster mask (*below, left*). She is very similar to figures found in the "inhabited vine," a motif that originated in West Asia and the eastern Mediterranean, and also closely resembles one carved on the plinth in the almost contemporaneous tomb of Sima Jinlong and his wife, near Datong (*below, right*). Such voluptuousness was associated with the fruitfulness of vegetation

Perhaps the mostly overtly Buddhist symbol on the sarcophagus occurs between the horns of the *pushou* carved on the stone slab to the east of the front door. Here, a small chubby figure with outstretched arms is wrapped with flowing scarves. At a casual glance, the figure could be mistaken for a dancer except for the halo encircling its head. Figures referred to as *feitian* or *tianren* in Chinese (*apsaras* in Sanskrit) are very similar in form and stylistic details to the numerous ones that occur across the upper registers of Yungang Cave 10. These are celestial beings rather than deities, and they fly about trailing scarves as they play music, dance, or carry offerings (fig. 33). Opposite, on the slab west of the tomb door, a human figure kneels between and grasps the horns of a *pushou;* similar figures inhabit palmette vines (fig. 34), particularly on the lintel above the door to Yungang Cave 10 as well as in other Datong tombs from the last quarter of the fifth century, such as that of Sima Jinlong (died 484), prince of Langya.[49]

Besides its contents, however, what makes Song Shaozu's tomb so remarkable are the juxtapositions. The tomb's stone sarcophagus ingeniously imitates a Chinese-style wooden ceremonial hall with the faded remains of wall paintings that depict musicians with ancient Chinese instruments and dancers dressed in the style of the Han, but all of the tomb's *mingqi* take the form of nomadic Xianbei figures.[50] Painted on the inside surface of the north slab of the west wall, a seated figure in traditional Han dress, which is larger than the nearby dancers and seems to watch the entertainment, may actually represent Song Shaozu himself.[51] Along the north wall, parallel to the remains of the deceased, the fluent black brushwork on the center slab depicts two seated musicians dressed in traditional Chinese clothing and hats and playing, respectively, a *qin*—an ancient Chinese, flat, seven-stringed plucked instrument—and a *ruan,* or moon lute—a four-stringed lute with a round body (fig. 35).[52] In contrast, the decorative carvings of lotus flowers and *pushou* reflect the growing diversity of the visual cultures of the Buddhists,

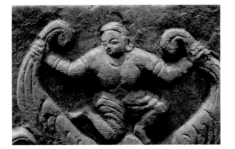

Figure 35 A line-drawing rendering (*top*) of the design seen in the remains of a painting (*bottom*) of musicians seen on the inside surface of the north wall of the sarcophagus; the figure on the left plays a *qin* and the other a *ruan*, or moon lute. Both musicians, dressed in traditional Han clothing, are there to entertain the deceased

the varied nomadic tribes, and Central and Western Asia. Finally, in addition to the typically Chinese *mingqi*—clay models of stoves, carts, a grinding mill, oxen, horses, pack mules, and camels—nearly all the human figures depicted wear clothing and headgear and bear the facial characteristics of Tuoba Xianbei. In fact, however, a small number of others show distinctly different physiognomies and clothing, which suggests other ethnic minorities from western and northern regions may also be represented.

When Luoyang, the Northern Wei capital, was sacked and burned by rebel nomadic garrisons, the last emperor fled, taking refuge in Chang'an (modern Xi'an), Shaanxi province. This move effectively split the northern empire into two warring states, the Western Wei (535–557), with Chang'an as its capital, and the Eastern Wei (534–550), whose capital was Ye (modern Taiyuan), Shanxi province. Upon the overthrow of Eastern Wei in 550, the Northern Qi dynasty (550–577) was established, and seven years later Western Wei became Northern Zhou (557–581; see figs. 8–10). During this time, the boundaries between "foreigners and nomads" and the Han Chinese in northern China became increasingly permeable. In the Zhou court, Xianbei surnames were bestowed on Han subjects, while the court modeled its rule on *The Rituals of Zhou,* the classic guidelines of the Han dynasty, from which it even derived its dynastic name as it became ever more Chinese. Meanwhile the Qi court "routinely used the Xianbei language, and ambitious Han parents instructed their children in this tongue to advance their careers."[53] In addition to literary and historical references, the creation and decoration of Song Shaozu's Northern Wei tomb and Lou Rui's Northern Qi tomb provide clear visual evidence of this "permeability of boundaries."[54]

Lou Rui, an influential figure of the Northern Qi, died in 570 and was buried in the southern suburbs of Taiyuan.[55] Although the power base and official capital remained in Ye, Northern Qi emperors still spent half their time in Jinyang, their alternate capital. A Xianbei tribesman from the far north, Lou Rui had the good fortune to be the nephew of the Northern Qi's first empress, and this connection resulted in his being bestowed with important military, provincial, and court titles. Invested with the title prince of Dong'an, he was honored at his death as the "Grand Minister of War."[56] His tomb was discovered in 1979, and its excavation continued to 1981. Even though previously tomb robbers had disturbed it, extraordinary objects remained in situ, including clay *mingqi,* jades, jewelry, other furnishings, and spectacular wall paintings (pls. 5–9). The painted depictions of horses, horseback riders, and other figures not only delineate the extravagant lifestyle Lou Rui enjoyed, but they are works of the highest quality that serve to fill what had been a gap in the history of sixth-century Chinese painting. Horses, which were fundamental to the nomadic lifestyle, also were admired and coveted by the Chinese, not only for their beauty, strength, and intelligence, but also for the mythic association as "the close kin of dragons" they had acquired.[57] Lou Rui's

burial, together with the many other richly furnished and painted tombs of the Xianbei elite in the vicinity of Jinyang—such as those of Xu Xianxiu and his wife, unearthed in 2003—provides critical information about the history, culture, and art of this turbulent period in Chinese history.[58]

The plan of Lou Rui's tomb, like that of Song Shaozu's, is of the single-chamber type that, already prevalent during the Northern Wei, Eastern Wei, Northern Qi, and Northern Zhou dynasties, continued to be built into the Tang (fig. 36). The earthen mound that marked Lou Rui's burial covered and protected the entrance passage and tomb structure. Facing south, the entrance led to a long sloping path nearly 70 feet (21.3 m) long and close to 12 feet (3.55 m) wide, which descended to a narrower, short, level corridor ending in two carved and gilded stone-slab doors. (Originally they had been bricked up.) These led directly into a brick, barrel-vaulted hallway and the 61 1/3-square-foot (5.7-sq. m) burial chamber. Slightly curved walls rise 9 1/8 feet (2.8 meters) to the pointed, domed roof, which at its highest point reaches another 21 1/2 feet (6.58 m) in height. On the west side, a brick coffin platform supported an inner and outer coffin constructed of wood planks with mortise and tenon joinery and butterfly-shaped wooden clamps.[59]

One of the most exciting aspects of the Lou Rui tomb is the complex pictorial program on almost all the available walls flanking the long sloping entry path

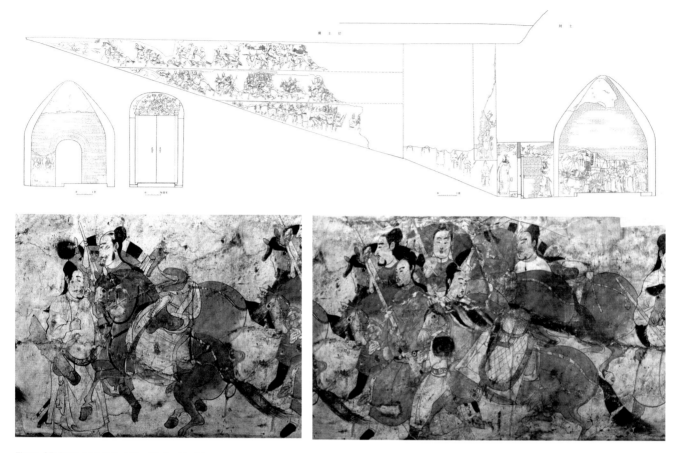

Figure 37 Both west and east walls flanking the sloping ramp to the entrance of Lou Rui's tomb were divided into three registers (*top*) filled with exceptional paintings (*bottom*) of journeys or processions, perhaps from the military career and life of this wealthy, powerful member of the imperial court

into the burial chamber (fig. 37, top). Wall surfaces were prepared for painting with a plaster base mixed with straw and then covered with "lime."[60] Apparently, outlines first were sketched with a bamboo stick and ink, and then colors, including vermilion, grayish yellow, grayish green, dark blue, and light and dark brown, were added. Unfortunately, ravages of water and tomb robbers resulted in a significant portion of the paintings being damaged or becoming detached from the wall, but the quality of the small surviving portion is breathtaking. The content and composition of the paintings reflect a mixture of Buddhist, Daoist, and Confucian tales and stories replete with ancient myths, symbolism, and events of the human world, all rooted in the traditions of the Han and Wei dynasties.

Organized very much like a horizontal scroll painting, the theme of the journey dominates the pictorial program throughout. The east and west walls were divided into three registers, each filled with continuous imagery of galloping processions and dismounted horsemen, saddled riderless horses amid armed equestrians and musicians (fig. 37, bottom). The two top registers on the west wall

depict what Chinese archaeologists interpret to be activities from the life of the tomb's occupant:[61] Horsemen are shown galloping out of the tomb into external spaces symbolized by an animal hunt and bits of landscape with rocks and trees. In the top register, above the horsemen, heavily laden camels, typical of those accompanying Silk Road trade caravans, can be seen. The eastern wall describes the return of the horsemen, as camels gallop into the tomb with a cluster of trotting, unsaddled horses, signs of Lou Rui's wealth.

Near the ground on both walls, the third and shortest register shows musicians blowing long Xianbei horns and saddled, unmounted horses led by a flag-bearing honor guard walking toward the burial chamber's stone door (fig. 38). Rulers rewarded their ministers and generals for outstanding service by sending honor guards to the funeral procession, and the number of guards painted on the sloping ramp just before the entrance to the burial chamber was an unmistakable confirmation of status. In what remains of the paintings above the heads of the honor guard on the east wall, three fantastic creatures associated with pursuit of immortality and the afterlife appear. Two bird-bodied creatures, each with a deer

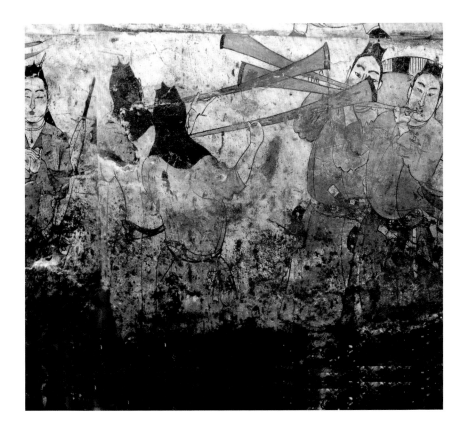

Figure 38 A detail from the east wall of the ramp down to Lou Rui's tomb includes musicians blowing long Xianbei horns as they descend alongside a saddled, riderless horse toward the chamber

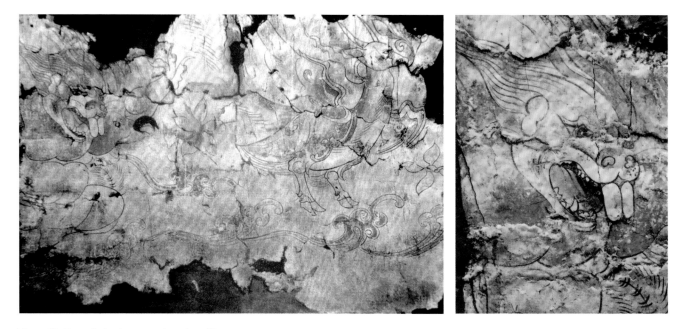

Figure 39 Two painting fragments from the ceiling in the barrel-vaulted passage to Lou Rui's burial chamber show fantastic hybrid creatures that inhabit the celestial realms: one has a bird's body with a deer's head (*left*); to the left of the bird, a muscular human-bodied being—perhaps a wind god—bares its monstrous leonine fangs as its head swoops down through the air (*right*)

head, pair of horns, and two cloven-hooved feet stand amidst cloud wisps as floral pinwheels whirl in the heavens (fig. 39, left). Next to one bird creature, a large fearsome monster lunges through the air; this hybrid has a muscular human body with bulging belly, hair or wings flapping back from its shoulders, clawed hands and feet, and a monstrous, leonine face with huge fangs (fig. 39, right). Such fantastic creatures were very popular in sixth-century mortuary art, and they decorated tombs and epitaph covers. In pre-Han and Han mythology, a human-headed bird was considered an auspicious bird or wind spirit, while a deer-headed bird was thought to manifest a wind god.[62] Apparently these hybrid animals could move freely between earthly and heavenly realms. It was also believed that physical immortality could be achieved by coming in contact with immortal spirits— such as feathered men known as *xian,* and drinking their elixir of deathlessness— or by the human's metamorphosing into a bird. The other clawed and fanged monster is associated with thunder. Inside the tomb chamber, on the ceiling at the north end of the east wall, another such monster, encircled in a ring of drums, streaks through the sky, banging the drums with mallets it grasps in its clawed feet and hands in order to create thunder (fig. 40).[63]

Inside the burial chamber, the paintings on the four walls and domed ceiling focus on reinforcing the concept of the burial chamber as a microcosm of the universe within which the deceased is properly aligned with the cosmic forces to insure a successful journey to the afterlife. The iconographic arrangement is

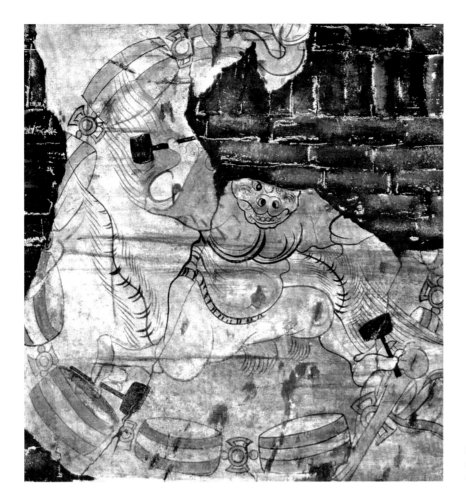

Figure 40 On the east wall at the north end of Lou Rui's burial chamber, a pig-faced thunder god swoops through the heavens beating drums arranged in a circle with mallets grasped in his clawed hands and feet

standard for most sixth-century aristocratic tombs in the northern dynasties. Painted images on the four chamber walls reflect this connection to the transitional earthly realm by depicting the accoutrements of Lou Rui's luxurious palace life among symbols of death and the afterlife. On the north wall, Lou Rui and his wife are seen seated on a platform under canopies, attended by entertainers and servants carrying food; such formal frontal portraits often appear in burial chambers behind the coffin platform in sixth-century tombs.[64] Unfortunately, this stylized portrait is rather badly damaged, and crucial details are missing. However, the canopy or curtains overhead, with hanging banners, overlapping V-shaped layers of fabric, and strings of beads strongly resemble the canopies depicted in Buddhist sculpture and paintings that denote the Pure Land or Western Paradise.[65] The western wall shows a sumptuously decorated ox cart, the symbol of Lou Rui's wife's death, and on the eastern wall, a saddled, riderless horse represents his own. Lines of halberds and feathered fans associated with the court and a

parasol or umbrella are seen, and people of different social classes and ethnicities have been observed and recorded carefully. A very similar decorative program is found in the tomb of Xianbei aristocrat Xu Xianxiu and his wife.[66]

The spaces along the tops of the walls of both the barrel-vaulted entrance tunnel and the tomb chamber were reserved for a *fangshi* meant to repel evil, as well as for symbols and creatures intended to gain blessings for and provide guidance to the afterlife, among them a unicornlike animal said to be a just judge, the animals of the four directions, an immortal driving a dragon chariot, and a tiger following a Daoist priest to heaven. The stone-slab doors between the tunnel and the chamber also served a protective function through symbols that offer wishes for a safe journey (see fig. 28, middle). Just below the large monster mask filling the lunette above the door flanked by the symbolic red bird of the south, five carved lotus-flower roundels alternate with half-palmette vines that also cover the face of the arch. Each door has a brightly colored auspicious, Green Dragon of the East and a White Tiger of the West, both of which are shown moving through wispy clouds. Just above the lunette and arched entrance door, is a large, painted *cintamani,* a flaming, wish-fulfilling, sacred jewel associated with Buddhism. The side of the lunette visible from within the tomb is also occupied by a central *cintamani,* with lotus-flower tendrils growing upward, which may allude to the Buddhist concept of rebirth in a lotus flower into the paradise of the Pure Land (fig. 41).

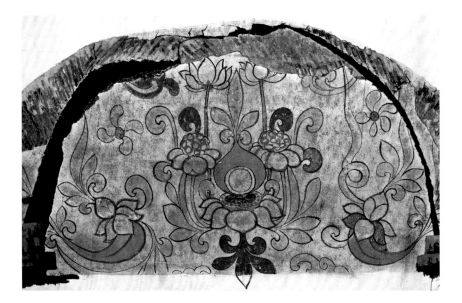

Figure 41 The lunette above the door inside Lou Rui's burial chamber depicts a *cintamani*—a sacred Buddhist wish-fulfilling jewel, flanked by flowering lotuses

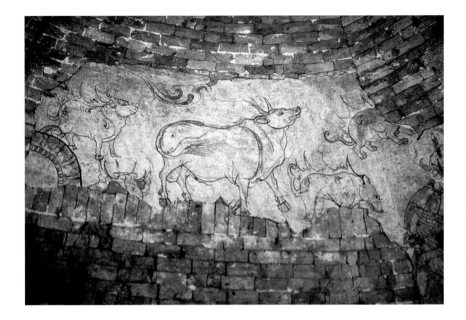

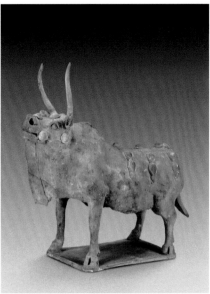

Figure 42 Painting of an ox as it walks across the ceiling on the east side at the north end of the Lou Rui tomb (*left*); and a clay figure of an ox found inside the tomb (*right;* pl. 5) showing evidence of glaze. In both the painting and the *mingqi,* the ox is intended as a symbol of one of the twelve calendric branches associated with time and the functioning of the universe.

Finally, a masterfully painted ox—symbol of the *chou* branch of the twelve calendric animals—walks confidently across the sky among the mythical creatures (fig. 42).[67] This magnificent animal also was placed in the tomb as a majestic clay *mingqi* of an ox (pl. 5). Because they generally were mass-produced in groups or sets, the sculptural realization and quality of *mingqi* vary widely depending on the skill of the mold maker and the status of the deceased. It is rare, however, to come across an animal-form *mingqi* modeled with the conviction, authority, and acute observation that this ox displays, transforming the clay into an exceptional sculptural form with vivid presence. The ox may have been, at least partially, molded expertly and then hand finished.

The seated clay camel (pl. 6) offers another well-conceived, animated sculptural form of a rather ungainly animal exemplary of those that began to appear in the *mingqi* repertory around the third century. By the late fifth century and on through the eighth, two-hump Bactrian camels standing, sitting, and kneeling, with or without riders, and often laden with intriguing goods became standard. The highly valued camel was second only to the horse in prestige and importance. It was essential to the lucrative Silk Road trade, and ownership became synonymous with wealth and status. This earthenware camel laden with full saddlebags, saddle boards, and rolls of cloth may await the start of the long desert trek. The powerful curve of his thick neck culminates in the raised head, open mouth, and bared teeth that suggest an apparent bray. The anatomical details—particularly

eyes, head, and mouth—as well as the contrast in textures of fur on the back and front of the neck all imbue the clay camel with impressive energy.

Despite the damage to and theft from the tomb, nearly 850 objects were salvaged, including 600 standing or mounted figures, guards, warriors, maids, servants, and musicians along with four striking pairs of *zhenmushou*.[68] The bodies of both in each pair are those of a hoof-footed animal, but one of them bears a human head while the other's is fanged and leonine. Their spines bristle with spikes. The clay surfaces of these *zhenmushou* were completely painted but not glazed, and they are the predecessors of the fully developed, flamboyantly glazed or painted, even gilded, versions from the Tang dynasty found in the Lingtai tomb, Gansu province (pls. 13, 14). By the Tang, the standard arrangement placed two *zhenmushou* by the coffin and two other guardian figures inside the burial chamber, on either side of the doorway. The Tang guardians were derived from Buddhist *tianwang* (heavenly guardians), which stand aggressively atop rocks or defeated animals, dressed in full fantastic armor, their facial features exaggerated, bulging, and distorted (pls. 11, 12). The pair of guardian figures originally guarding the door in Lou Rui's burial chamber have a more traditional military demeanor and rigid stance and are larger than the other *mingqi* figures. The left hand holds a long shield bearing a lionlike monster mask, while the right grasped a now-lost weapon, perhaps the shaft of a halberd (pl. 7).

Eleven large, very ornate pieces of earthenware with a greenish-yellow glaze—five ewers with chicken-headed ornaments and dragon handles, four lamps, and a pair of jars—were uncovered in Lou Rui's tomb.[69] *Pushou*—monster masks with rings (see fig. 27)—or other masks without, some more leonine and others more monstrous, are featured as appliqué decoration on a group of ceramics unearthed from the tomb. Only one chicken-headed ewer, the example in *Unearthed* (pl. 8), is known to bear two appliqué-relief monster masks, one at the base of the handle and the other under the ornament, and this sets this ewer apart from the other four. Although the mask on the chicken-headed ewer may be an embellishment, it retains a powerful protective role. The applied decoration—the monster masks, beaded borders, tasseled streamers, and a variety of ornamental floral and plant elements, particularly lotuses—usually were stamped from molds and attached to the surface of ceramics, which then were glazed and fired at a low temperature.

This ewer manifests cultural interaction and exchange not only from beyond China's borders but also from within. The vessel form itself was inspired by plain,

celadon-glazed stoneware from Zhejiang province in the Chinese-controlled south near the end of the fourth century. Two centuries later, in the second half of the sixth century, these rather modest southern versions were transformed by the Xianbei's penchant toward greater flamboyance and ostentation.[70] Most of these more extravagant vessels come from the mid- to late-sixth-century Xianbei tombs whose owners bore a direct association with the Gao family, founders of the Northern Qi dynasty. These marvelous ewers contrast elegant wheel-controlled bodies with the irregularity of hand-fashioned forms, such as the chicken-headed ornament placed on one shoulder and, on the opposite side, the dragon that rears up from the shoulder to bite the rim of the vessel, thus creating its handle.

The complex threads of cultural exchange expressed in *Unearthed* are best captured in one of the few exquisite gold ornaments that survived the looting of Lou Rui's tomb (pl. 9). This unique gold plaque, just under 6 inches (15 cm) long, "testifies to the highly developed filigree technique possessed by Northern Qi craftsmen."[71] Its surface teems with what remain of the inlaid pearls, clamshell, agate, sapphire, turquoise, and multicolored enamel it originally held. The design comprises an undulating ribbon flanked on one end by two halves of a palmette, a pseudo-flower motif that ultimately derives from the art of the Mediterranean and ancient Egypt. A bird with a hooked beak peers back over its wing at the opposite end of the ribbon.[72] Palmettes, bejeweled ribbons and garlands, and vegetal motifs are typical features of Northern Qi art that appear both in Buddhist figural sculpture and in architecture. The ribbons and leaves are edged in continuous rows of pearls, evoking the linked-pearl-roundel motif popular in Persian art. The pearls, each with a hole in its center, probably were imported as strands from India or Persia. In China, turquoise was employed as an inlay material at least as early as the Shang dynasty (about 1650–1050 B.C.E.), and clamshells commonly were used in steppe, Inner Mongolian, and Liaoning burials.[73]

Interestingly, from the perspective of the purely visual world of Chinese tombs of the late fifth through tenth centuries, in spite of Buddhism's popularity and pronounced presence elsewhere in the arts, the impact of Buddhist art remains somewhat peripheral. Traces of Buddhist elements are evoked explicitly in decorative floral vocabulary and in the adoption of isolated motifs; occasionally elements such as the celestial beings (*tianjen*) are incorporated into paintings of the heavenly realms on tomb ceilings and implicit allusions to the Pure Land or Western Paradise. But, as Wu Hung pointed out, "no independent 'Buddhist'

programme developed in funerary art [on tomb walls]."[74] This absence is demonstrated clearly in the largely traditional Chinese burial decor and furnishings of Lou Rui's tomb, where Buddhist content was secondary, although he apparently was an ardent Buddhist himself.

Moving beyond the tomb into sixth-century northern China, of all the foreign religions to penetrate China, Buddhism had the most profound effect, winning millions of converts, modifying cultural values, and even transforming the Chinese landscape with many-storied pagodas that derived from Indian stupas, monasteries, and vast cave temples. During the Northern and Southern Dynasties, northern China experienced almost continuous political disunity, incessant civil strife, and repeated nomadic invasions, but Buddhism flourished nonetheless, inaugurating a period of great religious fervor fueled by the movement of monks and merchants along the Silk Road. This was particularly the case in northern China, where this once-foreign religion offered refuge from the dire conditions of the age, a necessary way of understanding and moderating suffering. The nomadic rulers of the north were further attracted to Buddhism as a non-Chinese bridge between their mobile culture and that of their land-rooted Chinese subjects.

A NORTHERN QI STONE BUDDHIST STELE

A small stone stele (pl. 1) unearthed from the place where the Huata Monastery had been located in Taiyuan fully reflects the exquisiteness of Buddhist sculpture created during the reign of the nomadic rulers of the Northern Qi dynasty. The leaf-shaped stone has been transformed into a microcosmic Buddhist universe through the use of deep, three-dimensional and shallow-relief carving as well as extensive polychrome and gilding. At the stele's center the Śākyamuni (or historic) Buddha sits cross-legged on a lotus throne in front of a deeply cut, pointed niche. Three-step plinths flank the Buddha's throne, and on the top step of each, just inside the niche, stand the Buddha's two famous disciples—Ānanda, the youngest, at his left, and the oldest, Kaśyapa, at his right. On the second steps just below these disciples, outside the niche, are bodhisattvas, the enlightened, crowned beings who chose to stay back on earth to help others achieve enlightenment rather than enter Nirvana, which they had attained and where they would have been freed of suffering. On the lowest level of the plinth stand two figures that seem to hold offerings; they may be devotees or nuns. Framing the edge of the niche's top half, *tianren* with fluttering scarves carry offerings and *cintamani* toward the Buddha and upward to the "flying stupa" that hovers at the apex of the stele (fig. 43).

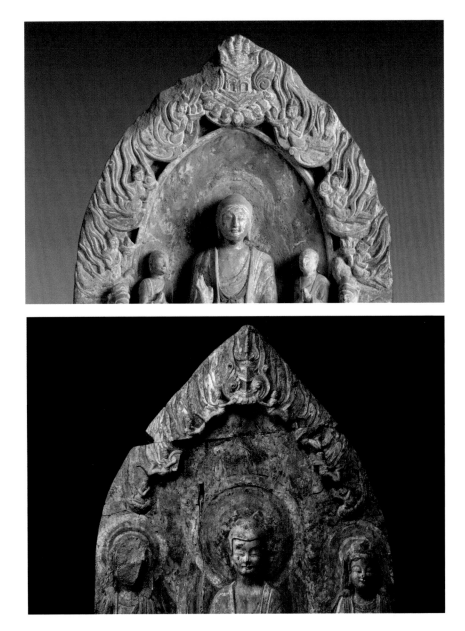

Figure 43 The "flying stupa" was a popular motif in sixth-century Buddhist sculpture, particularly during the Eastern Wei and Northern Qi dynasties. Here, the flying stupa adorning the apex of the Northern Qi Buddhist stele found at the site of once-famous Huata monastery (*top;* pl. 10) is compared to that on an Eastern Wei stele found in a cache burial at Qingzhou, Shandong province; both have extensive coloration and gilding

Before the center of the Buddha's lotus throne rises an incense burner held upward by a figure emerging from a lotus, and on either side of this central motif, two smaller figures seated on lotus flowers rise above a pair of lions (see pl. 10, detail). These small figures refer to the rebirth of the blessed into the Pure Land or Western Paradise and reflect the interest in paradise cults of that period. Their growth was spurred by the political instability of the north and the pessimistic Buddhist belief in the coming *mofa,* or apocalypse, prophesied to occur in the mid- to late sixth century. The faithful sought paths to salvation that were perceived

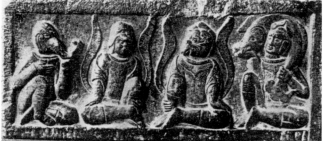

Figure 44 A rare painted image of the Buddha's realm survives on the back of the rectangular base of the Northern Qi stele (*left;* pl. 10), which shows two painted spirit kings that are similar to four spirit kings carved on one side of a square stone base that once supported a now-lost Northern Qi Buddhist deity (*right*)

to be easier in Buddhist cosmology of multiple Pure Lands. The sense of promised salvation via rebirth into a blissful realm—the Western Paradise of palaces, gardens, jewels, sweet sounds, and other delights—is captured by the elegance and tranquility of the Buddha, whose gilded face, body, and hands glow.

The back of this stele bears a feature rarely surviving in such excellent condition on comparable sculpture: a delicately painted image of a Buddha seated on a lotus throne, closely flanked by figures of monks and bodhisattvas standing on lotus flowers (fig. 44). Two seated figures with haloes and flying shawls are shown on the face of the plinth below. Their postures—ankles crossed, one leg up and the other on the ground—and the few facial details suggest that they may be two of the ten male deities usually referred to as the spirit kings. Such figures appear frequently in sixth-century Buddhist sculpture on steles and in cave temples, most often carved in relief, although similar painted images are found on the walls of the Dunhuang caves.[75] Other examples of painted scenes on stone images are known, most notably those on stone sculptures in the extraordinary hoard of Buddhist sculpture found in a pit at Qingzhou city, Shandong province, part of the Northern Qi territories. More commonly, however, such scenes on the backs of steles are carved in low relief. A number of Northern Qi pieces from the hoard had extensive painting that included portraits of Sogdian traders.[76] Unfortunately, on this stele the red, black, white, and other pigments have faded.

The style, iconography, and sculptural quality of this stele all draw from a complex of sources that includes Buddhist India, Central Asia, and Southeast Asia, blended with Chinese aesthetic values. Although its symbolic meaning has yet to be established, the flying stupa atop the stele, the adoring *tianren,* and the painted images clearly relate both stylistically and iconographically to the Qingzhou finds in Shandong (see fig. 43, bottom). Assessing this stele in the context of the Qingzhou sculptures not only deepens our understanding of this individual piece, it also provides a more coherent art historical and cultural context within the period.

The tombs discussed so far share a single-chamber plan and a tripartite structure: a sloping entrance ramp, a level corridor and barrel-vaulted passage into a square, brick, coffin chamber with domed ceiling. Their internal architecture, furnishings, and decor, however, manifest the concept of the afterlife somewhat differently. For example, the only painted images that survive in Song Shaozu's tomb all occur on the inside surfaces of the walls of the stone sarcophagus, whereas the tomb's interior walls, those of its entrance ramp, barrel-vaulted passage into the burial chamber, and the chamber itself are all bare of paintings. Clearly, the deceased were to be entertained in the afterlife by the painted musicians and dancers, who closely surround their two bodies where they lay in repose on the stone platform. All attention has been directed inward—into the sarcophagus as a physical residence for the dead, which is protected on all four exterior walls by *pushou* (see fig. 27).[77] Principally on the west and east sides, 170 clay *mingqi* fill the space between the chamber's brick walls and the stone walls of the sarcophagus, re-creating the funeral procession that bore Song himself (symbolized here by several riderless horses) and his wife (represented by six ox-carts) to the tomb. These *mingqi* are surrounded by rows of fully armored, miniature equestrian warriors, while those in another small group wearing light armor play musical instruments.

While laid out similarly, Lou Rui's tomb incorporates paintings and furnishings to recreate a microcosm that is both more literal and deeply symbolic of the life and death journeys. Painted narratives reaching back to the life of the deceased as a military leader and voyager on the Silk Road line the long sloping entrance path, and other images manifest his transition into the afterlife. A carved, painted, and gilded stone door surmounted by a lunette with a protective monster, and flanking corridor walls painted with handsome honor guards mark the transition, as do cosmologically appropriate images of the Red Bird of the South on the lunette, the Green Dragon of the East on one stone door slab, and the White Tiger of the West on the other. On the north wall, just beyond the door, a painted portrait showing the deceased couple under an elaborate canopy presents an "idealized mortuary icon," or spirit presence; their images would have overlooked the now-collapsed wooden coffins originally raised on a platform.[78] The traditional empty ox-cart is depicted on the west wall, and the riderless horse on the east, signs of death associated with the funeral procession and the journey to the afterlife and immortality. At the ceiling's apex, the Heavenly

River—the Milky Way and constellations—hovers like a canopy, and fantas-
tic creatures associated with the afterlife and Daoist, Confucian, Buddhist, and
other popular auspicious symbols with roots in both China and West Asia encir-
cle it at its lower level.

These two tombs from the late fifth and late sixth centuries, respectively,
reflect a period of flux in China's history that is known as the Northern and
Southern Dynasties, during which traditional Han cultural values were chal-
lenged by the influx of new value systems of the Buddhists, cultural influences
of foreign merchants arriving via the Silk Road, and invasions of nomadic con-
querors in the north. These tombs, their plans, decor, and furnishings serve to
demonstrate "the tenacity of Chinese views of the afterlife and the universe in
which that afterlife was situated."[79] The burial practices discussed in relation-
ship to the Northern Wei and Northern Qi tombs became integrated into Tang-
dynasty burials through the use of stone sarcophagi and the inclusion of narra-
tive and symbolic paintings along the long sloping ramps leading to the entrance
to the burial chamber. Adaptation was reciprocal, as non-Chinese motifs, arti-
facts, and practices also found a place in this traditional context. Besides insta-
bility, the political fragmentation of the time fostered a cultural and regional
diversity that enriched enormously the traditional Chinese aesthetic of the Tang
dynasty and later.

In 577, shortly after Lou Rui was buried, the Northern Zhou dynasty under
Emperor Wudi (reigned 560–578) conquered the rival Northern Qi. Yang Chien,
an eminent statesman and general at the Northern Zhou court in Chang'an
(today's Xi'an), Shaanxi province, assumed the throne and quickly unified north-
ern and southern China, establishing the short-lived Sui dynasty (581–618). Sur-
viving almost four decades, the Sui nonetheless was an eventful period of con-
tinuity, change, and innovation, during which a new legal system was created
that laid the foundation for the success of China's second great empire. The Tang
dynasty unified the country under a powerful central government that fostered
great political, artistic, and cultural coherency. This resulted in the character-
istic national Tang style, an exquisite synthesis of diverse nomadic and foreign
elements with Chinese aesthetic values. Some aspects of this synthesis can be
explored profitably in several finds from the late seventh century into the early
eighth: the tomb and furnishings unearthed at Fengjia Mountain, Fujiagou Vil-
lage, Lingtai county, in southeast Gansu province, near the border with Shaanxi

(pls. 11–16); clay models of civil and military officials from Qin'an county in southeast Gansu (pl. 17); and a stone Buddhist reliquary, also from Lingtai county (pl. 18).

By the sixth century in North China, the single-chamber plan for tombs became the most common, and it endured into the Tang for sub- or non-imperial burials.[80] Tang imperial tombs retained the basic characteristics but added a second chamber connected by an inner corridor to the final room, where the body lay in repose; in the case of the tomb of Princess Yongtai (died 701) near Xi'an, this antechamber provided the deceased with additional worldly comforts appropriate to her status (fig. 45).[81] Paintings of two soldiers, the White Tiger of the West and Green Dragon of the East on their respective walls, guard the long, steep entrance tunnel that slopes from the southern end of the complex down to the antechamber and coffin chamber at the northern end. Just beyond these two-dimensional guardians, on either side, watchtowers, heavily garrisoned walls, and weapons

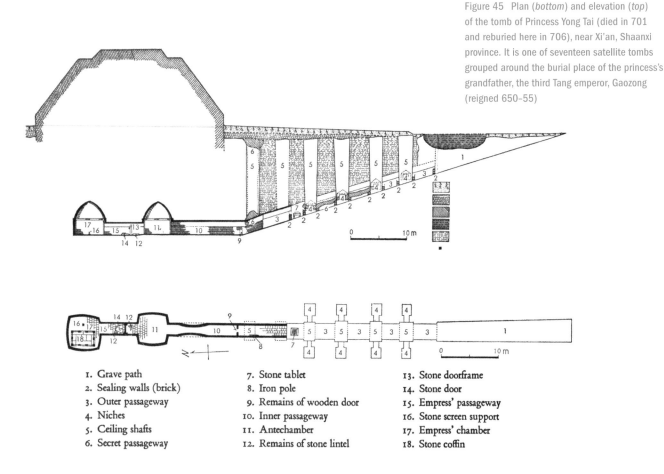

Figure 45 Plan (*bottom*) and elevation (*top*) of the tomb of Princess Yong Tai (died in 701 and reburied here in 706), near Xi'an, Shaanxi province. It is one of seventeen satellite tombs grouped around the burial place of the princess's grandfather, the third Tang emperor, Gaozong (reigned 650–55)

1. Grave path
2. Sealing walls (brick)
3. Outer passageway
4. Niches
5. Ceiling shafts
6. Secret passageway
7. Stone tablet
8. Iron pole
9. Remains of wooden door
10. Inner passageway
11. Antechamber
12. Remains of stone lintel
13. Stone doorframe
14. Stone door
15. Empress' passageway
16. Stone screen support
17. Empress' chamber
18. Stone coffin

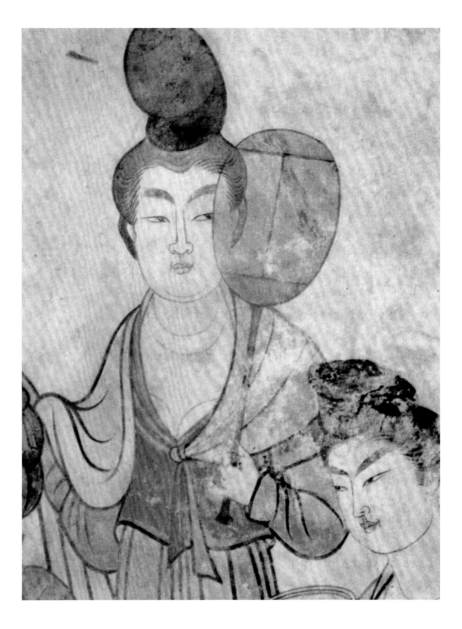

racks were painted to simulate entry into a fortified city, perhaps the precincts
of the Tang imperial capital at Chang'an, where the princess lived. Twelve lances
stacked in the racks indicate her rank and the degree of protection and homage
her position demanded. The antechamber's walls are painted to resemble an inte-
rior palace room, with red pillars and brackets and life-size images of two groups
of young female servants, who were sensitively captured in masterful, fluent
black line and color, and undoubtedly tend to the princess's pre-sleep rituals (fig.

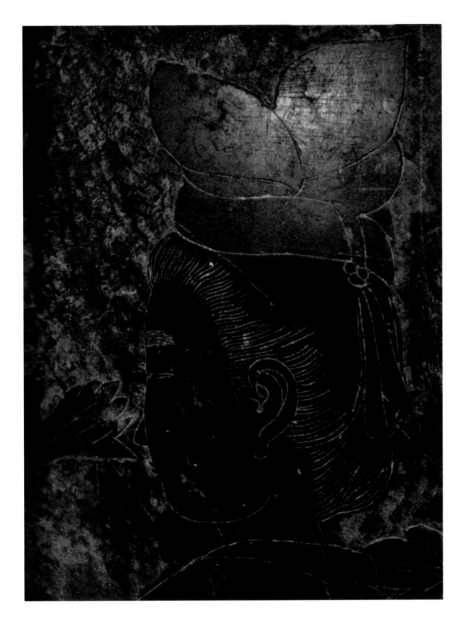

Figure 47 Detail of the head of an attendant incised on the outside surface of Yongtai's house-shaped limestone sarcophagus

46). A short corridor leads first to a stone door, beyond which rests her eternal bed within a beautifully carved stone house-sarcophagus in the second chamber. Renderings of court ladies and servants, some in a garden, have been elegantly incised on the outside and inside of the limestone house (fig. 47).[82] After first reappearing in northern and northwestern China during the fifth and sixth centuries, such stone house-shaped sarcophagi "gained popularity among Tang aristocrats" and relatives of the emperor.[83]

EASTERN GANSU PROVINCE

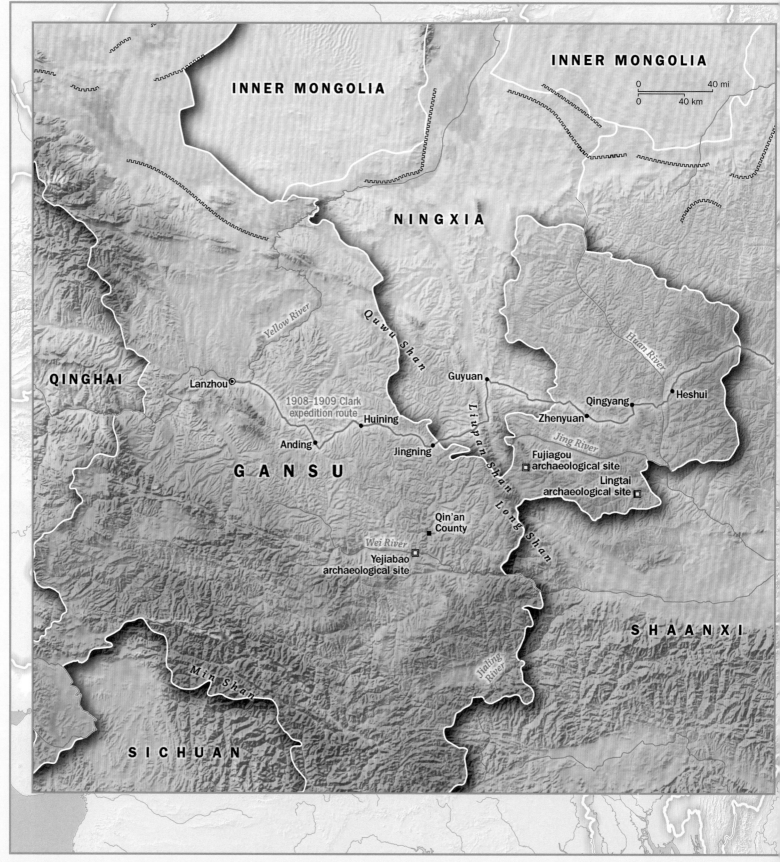

INNER MONGOLIA

INNER MONGOLIA

NINGXIA

QINGHAI

GANSU

SHAANXI

SICHUAN

Yellow River

Quwu Shan

Liupan Shan

Long Shan

Huan River

Jing River

Wei River

Jialing River

Min Shan

Lanzhou

Guyuan

Qingyang

Heshui

Zhenyuan

Huining

Jingning

Anding

1908–1909 Clark expedition route

Fujiagou archaeological site

Lingtai archaeological site

Qin'an County

Yejiabao archaeological site

0 40 mi

0 40 km

Figure 48 The discovery of Tang tombs M1 and M2 on the loess terraces of Fengjia mountain, Fujiagou Village, Lingtai county, Gansu province

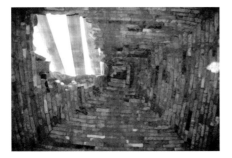

Figure 49 During the excavation of tomb M2, a forklift accidentally pierced this hole in the domed brick roof of the burial chamber

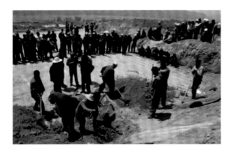

Figure 50 After the forklift accident, tomb M2 was treated as an emergency rescue operation; a team of excavators worked three days and nights to secure the tomb and protect its undisturbed contents

Figure 51 The steep, sloping entrance ramp to tomb M2

A TANG TOMB AT FUJIAGOU VILLAGE, LINGTAI COUNTY, GANSU

In May 2009, during the construction of loess farming terraces at Fengjia Mountain, near Fujiagou Village, Lingtai county, north of the Liupan Mountains in southeast Gansu, two Tang tombs (designated M1 and M2) were discovered nearly 42 feet (13 m) apart on the second terrace. M1 had been destroyed completely by looters, but M2, despite a large hole in the domed brick ceiling of the burial chamber accidently gouged by a forklift, apparently remained undisturbed by tomb robbers (figs. 48, 49). To protect and preserve the contents of M2, a salvage excavation team under the direction of the Museum of Lingtai County worked day and night for several days (fig. 50). The final analysis of M2 and its contents has not yet been completed, and little concerning its excavation has been published. The tomb plan, photographs of the excavation, and some tomb furnishings have been provided by the Gansu Administrative Division for Cultural Relics and the team from the Museum of Lingtai County, headed by its former director, Wang Zhongxue.[84]

Much like the burials of Song Shaozu and Lou Rui, tomb M2 at Fujiagou Village has a typical one-chamber plan, and although its actual length has yet to be published, it is clear that it was built on a smaller scale than the two tombs discussed earlier. A short entrance ramp sloping downward at a 45-degree angle ends at the tomb (fig. 51), which had no stone door, but instead was bricked closed. The entry arch, which measures 6 2/5 feet (1.95 m) high by 2 4/5 feet (0.88 m) wide, opens to provide access to the short, brick, barrel-vaulted passage roughly 11 2/3 feet (3.55 m) long and 3 1/3 feet (1 m) wide that leads into the burial chamber. Neither the sloping entrance ramp nor the tomb chamber's walls or ceiling show any evidence of having had paintings on them. The main burial room, somewhat more rectangular in shape, measures 12 2/5 feet (3.77 m) from east to west and 7 4/5 feet (2.34 m) north to south. Its four walls rise twenty-six horizontal-brick layers before the pointed, four-corner, domed ceiling begins at the twenty-seventh (fig. 52). The tomb has a north-south orientation, and the coffin was placed close to and along the north wall, perhaps originally resting on a low, earthen platform. The amount of visible debris suggests that the original wooden coffin has rotted into splinters and the bones of the deceased have turned to dust, leaving only bronze belt buckles, which are completely corroded.

Among the fifty burial objects in M2 are brightly painted *mingqi* of a pair of *tianwang* (guardian warriors or heavenly kings; pls. 11, 12) and a pair of *zhenmushou* (guardian monsters; pls. 13, 14). Also found were a bronze mirror with

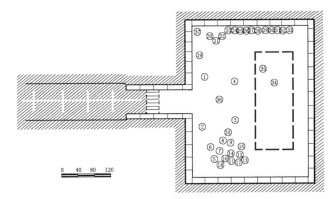
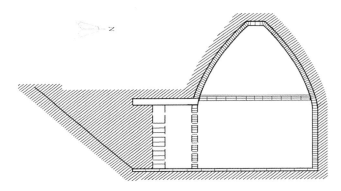

Figure 52 Drafts of the plan (*left*) and elevation (*right*) of tomb M2.

with an exotic lion-and-grape pattern, three coins of the Tang Kaiyuan reign (713–741), and *mingqi* of foreigners, camels, equestrians, grooms, saddled but riderless horses, a pig, a well, mills, and ceramic jars. The clay *mingqi* figures and animals are quite stunning, and they retain most of their variegated textures and lush floral designs in vivid colors typical of the cold-paint technique[85] of the Tang—rather than glazing—and extensive touches of gilding, particularly on the *tianwang.* These furnishings were positioned against the east and west walls, and clay jars were lined up in the space between the coffin and the east wall, where taller figures of robust foreign grooms with arms raised and fists clenched, positioned appropriately to hold the reins of horses or camels, have been placed next to smaller mounted riders (fig. 53). On the west wall, a large camel about 28 inches (71 cm) tall stands next to what appear to be two saddled but unmounted horses, a foreign groom, and a female figure dressed in traditional Han style. Some clay *mingqi,* which probably stood in front of the coffin platform, lay broken among the collapsed piles of rotted wood, while others, such as the three seated female servants who appear to be preparing food, survived intact (fig. 54).

With the original arrangement, the placements of the burial goods accompanying the deceased, particularly the guardians, remain unchanged from the day the tomb was sealed in the early eighth century. It is clear that, through their boldly flamboyant sculptural style and large size, the protective *tianwang* standing perpendicular to the arched doorway and the two *zhenmushou* sitting before the coffin dominated the burial chamber (figs. 55 and 56). The *tianwang,* each about 42 ½ inches (108 cm) in height, tower above all the other clay sculptures in the tomb. The differential in sizes among the *mingqi* underscores the importance of their function in the hierarchy of the tomb as protectors of the realm of the

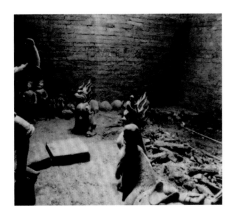

Figure 53 Pottery jars were lined up against the east wall of the burial chamber in tomb M2 along with two earthenware sculptures of grooms (just visible at far-left edge of photograph) and two smaller equestrian figures

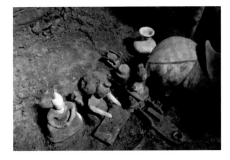

Figure 54 Also in the burial chamber, three seated earthenware female figures, who appear to be preparing food, were positioned to the left of the rump of a horse that stood in front of the west end of the coffin's remains

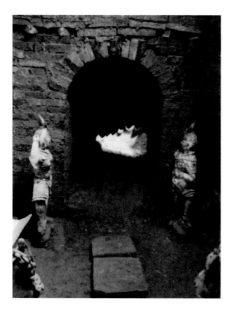

Figure 55 Just inside the burial chamber of tomb M2, two earthenware *tianwang* (heavenly guardians) with extensive pigments and gilding flank the arched doorway (see pls. 11, 12).

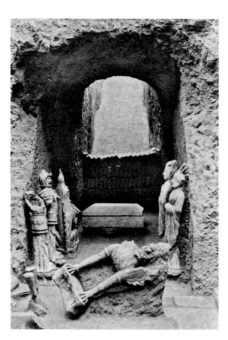

Figure 56 Entrance to the Tang tomb of Dugu Sizhen (died 698), excavated in the suburbs of Xi'an; the *tianwang, zhenmushou* (which have fallen on the ground), and civil officials stand just inside the bricked entrance to the barrel-vaulted brick corridor that leads into the burial chamber.

dead.[86] In Tang tombs, pairs of *zhenmushou* and *tianwang* together in the burial chamber became a consistent element in the iconographic program.[87] The special names for these two types of guardians in contemporaneous Tang texts reinforce this protective function: *dangkuang* (keeper or protector of the burial vault) and *dangye* (keeper or protector of the wilderness of burial ground) for the two human guardian kings, and *zuming* (ancestral intelligence) and *dizhu* (earthly axis) for the two animal guardians (*zhenmushou*).[88]

This association of scale with importance also applies to the two standing officials or court attendant figures, with *sancai* (three-color) glaze, found in another tomb in southeast Gansu province at Yejiabao in Qin'an county and included in *Unearthed* (pl. 17). Standing on stylized rock bases, they each reach a height of approximately 52 ¾ inches (134 cm). While both are officials, one is a civil official who wears a belted tunic with broad, loose sleeves over a flowing skirt and upturned court shoes; the other is military, but he wears his long, belted tunic over trousers and pointed boots. In China, with the exception of servants and soldiers, who always wore pants, it was customary for men to wear trousers hidden under a long skirt or flowing robe. The influence of the nomadic rulers in the north led to its being acceptable, even fashionable, among aristocrats to dress in trousers rather than skirts, a fashion that eventually became accepted in both the north and the south.[89] By the beginning of the Tang, large figures of officials, such as these, often joined the pairs of *tianwang* and *zhenmushou* at the front or just inside of the barrel-vaulted entrance passage that leads into the burial chamber (fig. 56).[90] At once formal and majestic, these officials could be placed in the entrance passage to serve as honor guards as well.[91]

Essentially *tianwang,* the category of guardians known as heavenly kings, which are dressed in elaborate armor and helmets, were adopted from the *lokapāla,* their Buddhist counterpart. In Sanskrit, *loka* means "world" and *pāla* means "guardian," so *lokapālas* are a distinct set of guardians who protect the four cardinal points of the universe and are "among the most widely known supernatural figures in Buddhist legend."[92] According to tradition, these four guardians dwelled on Mount Sumeru, which in ancient Indian cosmology was the vertical axis at the center of the universe. Once adopted into Buddhism, guardians came not only to secure the four entrances to the Buddhist stupas, temples, and altars, but also were involved in all important events in the Buddha's life, from assisting at his birth to being present at his parinirvāṇa (see figs. 62, 63).[93]

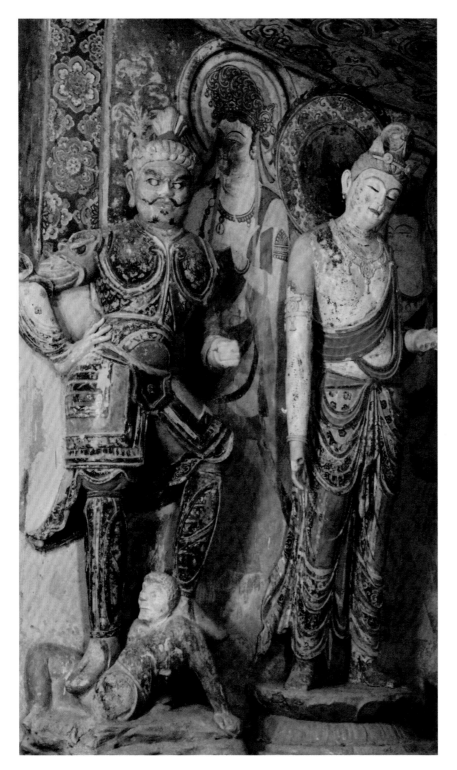

Figure 57 In Cave 45, Dunhuang Mogao Buddhist cave temples, Gansu province, a *tianwang* from the first quarter of the eighth century guards the entrance to the niche containing the Buddha's image; the figure is stucco and clay with extensive pigment and gilding

In China, the concept of the four *lokapālas* found a receptive audience and came to be connected to existing cosmological symbols of the four directions, the seasons, specific colors, and unique animals. Originally four guardians naturally made up the complement, but by the Tang dynasty only one pair rather than all four were included in the iconographic configurations of Chinese Buddhists and in their burial chambers. By the seventh century, the pair of heavenly kings having increasingly gained popularity in Chinese Buddhist art, their iconography evolved to depict them as fierce warriors subduing a demonlike creature or large animal, such as oxen, rams, or deer, and they now bore powerful apotropaic connotations, with their furious demeanors meant to repel any intruders. As the Buddhist *lokapālas* in full-armored regalia replaced the indigenous, more realistic tomb warrior (see pl. 7), they spawned increasingly flamboyant and fantastical *mingqi.* Buddhist figures in Chinese cave temples, including those at the Dunhuang oasis in northwest Gansu, became virtually indistinguishable from tomb guardians dressed in full armor and standing atop demons or large animals (fig. 58).

The powerfully conceived sculptural forms of the pair of exceptional *tianwang* from Fujiagou Village effectively convey a sense of menace, a required attribute of a guardian protecting the deceased's residence in the afterlife (fig. 58 and pls. 11, 12). Bulging eyes with furrowed, bushy eyebrows and an exaggerated mustache sweeping between flaring nostrils and clenched lips make the threat seem imminent. Each robust figure strikes an energetic pose, with one hand resting on a hip to accentuate the aggressive thrust and twist of the body. The raised arm terminates in a hand that originally clutched a weapon. One leg presses on the head and the other on the body of a recumbent animal, in one case an ox with short pointed horns, while the other is a ram with curled ones.[94] Heavy, molded, multilayered leather armor covers the entire body of each figure. Typically, such armor includes elbow-length shoulder guards and a breastplate or cuirass held in place by ropelike straps that descend from the stiff, curved collar and encircle the midriff. A girdle tied beneath the bulging stomach secures the hip protector and stomach plate. Parts of the tight-sleeved under-tunic flare out at the forearms and at the pleated-cloth edges of the hip protectors. Their trouser-clad legs are covered by tight-fitting boots and shin guards. Enormous vitality flows from every aspect of the sculptural form, even the close-fitting helmet with flaps sweeping outward on each side of the head, which are accentuated by gilded C-shaped curls and a fiery, triangular plume. The style of the armor—with its stiff, scrolled collar protecting

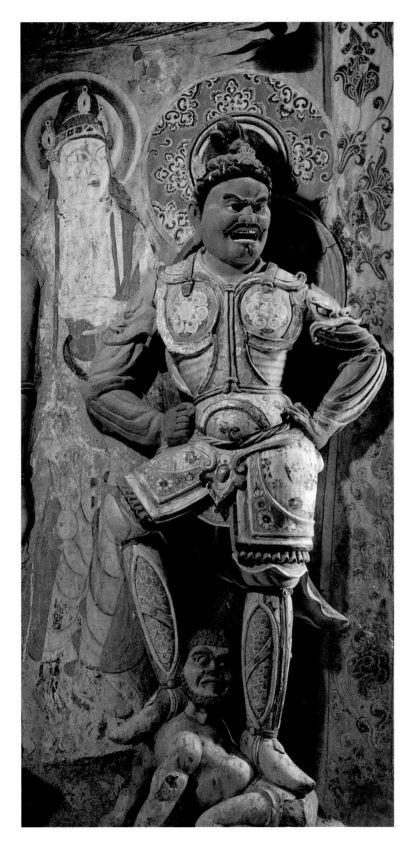

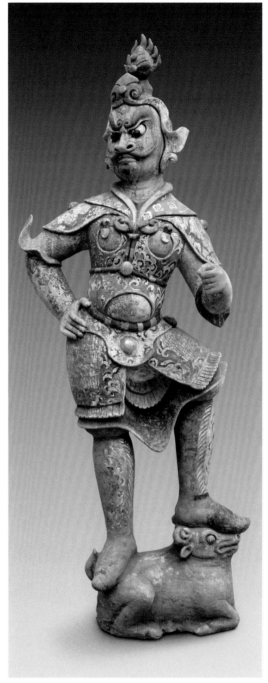

Figure 58 Two roughly contemporary *tianwang* from Gansu province: at the outer edge of the main image niche, which houses the Buddha in Cave 46 of the Dunhuang Mogao Buddhist cave temples, an early-eighth-century stucco-and-clay *tianwang* with extensive color and gilding stands atop a demon *left*, as does one dating to the late seventh to early eighth century, which guards the entrance to the burial chamber of tomb M2, Fujiagou Village

the neck, and the breastplate and hip guards fastened with knotted cording—was inspired by Central Asian and Western models.

Rather than three-color *sancai* glaze, these *tianwang* are painted masterfully, with lush floral patterns embellishing almost every surface. Although many elements of this highly varied vegetative vocabulary can be traced back to the Mediterranean area, the Tang achieved a synthesis of the palmette and acanthus combined with peony, lotus, and scrolling vines as well as rosettes to create quintessentially Tang forms that combine a sense of lavishness with delicacy. "Such an ornate outfit, impractical for combat, must have been designed for the palace guard, especially as the upper class Tang tomb was designed to resemble the residence of the deceased in real life."[95]

Often the *tianwang* are found paired with *zhenmushou,* the composite guardian beasts (pls. 13, 14). At two corners of the coffin, sitting impassively on their haunches with their chests puffed outward, they face north, the tomb door, and the heavenly kings. Both animal bodies have clawed feet, and bristling spines emerge from their heads and shoulders. One has a human head that replicates the features of the *tianwang,* and the other presents a grimacing, lionlike head displaying a row of teeth punctuated by two fangs. Stirrup-shaped epaulets on both of these *zhenmushou* replace the more usual notched wings that attach at the shoulders and flare outward. Two strips of spotted leopard fur are painted vertically from the neck down the front of each figure's body. The evolution of the form and iconography as well as the influences that inspired these creatures are not fully understood and remain a source of fascination for scholars and archaeologists.[96] This amazing, but still puzzling, pair seems to have emerged from the coalescence of several sources that include traditional Han culture as well as foreign value systems, certainly both Buddhist and nomadic.[97]

The history of Chinese art and literature is populated with a wealth of supernatural creatures—hybrid, human, and nonhuman. The lion-faced guardian evolved separately from the one with a human face, and both served individually as tomb guardians until the sixth century, when they were brought together as a pair and as such became a mainstay in Tang tombs. Like the *tianwang,* the guardian beasts also waxed increasingly flamboyant, with dramatic flourishes projecting from their bodies as well as from the subdued creatures underfoot. By the mid-eighth century, the *zhenmushou* developed another rather rare version in extraordinarily dynamic and physically expressive sculptural form: The four-legged creatures, which rear up on hind legs and assume an attack stance that is

at once more human and more aggressive and terrifying, not only subdue large beasts underfoot, they also grasp writhing snakes.

In the Tang, the tomb entourage brought together not only the *tianwang* and *zhenmushou,* but also included other popular figures, such as the Bactrian camel and foreign groom from the Fujiagou tomb that are included in *Unearthed* (pls. 15, 16). Known and used by the northern Chinese for centuries, the two-humped Bactrian camel was essential to the survival of Silk Road caravans. Only the Bactrian camel's ability to find hidden springs and even predict sandstorms could enable merchants to endure the most treacherous routes that connected the oases along the northern and southern edges of the Taklamakan desert in Xinjiang: "When such a wind is about to arrive, only the old camels have advance knowledge of it, and immediately stand snarling together, and bury their mouth in the sand. The men always take this as a sign and they too immediately cover their noses and mouths by wrapping them with felt."[98] During the Han, forays into Xinjiang created a great need for camels, but even greater urgency arose in the Tang as the empire extended further across Central Asia. Domestic camel herds now had to be augmented from outside China, and often they were purchased from nomads, who considered camels to be as valuable as gold and silver. Still other camels were given to the Tang emperor as tribute and war booty.[99]

The imperial bureaucracy of the Tang dynasty managed the empire's camel and horse herds. Along with sheep and cattle, camels and horses grazed in the grassy provinces of Shaanxi and Gansu. In *The Golden Peaches of Samarkand,* his landmark work on Tang exoticism, Edward Schafer tells that in 754, the official herds in Gansu and Shaanxi alone numbered nearly 300,000 cattle, sheep, and camels.[100] The *mingqi* representations of herdsmen, trainers, grooms, and camel drivers found in tombs were predominantly foreigners from Mongolia, Central Asia, and Tibet, which accords with the pronouncement by Du Fu, the famous Tang poet: "Western boys have power over camels."[101] Camels also were valued as swift messengers to and from distant borders—a kind of Bactrian "pony express"; as sources of exotic cuisine, such as boiled camel hump, a particular favorite of "Tibetan lads and Western boys"; and even for their hair, which made very soft cloth.[102]

Given the camel's significance to imperial civilization, it is not surprising to find them so well represented in tomb furnishings. Although camels often appear to be rather ungainly, the *mingqi* from the tomb in Fujiagou Village displays a well-proportioned and balanced form with an elegantly curved neck and

sharply articulated head. Measuring 28 ⅓ inches (72 cm) in height, the piece was necessarily assembled from several molds, and it may have been finished with some hand modeling. Its long, slender legs were attached to a rectangular base for added stability to support the body. Vivid red color applied to the buff earthenware describes the fur that lines the underside of the neck as well as patches on the humps and upper legs. Black brush strokes animate the ceramic surface and spark the eyes with energy. Like the seated Northern Qi camel from Lou Rui's tomb (see pl. 6), most clay camels from northern China during the fifth and sixth centuries and the Tang Empire that followed are shown laden with saddle bags and travel supplies or with goods acquired by merchants. Models of camels without loads and unsaddled horses are found less frequently.[103] Some glazed-ceramic camels include colorful blankets, with holes for accommodating the humps, thrown across their backs. The cargo shown on the backs of camels in unglazed pottery looks as if it was molded separately, then attached. A marked change in color and a faded line on the Fujiagou Village–tomb camel suggest that some object originally was attached to its back.

This camel was positioned against the tomb's west wall, and directly opposite, along the east wall, stood two foreign grooms (see fig. 53), including the bearded one in the exhibition. At 22 ⅖ inches (57 cm) in height, both are larger than the other figural clay *mingqi,* and are similar in size to the *zhenmushou,* which indicates their relative importance to the deceased. Excavators are not sure which groom belonged with this standing camel; both clench their hands, with one raised to shoulder height and the other at the waist, in a posture reflective of the standard depiction of a groom holding the reins of a horse or camel. With a thick beard and mustache, this groom clearly is a foreigner, and though less exaggerated, he shares the countenance of the human-faced guardian beast and *lokapālas* in the tomb (pl. 16). Wearing what appear to be knee-high boots, the groom stands astride a circular base, resolutely looking upward toward his camel. His clothing, appropriate for cold weather, includes a tight, long-sleeved, knee-length outer tunic or coat belted at the waist beneath which two other layers of clothing can be glimpsed. At the waist, cloth seems to be tucked under the belt, with its top pulled out and over. Identification of ethnicity by the facial features and clothing is elusive, and to date no attempts have been particularly successful. Ethnicities and descriptions of distinct non-Han peoples with names in contemporaneous Chinese texts or representations in art frequently cannot be connected.[104]

Unfortunately, the epitaph placed just inside the doorway of the burial chamber was made of pottery, not stone, and the Chinese characters written in red on its surface have suffered water damage that has rendered them illegible and made it impossible to determine the owner's identity. Incomplete analysis and partial publication of the tomb's contents have omitted the bronze lion-and-grape mirror as well as other *mingqi*, which leaves many gaps and unanswered questions. But the characteristics of this tomb at Fujiagou Village do permit some speculation. That the epitaph is on a clay slab rather than one of stone and the inscription was painted rather than carved suggest that the deceased was a local Gansu aristocrat or perhaps a lower-level, civil official in the government.[105] Although the tomb chamber is of a good size and has a high ceiling, no evidence so far indicates the presence of any platform—whether made from stone, clay bricks, or even wood—for the wooden coffin. The arched, brick doorway leading into the burial chamber was sealed with bricks rather than a stone door. The entrance ramp is quite short and raked at a very steep pitch, which would have limited dramatically both the space available for and the feasibility of painting on its walls. Nor are there any suggestions of paintings anywhere within the brick structure. Nonetheless, the burial furnishings, specifically the *tianwang, zhenmushou,* camel, and groom (pls. 11–16)—and perhaps others yet to be published—reflect a very high standard of craftsmanship, painting, and extensive, lavish gilding. Based on comparisons of the sculptural style and painted decoration with examples from dated tombs, the Fujiagou Village find can be dated to the late seventh or early eighth century.

During the Tang dynasty, both the scale of burials and the production of *mingqi* reached their apogees. Artisans became adept at conceptualizing sculptural images in a more three-dimensional manner, and at creating models and molds, casting, trimming, painting, and glazing—particularly with the lead *sancai* glaze that is a hallmark of the dynasty.[106] Although the rebellion of General An Lushan in 755 was ultimately crushed, it temporarily drove the Tang emperor from the capital of Chang'an, and the power and spirit of the dynasty were broken, thus ushering in a long, slow decline both politically and artistically. Over the past several decades, archaeological finds have confirmed that, although tomb-sculpture production did continue, its quality declined during the late-Tang period. Subsequent dynasties continued the practice of furnishing tombs with *mingqi,* often attempting to re-create the glorious accomplishments of the past, but attaining varying levels in quality. The attendant decline in quantity at

the end of the Tang also can be linked to political disintegration and the impoverishment of the population, which led to the growing popularity of burning simulated paper money and drawings of servants and animals during the funeral service. The smoke was thought to carry the images' essence to the deceased and the afterlife.[107]

THE FIVE DYNASTIES STONE BUDDHIST RELIQUARY

By the eighth century, under the Tang dynasty, Buddhism also reached its apogee. Now fully established, it enjoyed a broad-based support across all levels of society, from the imperial court to the smallest rural communities. The thriving Silk Road trade nourished a cosmopolitan environment in the capital of Chang'an, by now swollen to more than one million residents, and it attracted visitors from all over Asia, including Buddhist monks, emissaries, artists, and musicians from the oasis kingdoms of Central Asia. Eminent foreign monks were funded generously, and Chinese monks were encouraged to travel abroad in order to carry back new Buddhist doctrines and sutras for translation. The most famous Chinese monk, Xuanzang, left the Tang capital in 629 and traveled to India to experience in person the land of the Buddha's birth. He returned to Chang'an sixteen years later, in 645, bringing with him hundreds of sacred texts, and he devoted the rest of his life to their translation.[108] With the patronage of several Tang emperors, temples continued to be built across the empire, yet by the ninth century changes in the social, political, and intellectual climate brought the familiar grievances against Buddhism back to the surface. Antagonists maintained that Buddhism was a foreign religion, anathema to traditional Chinese values, given to profligate expenditures on temple building and images and, due to its tax-exempt status, financially damaging to the empire. Consequently, Emperor Wuzong (reigned 840–846) unleashed a devastating assault on the Buddhist establishment, bringing about widespread destruction of temples, shrines, and monasteries; clergy were secularized and lands confiscated.[109] After Wuzong's death, the persecution abated and rebuilding began, but organized Buddhism never regained its original glory in China.

After the Tang Empire collapsed in 907, the capital remained at Chang'an, but China experienced a brief period of disunity as five dynasties in the north passed in quick succession. The art made during the short-lived Five Dynasties period (907–960) reflects the continued strength of Tang artistic style and accomplishments. Tang art—particularly Buddhist art—achieved what may be described as

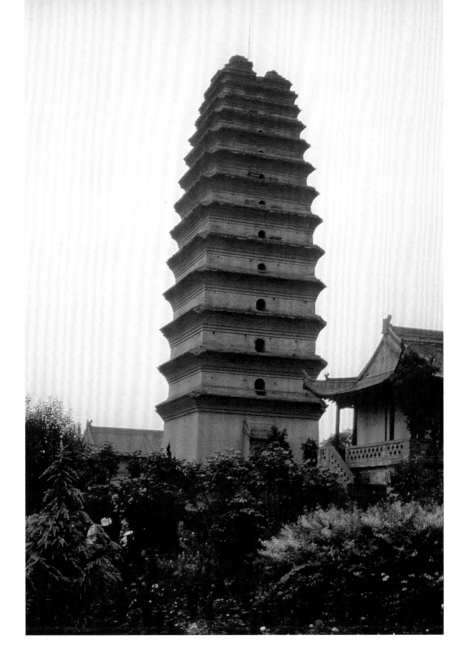

Figure 59 Xiaoyan Ta (Small Goose Pagoda), located in a suburb south of Xi'an, was built to house sutras and devotional objects a Buddhist master brought back from India; originally 15 stories tall when constructed in 707, two major earthquakes (in 1487 and 1555) cracked the structure, reducing its height by two stories; the crack was repaired in 1965

an international or truly cosmopolitan style that synthesized and assimilated the traditional with centuries of dynamic interaction with foreign influences from the Silk Road and beyond. *Unearthed*'s fine example of a stone reliquary (pl. 18), which was made to hold cremated remains, or *śarīra* (Buddhist holy relics), for veneration and burial reflects the continuation of Tang style and the survival of Buddhist art. Such reliquaries usually were placed in small crypts that sometimes encompassed multiple rooms and enshrined in the foundation of a pagoda, the multitiered tower that is part of a Chinese Buddhist temple complex.[110] Pagodas derive from stupas, the dome-shaped burial monuments in India (fig. 59), which were created to store and venerate the relics of the Buddha's cremated body, one such being the Great Stupa at Sanchi, built about the first century B.C.E.[111]

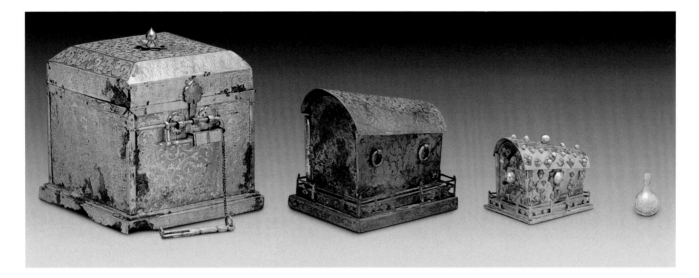

Figure 60 Set of reliquaries dated 649, from the Temple of the Great Clouds, Jingchuan county, Gansu province; they nest one within the next larger. *From left:* gilt-bronze square reliquary; smaller, coffin-shaped reliquary in silver; gold coffin-shaped reliquary (see fig. 61); and glass *śarīra* bottle holding fourteen grains. When nested, all fit within a large stone box bearing a long inscription.

The word *śarīra* originally meant "body," but in Sanskrit texts it was used to mean "relics," which generally referred to the pearl or crystallike, bead-shaped objects that were supposed to be found among the ashes of cremated Buddhist spiritual masters. According to Buddhist texts, if a true *śarīra* of the Buddha was not available, then precious substances, such as pearls, which in China were imported from Central Asia and northwestern India, could be substituted in the reliquary.[112]

Dated to the Five Dynasties period and carved from sandstone, this reliquary from Lingtai county (pl. 18) is coffin shaped, a lidded, rectangular box that slopes from its higher front toward the lower back, a form used in full-size stone and wooden coffins in Chinese burials since at least the fifth century C.E. Such coffin-shaped reliquaries, datable from the Tang to Northern Song dynasties, have been discovered at Buddhist temple sites in China.[113] Undoubtedly, this was the outer container that concealed one or more stacked boxes, one inside the next. The last and smallest of them, often crafted of gold, silver, or jade (fig. 60), usually contains the relic, such as the example discovered in the crypt of the pagoda at Dayunsi (fig. 61), the Temple of the Great Clouds, in Jingchuan county, Gansu, dated 694.[114] Unfortunately, when this stone container was unearthed in Lingtai county, nothing remained inside, and no evidence was revealed that would connect it to the site of a long-lost Buddhist temple or pagoda foundation. Half-lotus petals decorate the edges of the base and lid of the reliquary, and all four of its sides were carved in high relief and retain color pigment and patches of gilding;

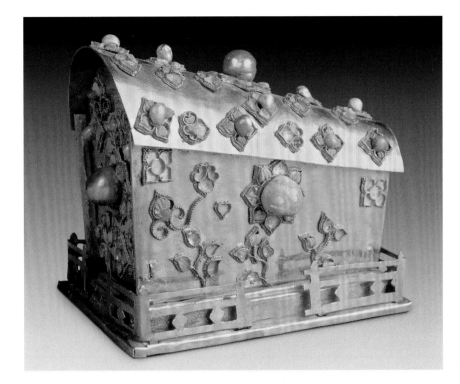

some of the small, square cartouches carved around the base still bear traces of predominately floral painted decoration.

The imagery and its placement create a minitomb with doors carved on both the south end's larger panel and that of the smaller north end; a carved directional animal identifies each. Both doors show a pair of incised *pushou* and circles indicating bosses, which resemble the motifs on the door to Song Shao-zu's sarcophagus. Flanking the south door, two standing *tianwang* or *lokapālas* guard the entrance to the symbolic burial chamber, while similarly situated, seated figures protect the north door (fig. 62). On the lid, directly above the south door, a *kalavinka* in a full-frontal stance with wings spread is shown. This distinctive bird-human creature has the trunk, head, and arms of a human, but the wings and legs of a bird. Such figures, which either play instruments or, by tradition, sing with exquisite voices, guard sanctuaries in both the Buddhist and Hindu traditions.

Three of the traditional Chinese animals that symbolize the cardinal points of the universe have been carved on the sides and back of the reliquary's lid: The Green Dragon of the East is on the left; the White Tiger of the West is opposite, on the right; and the Black Tortoise and Snake of the North sits on the

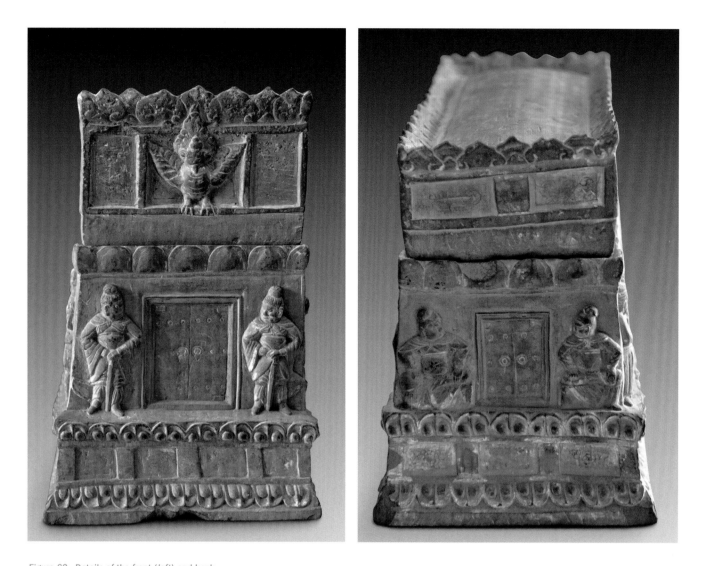

Figure 62 Details of the front (*left*) and back (*right*) ends of the sandstone reliquary dating from the Five Dynasties Period or the first half of the tenth century, that was unearthed in Lingtai county, Gansu province. The doors carved on each end have incised ring handles and bosses and are guarded by pairs of standing or sitting *tianwang*

narrow end. Each of the long, rectangular sides depicts a tableau from the Buddha's life. On the east side, under the dragon, the most familiar and poignant shows the parinirvāṇa capturing the Buddha at the point of his transition from life to extinction or final release—nirvāṇa (fig. 63). Parinirvāṇa images became widespread in Chinese Buddhist art by the second half of the fifth century.[115] The Buddha lies on his right side, his right arm folded under his head, and his left arm resting on his side, in the traditional depiction of this scene. A crowd of people, gods, disciples, and even animals gather around him and his funeral pyre. In their grief, some of the monks or disciples and celestial beings at the far left have fallen over, while others seem to be wailing. The carving in multiple levels of relief intensifies these touching and painful images. Seemingly unaware of the assembled mourners, the full, round, almost fleshy face, resonant with

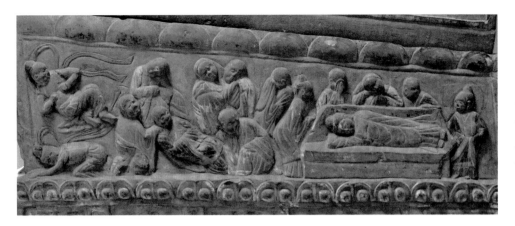

Figure 63 Detail of the east side of the sandstone reliquary (pl. 18) showing the pigment and gilding used to enhance the depiction of the parinirvāṇa of the Buddha—his transition from life to extinction, or nirvāṇa (the final release from suffering)

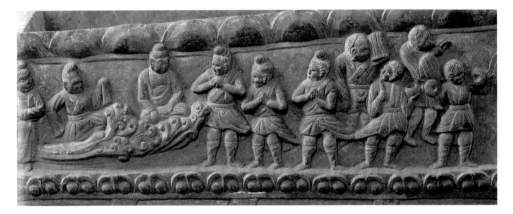

Figure 64 Detail of the reliquary's west side, which depicts the ascent of the Buddha into nirvāṇa, the Western Paradise or Pure Land

Gupta stylistic elements used to depict the Buddha, reflects a classic late-Tang style.[116] The tableau on the west side of the reliquary is less familiar. It shows the Buddha seated on a rising wisp of cloud joined by non-Chinese figures with top-knots and beards and dressed in boots and tunics; some of them play musical instruments (fig. 64). Chinese scholars have interpreted this scene as the Buddha's ascent to nirvāṇa.

The imagery on this reliquary presents a fascinating example of the cultural convergence or intersection of the traditional Chinese visualization of the journey from this world into the afterlife and the Buddhist conception of transformation from this worldly existence and subsequent rebirth into the Pure Land or Western Paradise. The entire coffin-shaped reliquary becomes a metaphor—a burial chamber including entry to the realm of the dead through doors protected by guardians. On the west side, after the parinirvāṇa, the tangible hope offered by the Buddha's ascension and transformation is heralded by the rare hybrid birds, the *kalavinka,* who beat their wings in the Western Paradise.[117]

ENDNOTES

1. Wang Zhongshu, *Han Civilization* (New Haven, CT: Yale University Press, 1982), 175. Numerous publications discuss the evolution of Chinese tombs, including Robert L. Thorp, "The Qin and Han Imperial Tombs and the Development of Mortuary Architecture," in *The Quest for Eternity: Chinese Ceramic Sculptures from the People's Republic of China* (Los Angeles: Los Angeles County Museum of Art; San Francisco: Chronicle Books, 1987), 17–37. For a description of tomb structure between the Han and the Sui dynasties, see Mary H. Fong, "Antecedents of Sui-Tang Burial Practices in Shaanxi," *Artibus Asiae* 51, no. 3/4 (1991): 147–98; Jessica Rawson, "The Eternal Palaces of Western Han: A New View of the Universe," *Artibus Asiae* 59, no. 1/2 (1999): 5–58, and "Creating Universes: Cultural Exchange as Seen in Tombs of Northern China between the Han and Tang Periods," in *Between the Han and Tang: Cultural and Artistic Interaction in a Transformative Period,* ed. Wu Hung (Beijing: Cultural Relics Publishing House, 2001), 113–49; Wu Hung, *The Art of the Yellow Springs: Understanding Chinese Tombs* (Honolulu: University of Hawaiʻi Press, 2010).

2. Hsun Tsu [Xun Zi, 340–373], *Basic Writings,* trans. Burton Watson (New York: Columbia University Press, 1963), 97–105.

3. K. E. Brashier, *Ancestral Memory in China,* Harvard-Yenching Institute monograph 72 (Cambridge, MA: Harvard University Press, 2011), 81–85, discusses the archaeology sites believed to be ancestral shrines that date to the Western Zhou; see also Dorothy C. Wong, *Chinese Steles: Pre-Buddhist and Buddhist Use of a Symbolic Form* (Honolulu: University of Hawaiʻi Press, 2004), 16–23.

4. Albert E. Dien, "Chinese Beliefs in the Afterworld," in *The Quest for Eternity,* 1.

5. Ibid.

6. According to Albert Dien (ibid., 3): "The Chinese have never doubted that something survives of the person after death, but ideas of what that something is have differed over time It would appear that new theories about life after death did not displace the old; they simply take their place among the others. The oldest terms referring to what survives after death are *gui* and *shen,* followed later by the terms *hun* and *po.*" *Gui* and *shen* often are referred to as spirits; the *gui* remains with the body and can become malevolent, but the *shen* ascends to heaven.

 A number of excellent sources explore the various interpretations of the *hun* and *po.* See Yu Ying-shih, "Life and Immortality in the Mind of Han China," *Harvard Journal of Asiatic Studies* 25 (1964/65): 80–122, and " 'O Soul, Come Back!' A Study on the Changing Conception of the Soul and Afterlife in Pre-Buddhist China," *Harvard Journal of Asiatic Studies* 42, no. 2 (1987): 363–95; Michael Loewe, *Chinese Ideas of Life and Death: Faith, Myth, and Reason in the Han Period (202 BC–AD 220)* (London: George Allen & Unwin, 1982), 26; Dien, "Chinese Beliefs in the Afterworld," 3; Susan L. Beningson and Cary Y. Liu, *Providing for the Afterlife: "Brilliant Artifacts" from*

Shandong (New York: China Institute Gallery, 2005), 2; Derk Bodde, *Festivals in Classical China: New Year and Other Annual Observances during the Han Dynasty (206 B.C.–A.D. 220)* (Princeton, NJ: Princeton University Press; Hong Kong: Chinese University of Hong Kong, 1975), 276–77. The concept of two souls can also be understood as an expression of the ideological theories based on the yin and yang principles and the five elements. The yin and yang represent two principles in the universe, and the interplay between them underlies all cosmic phenomena. The attributes of the yin are cold, darkness, wetness, squareness, femininity, earth, quiescence, and the *po* soul; those of the yang are light, heat, dryness, masculinity, circularity, heaven, movement, and the *hun* soul; see Loewe, *Chinese Ideas of Life and Death,* 38–47; and Bodde, *Festivals in Classical China,* 37.

7. One rare silk painting survived from Tomb No. 1 at Mawangdui, Changsha, Hunan province, which dates from the Western Han dynasty (about 206 B.C.E.–9 C.E.). This T-shaped banner probably was carried in the funeral procession of Lady Dai and then laid on top of her coffin. It has been interpreted variously as representing the netherworld, the world of humans, and the heavens, but it also can be seen as the journey of the *po* soul as it navigates to the heavenly realm located at the top—the crossbar of the *T.* See Michael Loewe, *Ways to Paradise: The Chinese Quest for Immortality* (London: George Allen & Unwin, 1979), 17–59.

8. Wu, *The Art of the Yellow Springs,* 7.

9. An alternate route to immortality did not require dying first. It could be attained through the efforts of shamans and intermediaries, who could attract and perhaps contact the immortal spirits, from whom they obtained the elixir of deathlessness; see Loewe, *Chinese Ideas of Life and Death,* 111–12.

10. Ibid., 18; and Loewe, *Ways to Paradise,* 96–126.

11. Loewe, *Chinese Ideas of Life and Death,* 32.

12. Dien, "Chinese Beliefs in the Afterworld," 9.

13. Eugene Y. Wang, *Shaping the Lotus Sutra: Buddhist Visual Culture in Medieval China* (Seattle: University of Washington Press, 2005), 371–72.

14. Wu, *The Art of the Yellow Springs,* 8.

15. Ann Paludan, *The Chinese Spirit Road: The Classical Tradition of Stone Tomb Statuary* (New Haven, CT: Yale University Press, 1991), 1–14. The tomb mound is placed to the north, and the entrance to the underground chamber faces south. Chinese cosmological symbolism includes the *sishen* or *siling,* the four spirits or four deities symbolic of the four quarters of the universe: the Green Dragon of the East, White Tiger of the West, Red Bird of the South, and Dark Warrior (tortoise and snake) of the North. The Dark Warrior, a particularly powerful symbol, repels the malevolence that comes from the north, including nomads,

cold winds, and devils. Placing the tomb mound above ground at the northern end also blocked the malevolent energy, and painting the Dark Warrior on the north wall of the tomb chamber provided a potent antidote to these threatening forces. Whenever possible, even when building a house, palace, or temple, the entrance faced south, where it was thought to be open to the positive forces of heat and light, and the unbroken rear (north) walls worked as "demon barriers." Annette Juliano, *Treasures of China* (New York: Richard Marek, 1981), 25–27.

16. Wu, *The Art of the Yellow Springs*, 8.

17. See Kenneth J. De Woskin, trans. *Doctors, Diviners, and Magicians of Ancient China: Biographies of Fang-shih* (New York: Columbia University Press, 1983), 2; the Introduction provides an overview of what the term *fangshi* means and describes the *fangshi*'s overlapping functions; ibid., 1–42.

18. Susan L. Beningson, "The Spiritual Geography of Han Dynasty Tombs," in Beningson and Liu, *Providing for the Afterlife*, 2.

19. Ibid., 3.

20. For an interesting discussion on the symbolism and role of *mingqi*, see Cary Y. Liu, "Embodying the Harmony of the Sun and the Moon: The Concept of the 'Brilliant Artifacts' in Han Dynasty Burial Objects and Funerary Architecture," in Beningson and Liu, *Providing for the Afterlife*, 17–27.

21. Hsun Tsu (Xun Zi), *Basic Writings*, trans. Burton Watson. New ed. (New York: Columbia University Press, 1996), 97–105.

22. Alexander Soper, who did pioneering research on the Northern Wei capital and the opening of the Yungang Buddhist cave temples, believes that, at the time it was established, Pingcheng must have resembled a huge refugee camp that periodically swelled due to forced migrations of conquered people, who eventually gave the city a thin Chinese veneer. See his "South Chinese Influence on the Buddhist Art of the Six Dynasties Period," *Bulletin of the Museum of Far Eastern Antiquities* 32 (1960): 51. In the capital, Chinese gentry and commoners were segregated from the Tuoba Xianbei; see Albert E. Dien, *Six Dynasties Civilization* (New Haven, CT: Yale University Press, 2007), 7.

23. In 460, the monk Tanyao, part of a forced migration from Gansu to Shanxi, became head-monk-in-charge at Yungang, where he started the construction of the first cave temples there. Soper, "South Chinese Influence on the Buddhist Art of the Six Dynasties Period," 56–63; and James C. Y. Watt, et al., *China: Dawn of a Golden Age, 200–750 A.D.* (New York: Metropolitan Museum of Art; New Haven, CT: Yale University Press, 2004), 22–23.

24. "It is likely that western precedents were transmitted in fragments, so to speak, by means of small, easily portable images and paintings, iconographic pattern-books, and the vague descriptions of travelers."

Soper, "South Chinese Influence on the Buddhist Art of the Six Dynasties Period," 56.

25. Among the significant tombs found is the Yonggu mausoleum located at Fangshan in Datong. It consists of brick chambers with stone doors and belongs to Emperor Xiaowen's grandmother, Lady Feng, the Empress Dowager Wenming (died 490); see Datong City Museum and Shanxi Province Cultural Relics Work Committee, "Datong Fangshan Bei Wei Yongguling" (The Northern Wei Yonggu mausoleum at Fangshan, Datong), *Wenwu* 7 (1978): 29–35. Yang Hong published a short description, "An Archaeological View of the Tuoba Xianbei Art in the Pingcheng Period and Earlier," *Orientations* 34, no. 2 (May 2002): 30–31. Also significant are two tombs dated between 474 and 484, those of Sima Jinlong, prince of Langya, and his wife Ji Chen; see Datong City Museum and Shanxi Province Cultural Relics Work Committee, "Shanxi Datong Shijiazhai Bei Wei Sima Jinlong mu" (Northern Wei tomb of Sima Jinlong at Shijiazhai Village, Datong, Shanxi), *Wenwu* 3 (1972): 20–33, and Yang Hong, "An Archaeological View of the Tuoba Xianbei Art," 32–33. Near Datong, the tomb at Zhijiabao Village contained a stone sarcophagus dated to the early 480s; see Wang Yintian and Liu Junxi, "Datong Zhijiabao Bei Wei mu shiguo bihua" (Paintings from the Northern Wei stone sarcophagus from the Northern Wei tomb at Zhijiabao near Datong), *Wenwu* 1 (2001): 40–51. See also Wu Hung, "A Case of Cultural Interaction: House-Shaped Sarcophagi of the Northern Dynasties," *Orientations* 34, no. 2 (May 2002): 35–38.

26. Shortly after its discovery in 2000, archaeologists published the first report of Song Shaozu's tomb; see Shanxi Province Archaeology Institute and Datong City Archaeology Institute, "Datong shi Bei Wei Song Shaozu mu fajue jianbao" (Short report of the excavation of the Northern Wei Tomb of Song Shaozu in Datong), *Wenwu* 7 (2001): 19–39. Two articles in English about this discovery and related material include Wu Hung, "A Case of Cultural Interaction," 34–41; and Liu Junxi and Li Li, "The Recent Discovery of a Group of Northern Wei Tombs in Datong," *Orientations* 34, no. 2 (May 2002): 42–47. For a comprehensive monograph on eleven tombs in the cemetery, including that of Song Shaozu, see Liu Junxi, ed., *Datong Yanbei Yuan Bei Wei mu qun* (Tombs of the Northern Wei in Yanbei Teacher's College at Datong) (Beijing: Cultural Relics Publishing House, 2008).

27. Liu and Li, "The Recent Discovery of a Group of Northern Wei Tombs in Datong," 43.

28. Ibid., 45; Soper, "South Chinese Influence on the Buddhist Art of the Six Dynasties Period," 52, points out that, while the nomadic tribes lived along the northern border, they would have acquired a rudimentary appreciation of Chinese administrative skills. Song and his clan would have been useful in the management of the capital and the empire.

29. Liu and Li, "The Recent Discovery of a Group of Northern Wei Tombs in Datong," 45–46.

30. Robert L. Thorpe, *Son of Heaven: Imperial Arts of China* (Seattle: Son of Heaven Press, 1988), 170.

31. Fong, "Antecedents of Sui-Tang Burial Practices in Shaanxi," 149–51.

32. Yang Hong points out that after the capital was established at Pingcheng, "the early pit burials in birch coffins with animal sacrifices all but disappeared, with only the poorest commoners retaining this practice" ("An Archaeological View of the Tuoba Xianbei Art," 30).

33. See Liu Junxi, *Datong Yanbei Yuan Bei Wei mu qun*, 71–73.

34. Wu, "A Case of Cultural Interaction," 34; and Wu, *The Art of the Yellow Springs*, 76–77.

35. Liu and Li, "The Recent Discovery of a Group of Northern Wei Tombs in Datong," 43. For an interesting discussion about the translation of wooden architectural forms into brick in later tombs, see Wei-cheng Lin, "Underground Wooden Architecture in Brick: A Changed Perspective from Life to Death in 10th- through 13th-Century Northern China," *Archives of Asian Art* 61 (2011): 3–36.

36. Similar honeysuckle vines are painted on the remaining fragments of a lacquer coffin from a two-chambered Northern Wei brick tomb outside Datong of approximately the same date; see Shanxi Province and Datong City Archaeology Institute, "Datong Hudong Bei Wei yihao mu" (The Northern Wei tomb at Hudong, Datong, Shanxi province), *Wenwu* 2 (2004): 30–32.

37. Liu and Li, "The Recent Discovery of a Group of Northern Wei Tombs in Datong," 43.

38. The *ren* 人, or man-shaped, strut in Cave 10 is found in the front chamber, on the east and west walls, upper tier; see *Yungang Shiku Diaoku* (Carved-stone cave temples of Yungang), vol. 10 of *Zhongguo Yishu Quanji* (Compendium of Chinese art) (Beijing: Cultural Relics Publishing House, 1998), 112–13. It is also seen in the early sixth century in the Guyang cave in the Buddhist cave complex at Longmen, outside of Luoyang, the second capital of the Northern Wei, Longmen Cultural Relics Preservation Institute; see Beijing University Archaeology Department, *Longmen Shiku* (Longmen stone caves) (Beijing: Cultural Relics Publishing House, 1991), pl. 138. Another *ren* is found on the stone sarcophagus of the Sogdian and Zoroastrian Shi Jun (died 580), which was excavated in the suburbs of Xi'an, Shaanxi, in 2003; *Zhonghua Wenwu zhu, Zhongguo Zhongyao Kaogu Faxian* (Major archaeological discoveries in China, 2003) (Beijing: Cultural Relics Publishing House, 2004), 138, and English summary, 138–39. It continues to appear as a decorative element in the sixth century, but by the Tang it has disappeared from building exteriors.

The direct translation of a traditional post and beam structure from wood into stone in Song Shaozu's sarcophagus is underscored by the analysis of the wooden Buddhist monastery Foguangsi constructed in 857 in the sacred mountains of Wutaishan, Shanxi; see Lothar Ledderose, *Ten Thousand Things: Module and Mass Pro-*duction in Chinese Art (Princeton, NJ: Princeton University Press, 2000), 105–14.

39. Rawson, "The Eternal Palaces of Western Han," fig. 26a.

40. For an excellent essay about the monster-mask motif, its role in ceramics of the mid-sixth century and beyond, and its sources, see Suzanne G. Valenstein, *Cultural Convergence in the Northern Qi Period: A Flamboyant Chinese Ceramic Container* (New York: Metropolitan Museum of Art, 2007), 31–35.

41. Ibid., 32.

42. Dien, *Six Dynasties Civilization*, 208–12.

43. *Wenwu* 7 (2001): 29, fig. 18, and 31, fig. 21. The monograph on Song Shaozu's tomb (Liu Junxi, *Datong Yanbei Yuan Bei Wei mu qun*, 1 and 3) shows one guardian next to the door, also on the right, and the other a little further back on the right; it is likely they were pushed out of position by tomb robbers.

44. Watt, *Dawn of a Golden Age*, 17–18, no. 57.

45. Liu and Li, "The Recent Discovery of a Group of Northern Wei Tombin Datong," 44–45.

46. Funerary beds or platforms found in tombs usually are rectangular, raised platforms made of brick, stone, or sometimes pounded earth placed against the north tomb wall; seldom do they fill the entire tomb chamber. For a number of examples, see Zheng Yan, *Wei, Jin, Nan Bei Chao bihua mu yanjiu* [Research on the tomb painting of the Wei, Jin, and Northern and Southern Dynasties] (Beijing: Cultural Relics Press, 2002).

47. For a general discussion of similar coffin platforms and the carved, footed supports, see Elinor Pearlstein, "Pictorial Stones from Chinese Tombs," *The Bulletin of the Cleveland Museum of Art* (November 1984): 302–31.

48. Jessica Rawson, *Chinese Ornament: The Lotus and the Dragon* (New York: Holmes & Meier, 1984), 66–67; also by Rawson, "The Ornament on Chinese Silver of the Tang Dynasty (AD 618–906)," *British Museum Occasional Paper* 40 (London: British Museum, Department of Oriental Antiquities, 1982), 8–9. The discussions of the use, sources, and development of floral motifs convey the complexity of the process, which was not always a simple linear one.

49. Clearly female, this figure (pl. 68:4) dressed in non-Han clothing is very similar to human figures on the vertical side of the small stone bases in the tomb of Sima Jinlong, a contemporary of Song Shaozu, also in the Datong area. For an excellent set of rubbings of the carved design of palmette scrolls inhabited by voluptuous figures, see Rawson, *Chinese Ornament*, 64, fig. 42; a similar decorative frieze over the lintel above the doorway of Yungang Cave 10 is reproduced in Watt, *Dawn of a Golden Age,* 20, fig. 16.

50. The remains of a later wooden sarcophagus that imitates a Chinese ceremonial hall were found in the tomb of a Northern Qi Xianbei nobleman, Kudi Huiluo (died 562), at Shouyang, Shanxi; see Wang Kelin, "Bei Qi Kudi Huiluo mu" (The Northern Qi tomb of Kudi Huiluo), *Kaogu xuebao* 3 (1979): 377–402. This sarcophagus as well as Song Shaozu's and other stone-house sarcophagi and beds or couches seem to suggest that the Xianbei and other foreigners, such as the Sogdians, revived this practice from the Han dynasty. Eventually, house-shaped sarcophagi during the "Northern Dynasties gradually entered the mainstream and became the norm in the following century [Tang] . . . adopted by aristocrats and members of the royal family"; see Wu Hung, "A Case of Cultural Interaction," 34–41.

51. Liu Junxi, *Datong Yanbei Yuan Bei Wei mu qun*, 83, fig. 60.

52. Pear-shaped lutes were introduced into China from Central Asia in about the fifth century, but the origins of the *ruan*—also known as *qin pipa* or *ruanxian* (moon lute)—remain unclear. The *ruan* was popular with the Seven Sages of the Bamboo Grove, which also suggests an influence from the Southern Dynasties and its capital at what is Nanjing today. Liu Junxi, *Datong Yanbei Yuan Bei Wei mu qun*, 168–69; see also *Zhongguo yinyue shiankaotu pian* (Chinese musical history reference pictures) 9: *Beichao de yue tian he yue ren* (Northern Dynasties heavenly music and musicians) (Beijing: Music Publishers, 1964), 12, pl. 13.

53. Mark Edward Lewis, *China between the Empires: The Northern and Southern Dynasties* (Cambridge, MA: Harvard University Press, 2009), 168.

54. Ibid., 169.

55. The first excavation report of the discovery of the tomb of Lou Rui was published by the Shanxi Provincial Institute of Archaeology and Taiyuan City Cultural Relics Management Committee, "Taiyuan shi Bei Qi Lou Rui fajue qianbao" (Short report of the excavation of the Northern Qi tomb of Lou Rui), *Wenwu* 10 (1983): 1–23. The Shanxi Provincial Institute of Archaeology and the Taiyuan City Institute of Cultural Relics and Archaeology copublished a monograph, *Bei Qi Dong'an Wang Lou Rui Mu* (The Northern Qi tomb of Prince Dong'an Lou Rui) (Beijing: Cultural Relics Publishing House, 2006).

56. Fong, "Antecedents of Sui-Tang Burial Practices in Shaanxi," 149, n.14.

57. See Robert E. Harrist, Jr., *Power and Virtue: The Horse in Chinese Art* (New York: China Institute Gallery, 1997), 17; Bill Cooke, ed., *Imperial China: The Art of the Horse in Chinese History* (Lexington, KY: Kentucky Horse Park; Prospect, KY: Harmony House, 2000).

58. The tomb of Xu Xianxiu and his wife—which was also robbed—has been published in a handsome, small monograph by the Taiyuan City Institute of Cultural Relics and Archaeology, *Bei Qi Xu Xianxiu* (Northern Qi tomb of Xu Xianxiu) (Beijing: Cultural Relics Publishing House, 2005); and in "Taiyuan Bei Qi Xu Xianxiu mu fajue qianbao" (Short report of the excavation of the Northern Qi tomb of Xu Xianxiu, Taiyuan), *Wenwu* 10 (2003): 4–40.

59. Stone lotus-flower plinths perforated through the base and eight pairs of small stone lions, four with bronze rings grasped in their mouths and four having just holes at the same location, were found near the brick coffin platform. Archaeologists suggested they may have provided support for a screen or curtains that would have created a three-sided enclosure on the coffin platform, often of a type seen painted on the tomb wall; see Shanxi Provincial Institute of Archaeology and Taiyuan City Institute of Cultural Relics and Archaeology, *Bei Qi Dong'an Wang Lou Rui Mu*, 151–60.

60. Ibid., 302.

61. Ibid., 303.

62. Annette L. Juliano, *Teng-hsien: An Important Six Dynasties Tomb* (Ascona, Switzerland: Artibus Asiae, 1980), 45; an identical deer-headed, bird-bodied creature has been carved on the stone door of the tomb of Xu Xianxiu; see Taiyuan City Institute of Cultural Relics and Archaeology, *Bei Qi Xu Xianxiu*, no. 13.

63. Susan Bush, "Thunder Monsters and Wind Spirits in Early Sixth Century China and the Epitaph Tablet of Lady Yuan," *Boston Museum Bulletin* 72, no. 367 (1974): 25–54.

64. Wu Hung suggests that the presence of the portraits of the deceased on the back wall of the tomb, behind the coffin, indicates a change in the concept of the *hun*. In his view, it now also remained in the tomb, like the *po*. It is possible that non-Chinese owners of tombs found the idea of two souls puzzling; Wu, *The Art of the Yellow Springs*, 74–78.

65. Shanxi Provincial Institute of Archaeology and the Taiyuan City Institute of Cultural Relics and Archaeology, *Bei Qi Dong'an Wang Lou Rui Mu*, 304.

66. Taiyuan City Institute of Cultural Relics and Archaeology, *Bei Qi Xu Xianxiu*.

67. Margaret Medley, *A Handbook of Chinese Art for Collectors and Students* (New York: Horizon Press, 1965), 41; the twelve branches, or duodenary cycle, of symbols is used to divide the twenty-four hours of the day into twelve two-hour periods. Each symbol equates with a sign of the Chinese zodiac as well as one of the twelve points of the Chinese compass.

68. Dien, *Six Dynasties Civilization*, 208–12.

69. The information on these wares was provided by Suzanne G. Valenstein, Research Curator Emeritus, Metropolitan Museum of Art, who published a groundbreaking monograph on these northern sixth-century glazed-ceramic wares. See Valenstein, *Cultural Convergence in the Northern Qi Period*.

70. Ibid., 75–78.

71. Sarah Laursen, "Leaves That Sway: Gold Xianbei Cap Ornaments from Northeast China," Ph.D. diss., University of Pennsylvania, 2011 (UMI 3463014). Laursen, a research fellow at the Institute for the Study of the Ancient World, has made a significant contribution to the field by

informing her extensive research with her expertise in gold-working techniques, offering new insights and methodological approaches.

72. Two parrot-like birds with heads twisted backward are found on one of the most complete ornamental plaques (similar to the one from the Lou Rui tomb), which was excavated from the Eastern Wei tomb of the Ruru princess, Cixian, in Hebei province; see Cixian wenhua guan (Cultural Center of Cixian County), "Hebei Cixian Bei Qi Gao Run mu" (Tomb of Gao Run of the Northern Qi dynasty found at Cixian county, Hebei province), *Kaogu* 3 (1979), 235–43.

73. Sarah Laursen writes: "In crafting the filigree, the artist would have placed pieces of wire around the circumference of the cut stones before fusing the wire to the gold backing sheet. The stones were then inserted into the pre-formed cells, and possibly held in place using a sticky resin. The process is reversed in creating the areas of enamel— the wire is formed into a frame in any desired shape and adhered to the backing sheet, the resulting cell is filled with ground colored glass in a flux, and they are fired together to make the glass paste solid. This enamel or cloisonné technique may derive from polychrome Hellenistic and Achaemenid jewelry, in which beaded or spiral-beaded wire was used to form ornamental borders that were then filled in, normally with blue and green enamel." See Herbert Hoffman and Patricia F. Davidson, *Greek Gold: Jewelry from the Age of Alexander* (Mainz/Rhein: Philipp von Zabern, 1965), 10–11."

74. Wu, *The Art of the Yellow Springs,* 57.

75. Among the earliest and most valuable discussions of these spirit kings is Emmy C. Bunker's "The Spirit Kings in Sixth Century Chinese Buddhist Sculpture," *Archives of the Chinese Art Society of America* 18 (1964): 26–37. More recent articles have appeared in Chinese sources, such as Chang Qing, "Bei Chao Shiku Shen Wang diaoke shulue" (Brief discussion of carved stone spirit kings in Buddhist caves of Northern Dynasties), *Kaogu* 12 (1994): 1127–41.

76. See *Shanxi Qingzhou Longxingsi chutu Fojiao shike zaoxiang jingpin* (Masterpieces of Buddhist statuary unearthed from Longxing Temple, Qingzhou City) (Beijing: Cultural Relics Publishing House, 1999), 115, for paintings of Sogdians on the Buddha's robe.

77. The arched entrance leading to the burial chamber was bricked over and not marked by a sealed stone door; the stone door to the sarcophagus itself served as the entrance to the realm of the dead. Because the tomb has been disturbed, it is difficult to know what was actually lost, damaged, or not there originally.

78. Zheng Yan, *Wei Jin Nanbeichao bihuamu yanjiu* (Research on the Wei Jin and Northern and Southern Dynasties tomb wall paintings) (Beijing: Cultural Relics Publishing House, 2002), 190–95.

79. Jessica Rawson, "Creating Universes: Cultural Exchange as Seen in Tombs in Northern China between the Han and Tang Periods," in *Be-* *tween Han and Tang: Cultural and Artistic Interaction in a Transformative Period* (Beijing: Cultural Relics Publishing House, 2001), 113–14.

80. Robert L. Thorp, "The Qin and Han Imperial Tombs and the Development of Mortuary Architecture," in *The Quest for Eternity: Chinese Ceramic Sculptures from the People's Republic of China* (Los Angeles: Los Angeles County Museum; San Francisco: Chronicle Books, 1987), 17–37; Institute of Archaeology, *Tang Chang'an chengjiao Sui Tang mu* (Sui and Tang tombs in the suburbs of Tang Chang'an) (Beijing: Wenwu Press, 1980); Mary H. Fong, "Antecedents of Sui-Tang Burial Practices in Shaanxi," *Artibus Asiae* 51 (1991): 147–56.

81. Yongtai's tomb was first excavated in 1960 and published in archaeological journals, such as *Wenwu,* in 1963 and 1964. Hers is one of a number of tragic stories associated with the vindictiveness of her grandmother, Empress Wu Zetian, who usurped the throne from Yongtai's father, Emperor Zhong Zong. In 701 at the age of seventeen, Yongtai, her husband, and her brothers were murdered for insulting Empress Wu. Zhong Zong regained control of the throne in 705 and had Yongtai reburied in 706 in a style befitting an empress. Her tomb seems to have been part of a "building boom" that ensued after Empress Wu was deposed, because during her reign she caused several members of the imperial household to be assassinated or forced to commit suicide, and all these victims were reburied upon Zhong Zong's resumption of the throne. The paintings in Yongtai's tomb are among the best that have been uncovered. See Terukazu Akiyama, Kōsei Andō, Saburo Matsubara, Takashi Okazaki, Takeshi Sekino, and Mary Tregear, *Arts of China: Neolithic Cultures to the T'ang Dynasty, Recent Discoveries* (Tokyo: Kodansha International, 1968), 222–23, no. 191, pl. 230; Jan Fontein and Tung Wu, *Unearthing China's Past* (Boston: Museum of Fine Arts, 1973), 154–57; Li Guizhen, *Da Tang Pihua* (Magnificent frescoes from the great Tang dynasty) (Shaanxi: Shaanxi Tourism Bureau, 1996), 15–25.

82. See Elinor Pearlstein, "Pictorial Stones from Chinese Tombs," *The Bulletin of the Cleveland Museum of Art* (November 1984): 318.

83. Wu Hung, "A Case of Cultural Interaction: House-Shaped Sarcophagi of the Northern Dynasties," *Orientations* 34, no. 5 (May 2002): 34. For examples of house-shaped sarcophagi from the Sui and Tang dynasties, see Elinor Pearlstein, "Pictorial Stones from Chinese Tombs," 313–19. Another fine example is the sarcophagus of Yang Hui (died 736), which includes painted court ladies and servants on the outside panels. Excavated in 1991, it was exhibited recently in Hong Kong; see *Zhongguo Kaogu xin faxian* (Major archaeological discoveries in China, recent years) (Hong Kong: Hong Kong Museum of History, 2007), 40–43.

84. Wang Zhongxue had worked at the museum for more than twenty years, published many scholarly papers, and won awards for his contribution to preserving cultural relics in Lingtai county. Drawing upon his professional knowledge and rich experience in field archaeology, he actively participated in the excavations of the terraced mountain-

side and led a team of highly trained provincial and city field archaeol-
ogists, who were fully prepared to handle this rescue effort.

All the information and photographs about this undisturbed Tang tomb (M2) at Fujiagou in Lingtai county cited and reproduced in this chapter were provided by the Museum of Lingtai County, which remains in charge of the salvage excavation of M2, and the team led by its former director Wang Zhongxue, who is a respected scholar at Arts Exhibition China, under Director Wang Jun. The preliminary draft report, published in March 2012, is titled: "Lingtai xian Liangyuan Xiang Fujiagou cun Yaozijianshe Fengjia Shan Tang mu qiangjiu xingqing liji ben qingguang" (Basic description of the emergency rescue excavation for the Tang tomb at Fengjia Mountain, Taozijian Cooperative, at Fujiagou Village in the Liangyuan district of Lingtai county, Gansu).

85. "Cold paint" refers to the process of applying paint to the clay *mingqi* after firing in the kiln. This leaves the color pigment more vulnerable to environmental affects, thus it is more likely to flake off due to dampness and to fade when exposed to light. In fact, the extensive painting on the Fujiagou *mingqi* has begun to fade.

86. Wu Hung suggests that disparity in size among the *mingqi* in the tomb may also be determined by the placement of the figures: In the case of the *tianwang,* which were placed flanking the entrance just inside the tomb, the larger size reflects their relationship to the tomb's architecture rather than to the clusters of clay figures that form a procession. See Wu Hung, *The Art of the Yellow Springs: Understanding Chinese Tombs* (Honolulu: University of Hawai'i Press, 2010), 116.

A comparable single-chamber tomb of the Tang dynasty that is very similar in scale and content also has a steep, sloping ramp, and no evidence of painting on the ramp or the walls of the burial chamber was unearthed near Xi'an during construction at the Northwest Institute of Political Science and Law. There, the brightly painted *mingqi* included a pair of *tianwang* subduing demons at the entrance, a pair of *zhenmushou* standing on rocklike bases in front of the rotted wooden coffin, and some elegant court ladies. Like the Fujiagou tomb, the one near Xi'an dates from the late seventh to early eighth century; see Institute of Archaeology and Preservation of Antiquities of Xi'an, "Xi'an Xibei Zheng faxue yuan nanxiao qu" (A brief report of excavation of a Tang tomb no. 34 in Xi'an at the Institute for Political Science and Law), *Wenwu* 12 (2002): 50–65.

87. Virginia L. Bower, *From Court to Caravan: Chinese Tomb Sculptures from the Collection of Anthony M. Solomon* (Cambridge, MA: Harvard University Art Museums; New Haven, CT: Yale University Press, 2003), 48. Fong, "Antecedents of Sui-Tang Burial Practices in Shaanxi," 190, suggests that the practice of burying a pair of warrior figures together with a pair of guardian creatures as a special set most likely was introduced from South China during the late Northern Wei.

88. *Da Tang Liudian* (Compendium of administrative law of the six divisions of the Tang bureaucracy), the Tang text on institutions (dated 738), and the *Tangdian* (Encyclopedic history of institutions; dated

801) describe the sumptuary laws regarding the number and types of *mingqi* allowed for various court ranks. One passage cites the number and size of tomb figures allowed in accordance with the deceased's court rank and mentions two sets of tomb guardian figurines by their special names. Bower, *From Court to Caravan,* 48; and Fong, "Antecedents of Sui-Tang Burial Practices in Shaanxi," 189; Yang Hong, "From the Han to the Qing," in Angela Falco Howard, Wu Hung, Li Song, and Yang Hong, *Chinese Sculpture* (New Haven, CT: Yale University Press; Beijing: Foreign Languages Press, 2006), 130.

89. Harada Yoshito, *Kan rikuchō no fukusoku* (Chinese dress and personal ornaments in the Han and Six Dynasties), with English summary (Tokyo: Toyo Bunka, 1967), 29.

90. See the tomb of Dugu Sizhen (died 698) excavated in Xi'an, where the tomb guardians—a pair of *tianwang,* officials, and one *zhenmushou*— were found in their original positions at the entrance to the tomb chamber. Institute of Archaeology, *Tang Chang'an chengjiao Sui Tang mu* (Sui and Tang tombs in the suburbs of Tang Chang'an) (Beijing: Wenwu Press, 1980), 30–32.

The painted-clay *mingqi* from the Fujiagou tomb preserve high-quality examples of sculpture that also display extensive painted embellishment. Although still richly patterned, the intensity of the cold-painted pigments on the six Tang pieces from Fujiagou shows definite signs of fading.

91. Guardians of this category also are found painted on walls flanking those on the outside of the stone tomb door; see Shanxi Provincial Institute of Archaeology and the Taiyuan City Institute of Cultural Relics and Archaeology, *Bei Qi Dong-'an Wang Lou Rui Mu* (The Northern Qi tomb of Prince Dong'an Lou Rui) (Beijing: Cultural Relics Publishing House, 2006), 56 and 57.

92. Alexander C. Soper, *Literary Evidence for Early Buddhist Art in China: Supplementum* 19 (Ascona, Switzerland: Artibus Asiae, 1959), 231.

93. On his deathbed, the Buddha is said to have summoned "Indra and the Four Lokapalas to His couch, enjoining on each a special share in the defense of the Church, in the evil times to come"; ibid., 233.

94. The *tianwang* subduing demons were powerful symbols of averting evil. According to Virginia Bower, "the inspiration for warriors standing on placid animals appears to have been a type of minor Buddhist deity referred to in Chinese as the *shenwang,* or 'spirit kings'." The version with the warrior standing on a demon came to represent the idea of "standing in power or triumph on an animal mount or vanquished foe." See Bower, *From Court to Caravan,* 51.

95. Fong, "Antecedents of Sui-Tang Burial Practices in Shaanxi," 190.

96. Several scholars have discussed the evolution of these creatures: see Dien, *Six Dynasties Civilization,* 208–12; Fong, "Antecedents of Sui-Tang Burial Practices in Shaanxi," 160–62 and 183–87; *Kaikodo Journal* 20 (autumn 2001): 228, 356–58.

97. Seated bolt upright on their haunches, sometimes with tongues hanging out, these creatures with their doglike qualities may suggest a connection to a Xianbei belief that the spirit of a sacrificed dog accompanied the deceased to the abode of the dead. Dien, *Six Dynasties Civilization,* 212. The human-faced guardian may reach back to the Han dynasty or earlier, and the Western Han text *Shanhaijing* (Classic of mountains and seas) contains descriptions of fantastic gods, demons, and animal deities, including one human-headed animal dwelling in the Northern Yufa mountains: "Two hundred *li* further north in the Yufa mountains . . . there dwells an animal which resembles a dog but has a human face, and is clever at hurling [things]. When it sees a man, it howls. Its name is Shan Hui." (Fong, "Antecedents of Sui-Tang Burial Practices in Shaanxi," 162.)

98. Edward H. Schafer, *The Golden Peaches of Samarkand: A Study of T'ang Exotics* (Berkeley: University of California Press, 1985), 13–14.

99. Ibid., 70–71.

100. Ibid., 71.

101. Ibid.

102. Ibid., 72–73.

103. E Jun, ed., *Gansu Sheng Bowuguan, Wenwu jingpin tuji* (Masterpieces from the Gansu Provincial Museum) (Xi'an: San Qin Publishing House, 2006, repr. 2008), 234 (horse) and 235 (camel).

104. One of the earliest efforts to identify the ethnicity of Tang figures was Jane Gaston Mahler's pioneering book, *The Westerners among the Figurines of the T'ang Dynasty of China* (Rome: Istituto Italiano per il Medio ed Estremo Oriente, 1959), which still proves useful at times, although an extraordinary amount of new archaeological material has come to light since its publication. More recent scholarship has focused on the attitudes toward the non-Han Chinese and the formation of ethnicity in ancient China; see Marc S. Abramson, *Ethnic Identity in Tang China* (Philadelphia: University of Pennsylvania Press, 2008); and Hyun Jin Kin, *Ethnicity and Foreigners in Ancient Greece and China* (London: Duckworth, 2009).

105. Lingtai county in Gansu province is very close to the northwestern border with Shaanxi. In 1991, a Tang tomb belonging to Yang Hui (died 736), an aristocrat and civil official appointed under the reign of Tang Empress Wu, was unearthed in Yulin City, Jingbian county, far north in Shaanxi province near the Inner Mongolian border and not far from Ningxia. This tomb contained a stone house-sarcophagus with elegantly painted, lush floral borders and stylish court ladies. Hong Kong Museum of History, *Zhongguo Kaogu xin faxian,* 41–43.

106. For an overview of Chinese funerary sculpture, see Wang Renbo, "General Comments on Chinese Funerary Sculpture," in *The Quest for Eternity,* 39–63.

107. Bower, *From Court to Caravan,* 55.

108. Xuanzang caused a sensation not only for what he brought back to court, but also by his travelogue, *Da Tang Xiyu ji* (Great Tang records of the western regions); see Sally Hovey Wriggins, *Xuanzang, a Buddhist Pilgrim on the Silk Road* (Boulder, CO: Westview Press, 1996). His travels provided the longest, most detailed descriptions of the political and social aspects of the countries he visited in Central and South Asia.

109. For an excellent, succinct summary of the development of Buddhism in China, see Arthur F. Wright, *Buddhism in Chinese History* (Stanford, CA: Stanford University Press, 1971); see pages 83–85 for discussion of the Tang persecution.

110. One of the most famous discoveries was the underground crypt, a multiroom chamber under the pagoda belonging to the Famen Temple, dated 871 and located 75 miles (120 km) west of Xi'an. A trove of precious cultural relics and reliquaries in gold and silver, it is home to the famous kneeling bodhisattva fashioned from gilded silver, whose clothes and crown are embellished with two hundred pearls; she offers up a tray shaped like a large lotus leaf on which rests a bone relic in a glass container. See Famen Archaeological Team, *Famen si digong zhen bao* (Precious cultural relics in the crypt of the Famen Temple) (Xi'an: Shaanxi People's Fine Arts Publishing, 1989).

111. Robert E. Fisher, *Buddhist Art and Architecture* (London: Thames & Hudson, 1993), 31–33.

112. According to Buddhist texts, King Asoka of India, an early patron of the religion, placed the *śarīra* of Śākyamuni Buddha in 84,000 exquisite caskets that were to be distributed for worship within and outside India; see also Annette L. Juliano and Judith A. Lerner, *Monks and Merchants: Silk Road Treasures from Northwest China* (New York: Asia Society; Abrams, 2001), 330; and Xinru Liu, *Ancient India and Ancient China: Trade and Religious Exchanges AD 1–600* (Oxford: Oxford University Press, 1999), 57–58.

113. See Sonya S. Lee, *Surviving Nirvana: Death of the Buddha in Chinese Visual Culture* (Hong Kong: Hong Kong University Press, 2010), 226, and *Kaikodo Journal* (Hong Kong, January 2000), 176.

114. Juliano and Lerner, *Monks and Merchants:* 328–29, no. 120.

115. Lee, *Surviving Nirvana,* 7.

116. The Gupta dynasty in northern India lasted from the fourth through the seventh century and remains one of the best-known periods of Indian Buddhist art, which had considerable impact on the rest of Asia. The controlled, sensual, and elegant sculptural forms influenced Buddhist sculpture and painting in Central Asia and Tang China. See Fisher, *Buddhist Art and Architecture,* 54–61.

117. Eugene Y. Wang, *Shaping the Lotus Sutra: Buddhist Visual Culture in Medieval China* (Seattle: University of Washington Press, 2005), 370–72.

EXHIBITION PLATES

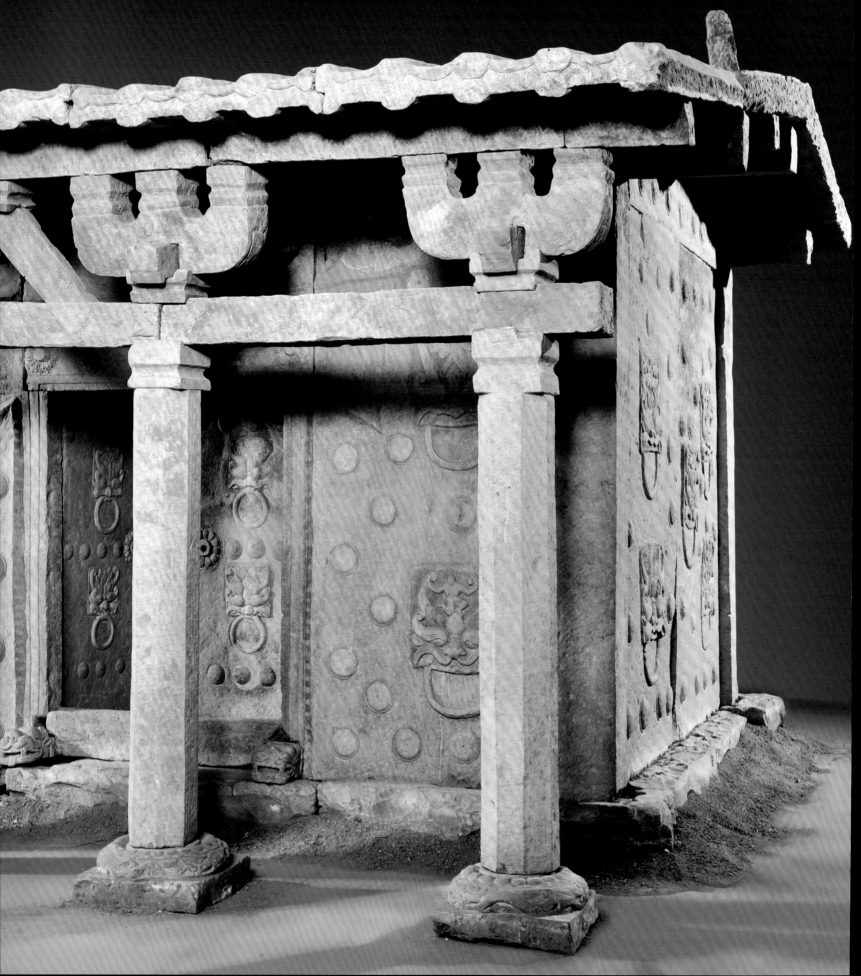

1. SARCOPHAGUS

Northern Wei dynasty (386–535 C.E.), tomb dated 477 C.E.

Excavated 2000, tomb of Song Shaozu (died 477 C.E.),

Caofulou Village, Datong, Shanxi Province

Sandstone

240 × 348 × 338 cm

Shanxi Museum, Taiyuan

石棺或外椁

北魏朝（公元前386 – 535年），墓地年代为公元前477年

2000年出土于山西省大同市曹福楼村宋绍祖墓

砂岩石

240 x 348 x 338 厘米

山西博物馆，太原

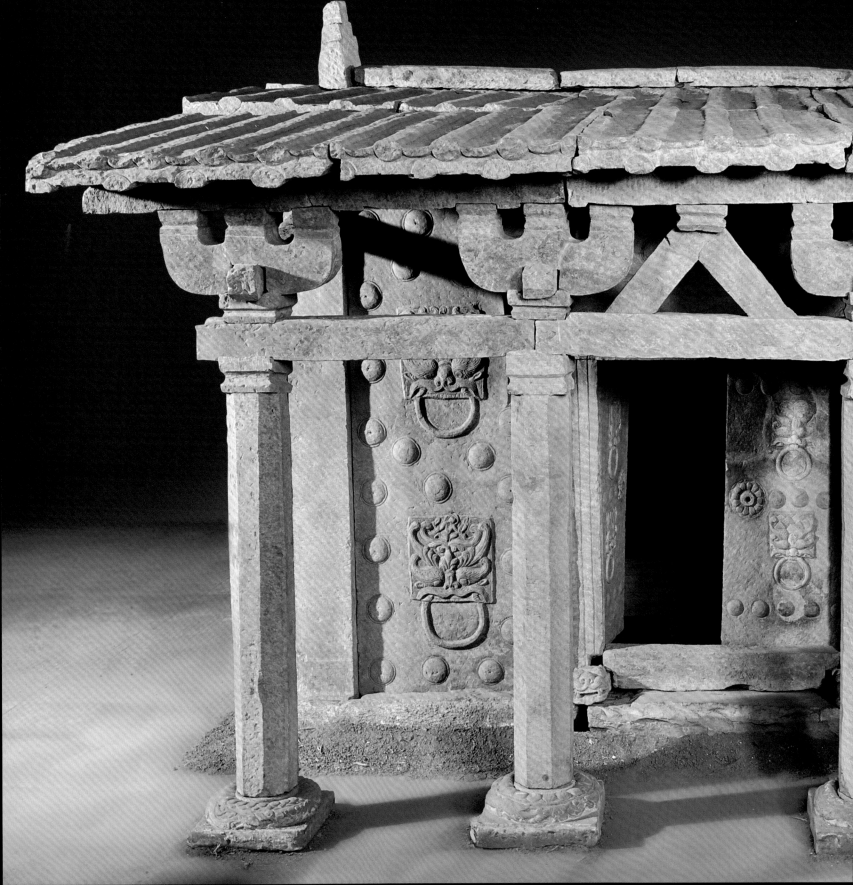

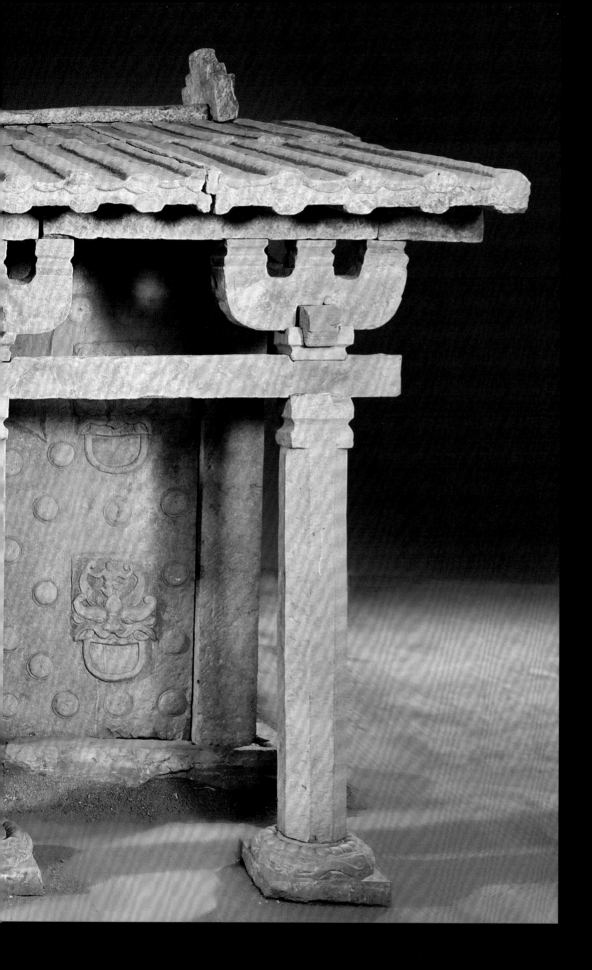

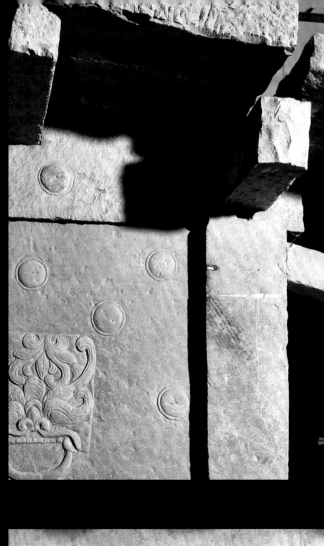

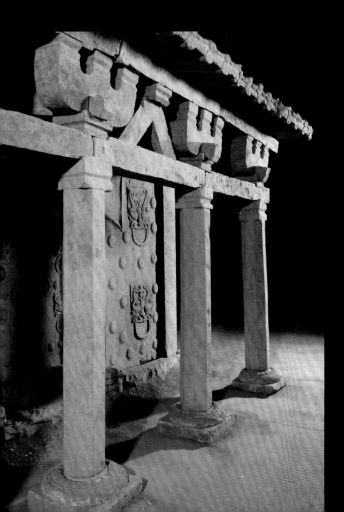

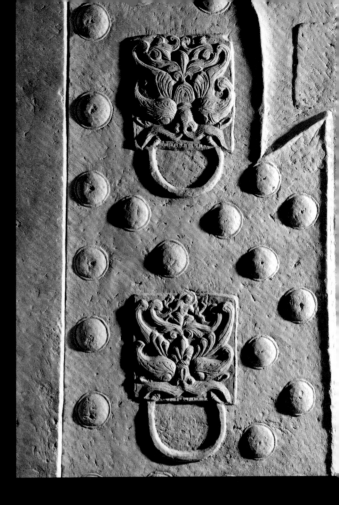

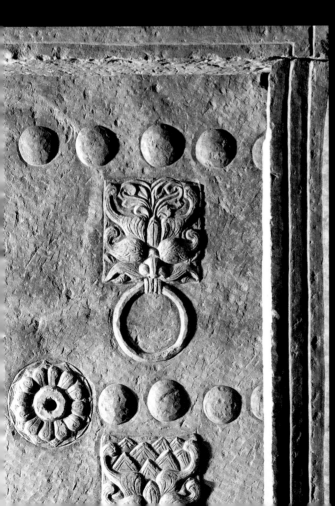

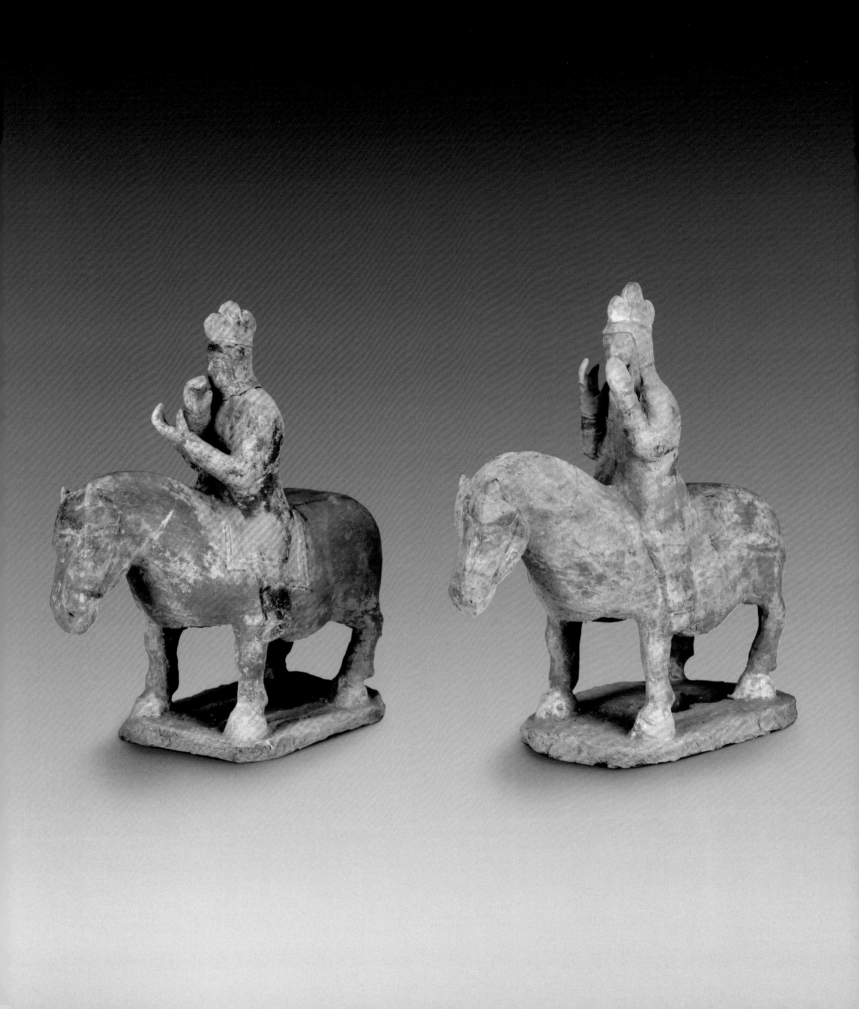

2. TWO MOUNTED MILITARY FIGURES WITH COCKSCOMB HEADGEAR

Northern Wei dynasty (386–535 C.E.), tomb dated 477 C.E.

Excavated 2000, tomb of Song Shaozu (died 477 C.E.),

Caofulou Village, Datong, Shanxi Province

Painted earthenware

Height 30.4 cm and 31.2 cm

Shanxi Museum, Taiyuan

两个戴鸡冠帽的军乐家

北魏朝（公元前386 – 535年），墓地年代为公元前477年

2000年出土于山西省大同市曹福楼村宋绍祖墓

彩色陶器

高30.4 厘米和31.2厘米

山西博物馆，太原

3. OX CART

Northern Wei dynasty (386–535 C.E.), tomb dated 477 C.E.

Excavated 2000, tomb of Song Shaozu (died 477 C.E.),

Caofulou Village, Datong, Shanxi Province

Painted earthenware

Length 32.6 cm

Shanxi Museum, Taiyuan

牛车

北魏朝（公元前386－535年），墓地年代为公元前477年

2000年出土于山西省大同市曹福楼村宋绍祖墓

彩色陶器

长32.6厘米

山西博物馆，太原

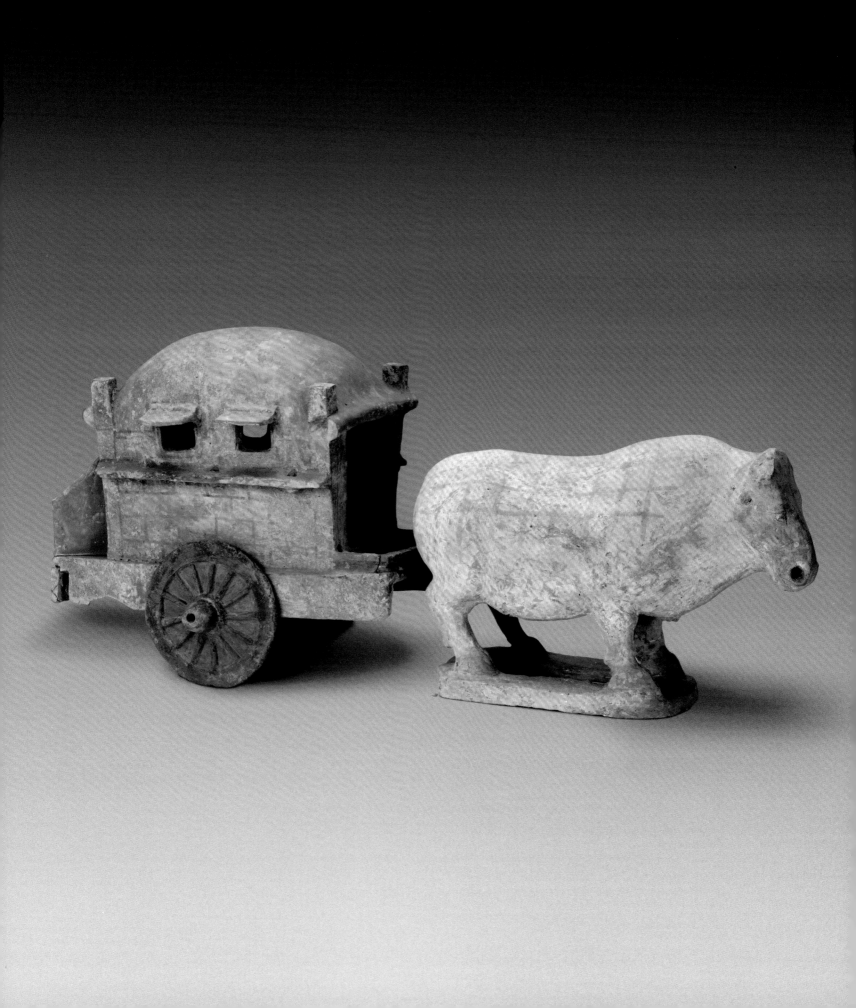

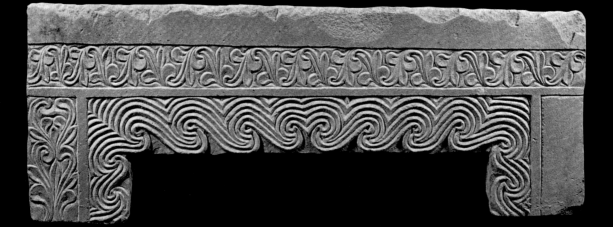

4. MORTUARY BED

Northern Wei dynasty (386–535 C.E.), tomb dated 477 C.E.

Excavated 2000, tomb of Song Shaozu (died 477 C.E.),

Caofulou Village, Datong, Shanxi Province

Sandstone

30 × 232 × 83 cm

Shanxi Museum, Taiyuan

停尸床

北魏朝（公元前386 – 535年），墓地年代为公元前477年

2000年出土于山西省大同市曹福楼村宋绍祖墓

砂岩石

30 x 232 x 83 厘米

山西博物馆，太原

5. OX

Northern Qi dynasty (550–577 C.E.), tomb dated 570 C.E.

Excavated 1979, tomb of Lou Rui (died 570 C.E.),

Wangguo Village, Taiyuan, Shanxi Province

Painted earthenware

35 × 35.5 cm

Shanxi Museum, Taiyuan

牛

北齐朝（公元前550 – 577年），墓地年代为公元前570年

1979年出土于山西省太原市王国村娄睿墓

彩色陶器

35 x 35.5 厘米

山西博物馆，太原

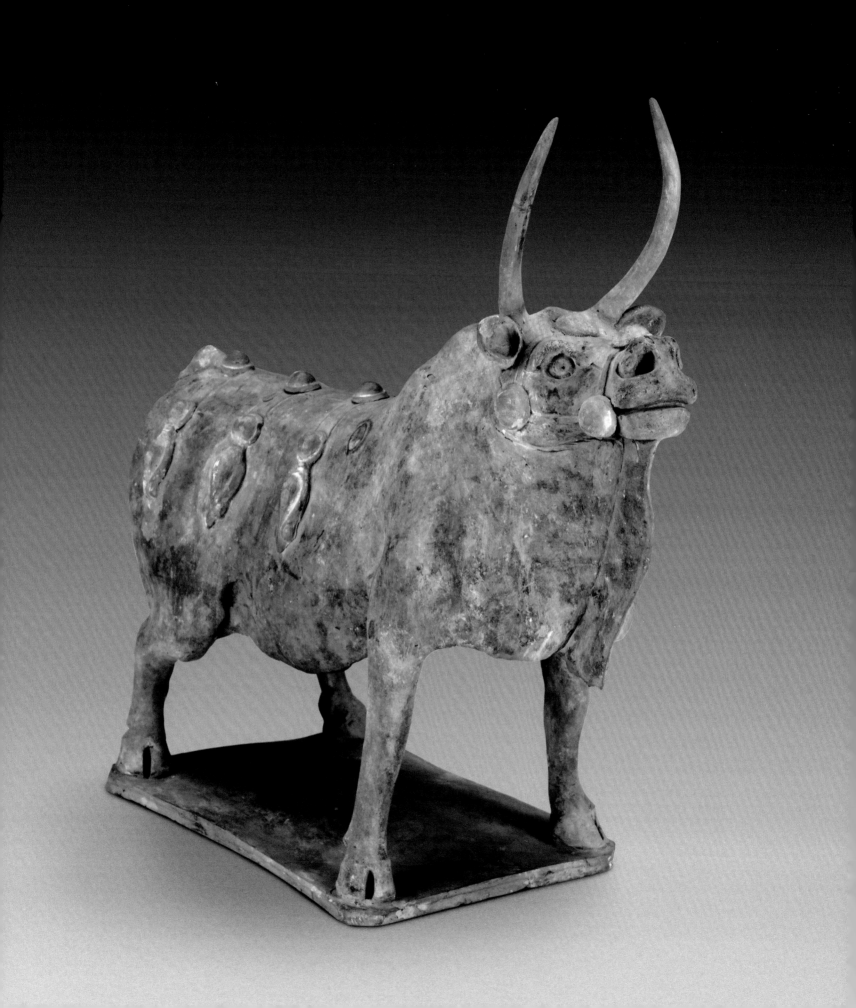

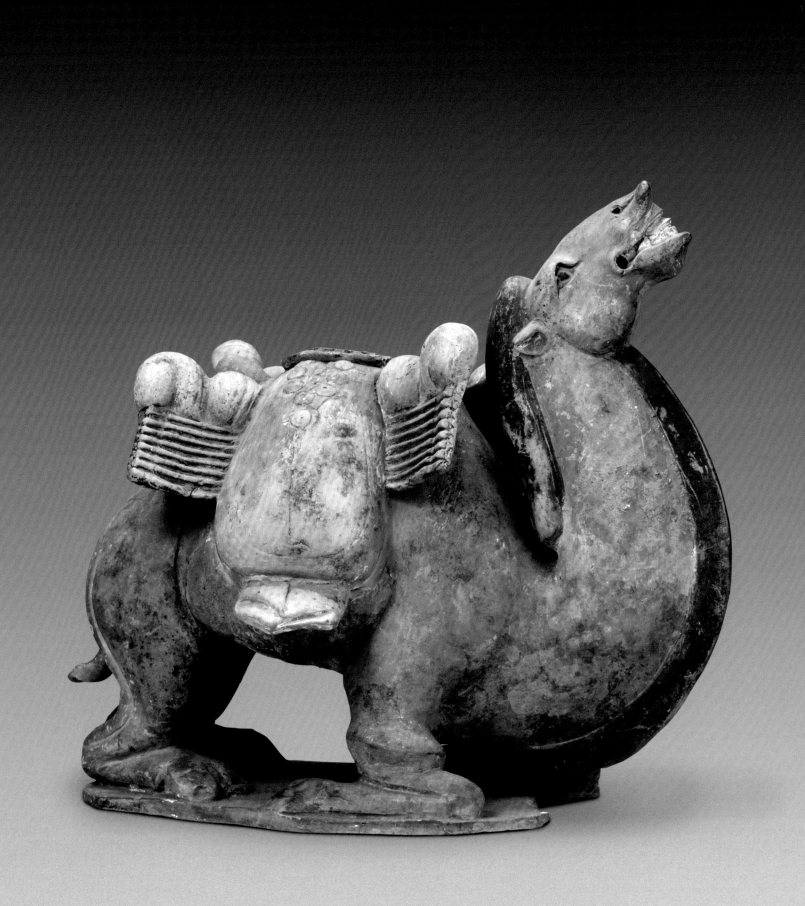

6. SITTING CAMEL

Northern Qi dynasty (550–577 C.E.), tomb dated 570 C.E.

Excavated 1979, tomb of Lou Rui (died 570 C.E.),

Wangguo Village, Taiyuan, Shanxi Province

Painted earthenware

24.7 × 29.7 cm

Shanxi Museum, Taiyuan

卧骆驼

北齐朝（公元前550 – 577年)，墓地年代为公元前570年

1979年出土于山西省太原市王国村娄睿墓

彩色陶器

24.7 x 29.7 厘米

山西博物馆，太原

7. WARRIOR GUARDIAN

Northern Qi dynasty (550–577 C.E.), tomb dated 570 C.E.

Excavated 1979, tomb of Lou Rui (died 570 C.E.),

Wangguo Village, Taiyuan, Shanxi Province

Painted earthenware

Height 63.5 cm

Shanxi Museum, Taiyuan

武士俑

北齐朝（公元前550 – 577年），墓地年代为公元前570年

1979年出土于山西省太原市王国村娄睿墓

彩色陶器

高63.5厘米

山西博物馆，太原

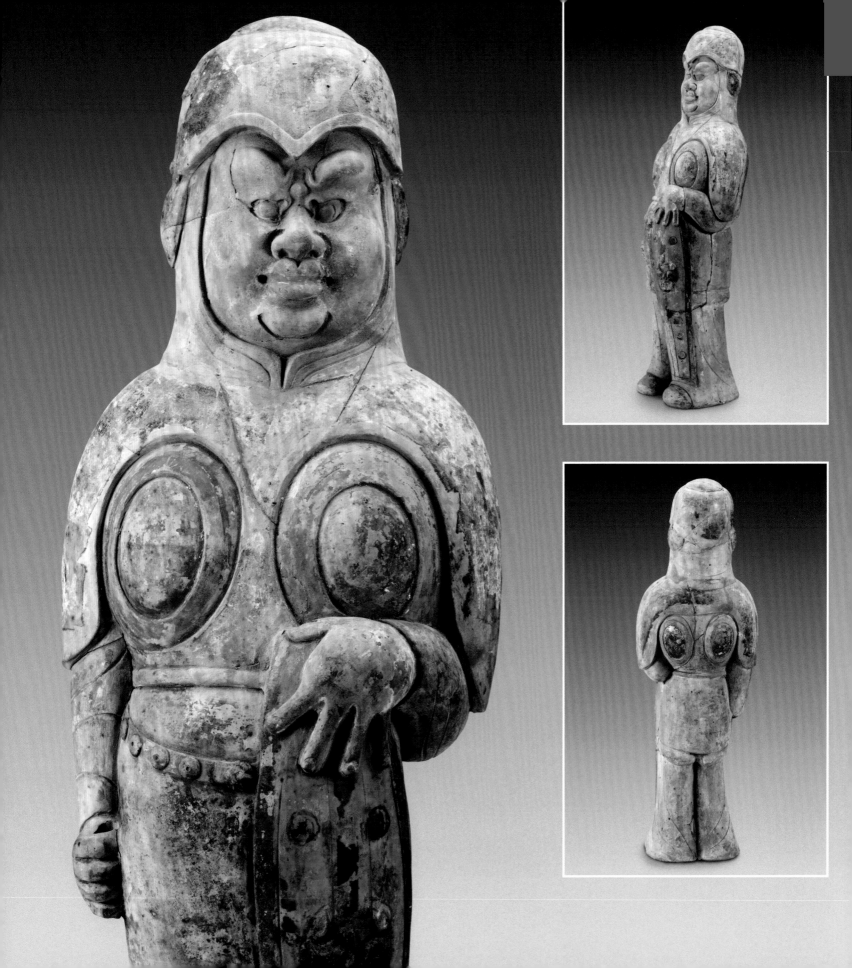

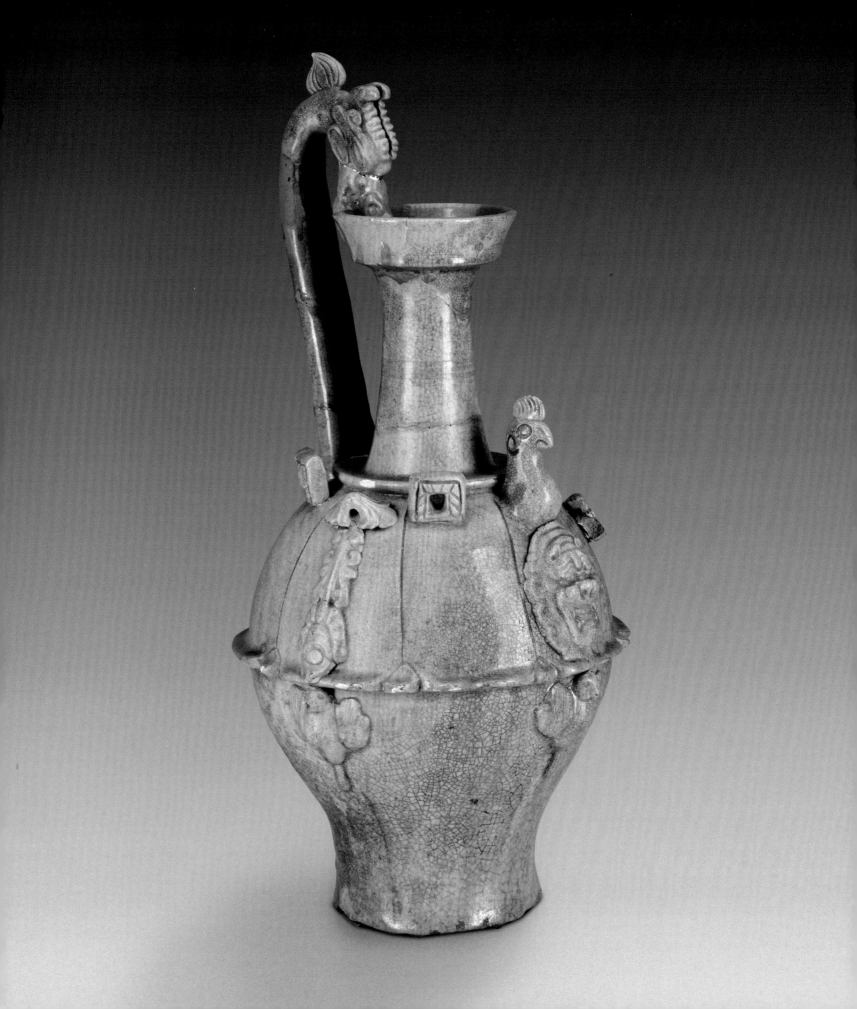

8. CHICKEN-HEADED EWER

Northern Qi dynasty (550–577 C.E.), tomb dated 570 C.E.

Excavated 1979, tomb of Lou Rui (died 570 C.E.),

Wangguo Village, Taiyuan, Shanxi Province

Glazed earthenware

Height 50.2 cm

Shanxi Museum, Taiyuan

鸡头壶

北齐朝（公元前550 – 577年），墓地年代为公元前570年

1979年出土于山西省太原市王国村娄睿墓

青釉器

高50.2 厘米

山西博物馆，太原

9. ORNAMENTAL PLAQUE

Northern Qi dynasty (550–577 C.E.), tomb dated 570 C.E.

Excavated 1979, tomb of Lou Rui (died 570 C.E.),

Wangguo Village, Taiyuan, Shanxi Province

Gold with turquoise, amber, and other semiprecious stones

and glass inlay

Length 15 cm; weight 33.6 grams

Shanxi Museum, Taiyuan

装饰牌匾

北齐朝（公元前550 – 577年），墓地年代为公元前570年

1979年出土于山西省太原市王国村娄睿墓

金丝装饰镶嵌着绿宝石，琥珀，珍珠，蛤壳，玛瑙，蓝宝石等多种颜色的珐琅

长32.6厘米； 重33.6克

山西博物馆，太原

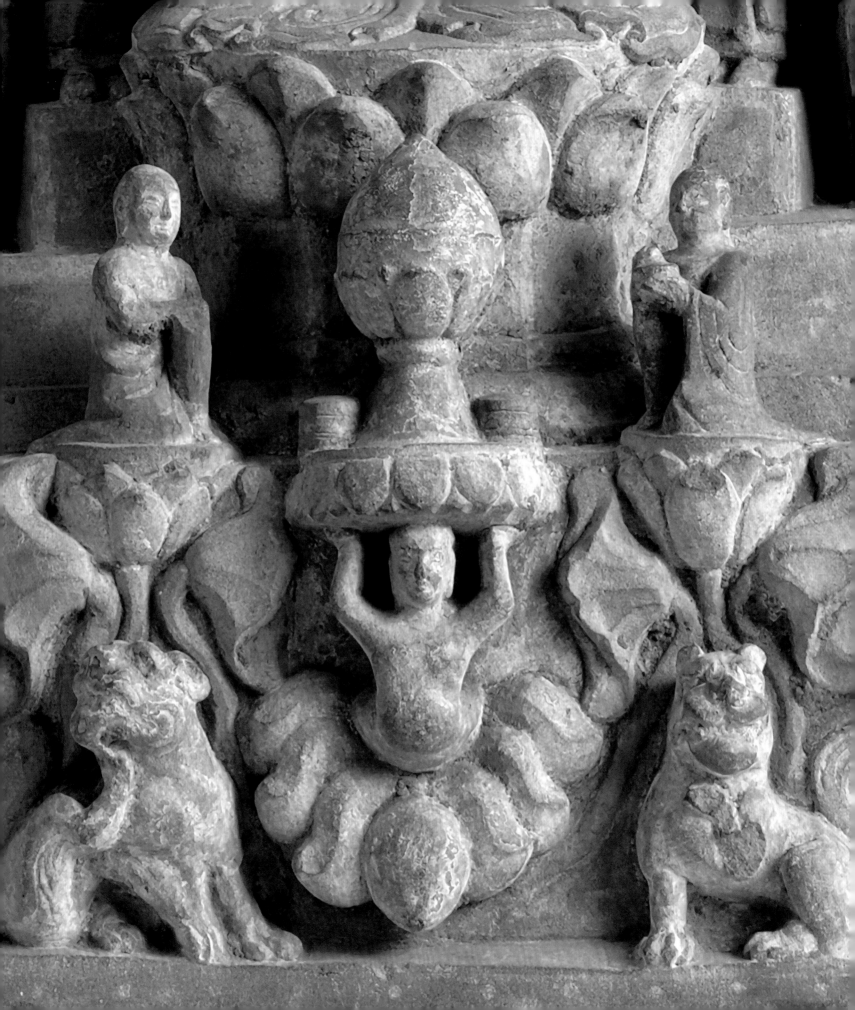

10. BUDDHIST STELE WITH SAKYAMUNI, MONKS, BODHISATTVAS, DEVOTEES, PATRONS, AND GUARDIANS

Northern Qi dynasty (550–577 C.E.)

Excavated 1954, Huata Monastery, Taiyuan, Shanxi Province

Sandstone with pigment and gilding

46 × 25.5 × 17.7 cm

Shanxi Museum, Taiyuan

佛教石碑刻有释迦牟尼，僧侣，菩萨，信徒，支持者和护卫者

北齐朝（公元前550 – 577年)

1954年出土于山西省太原市华塔寺

彩色镀金砂岩

46 x 25.5 x 17.7 厘米

山西博物馆，太原

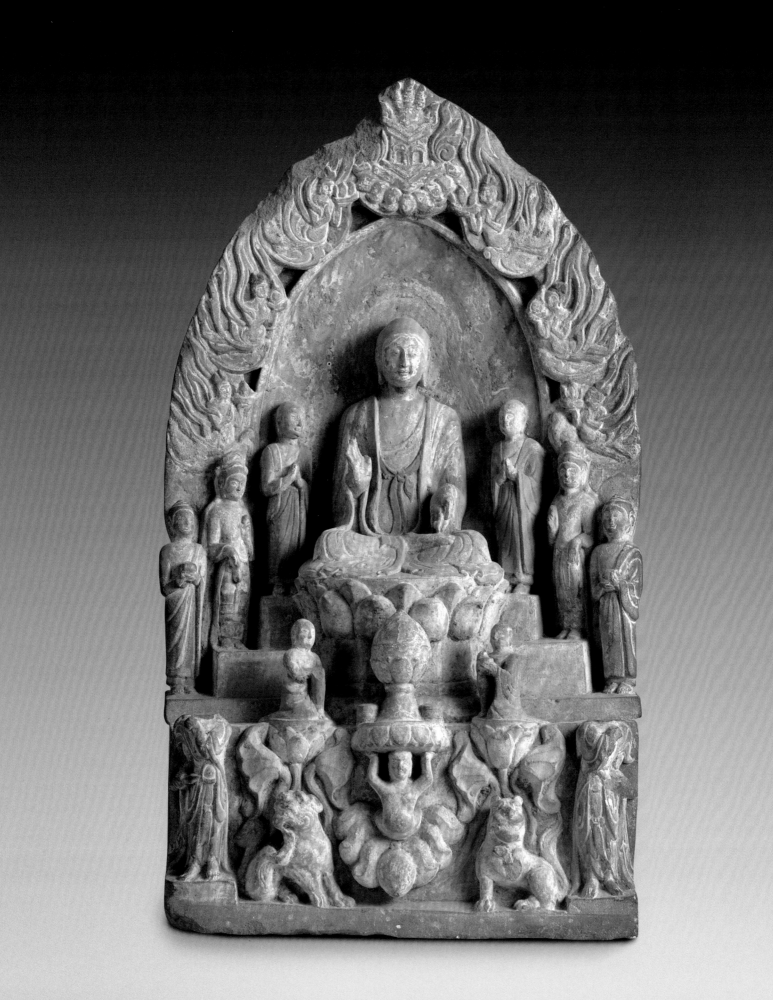

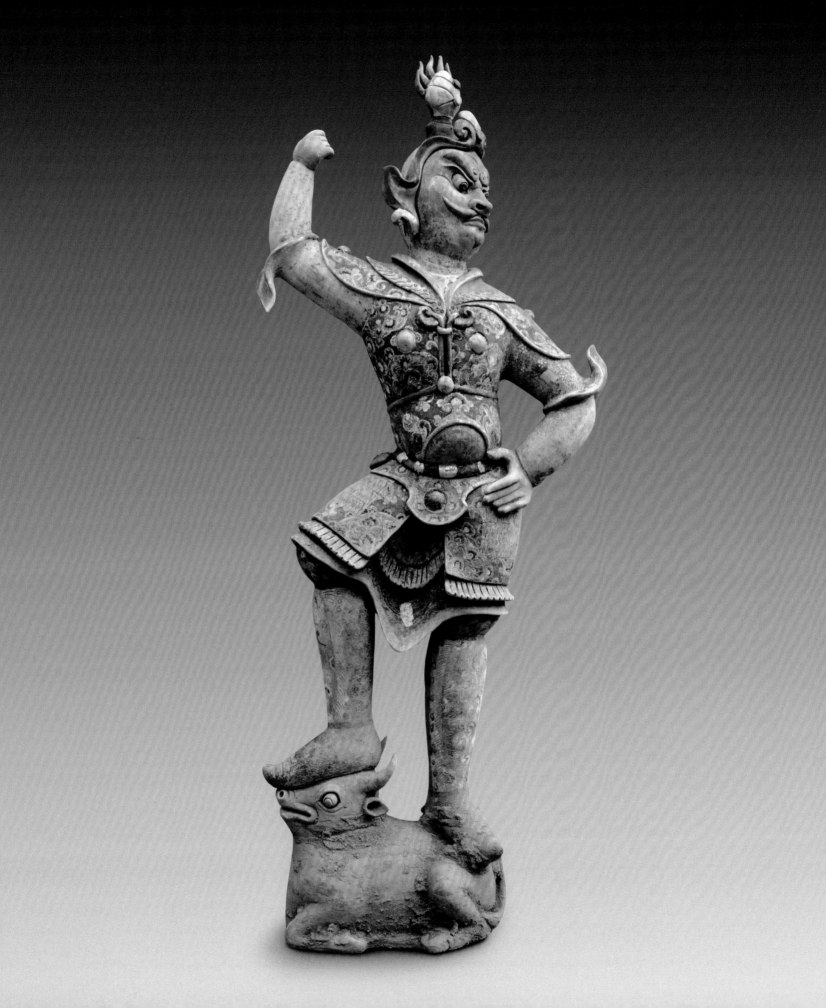

11. TIANWANG (HEAVENLY KING OR LOKAPALA, ONE OF A PAIR)

Tang dynasty (618–907 C.E.)

Excavated 2009, Tomb M2, Fujiagou Village,

Lingtai County, Gansu Province

Painted and gilt earthenware

Height 108 cm

Lingtai County Museum, Pingliang

———————————

天王 （天上的君王）

唐朝（公元前618 – 907年）

2009年出土于甘肃省灵台县富家沟村古墓M2

烤漆镀金陶器

高108厘米

灵台县博物馆，平凉

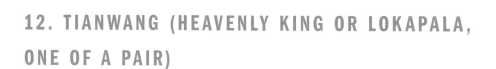

12. TIANWANG (HEAVENLY KING OR LOKAPALA, ONE OF A PAIR)

Tang dynasty (618–907 C.E.)

Excavated 2009, Tomb M2, Fujiagou Village,

Lingtai County, Gansu Province

Painted and gilt earthenware

Height 108 cm

Lingtai County Museum, Pingliang

天王 （天上的君王）

唐朝（公元前618 – 907年）

2009年出土于甘肃省灵台县富家沟村古墓M2

烤漆镀金陶器

高108厘米

灵台县博物馆，平凉

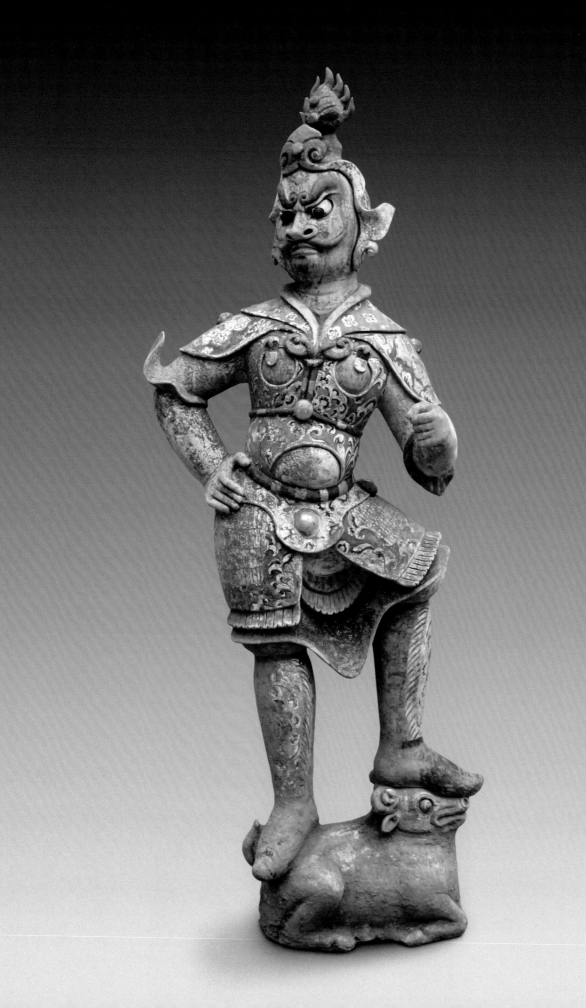

13. ZHENMUSHOU (TOMB-GUARDIAN BEAST, ONE OF A PAIR)

Tang dynasty (618–907 C.E.)

Excavated 2009, Tomb M2, Fujiagou Village,

Lingtai County, Gansu Province

Painted and gilt earthenware

65.7 × 30 cm

Lingtai County Museum, Pingliang

镇墓兽（护卫墓碑的野兽）

唐朝（公元前618 – 907年）

2009年出土于甘肃省灵台县富家沟村古墓M2

烤漆镀金陶器

65.7 x 30 厘米

灵台县博物馆，平凉

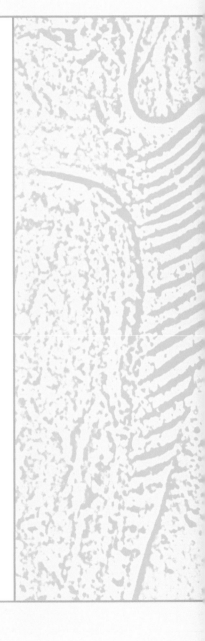

14. ZHENMUSHOU (TOMB-GUARDIAN BEAST, ONE OF A PAIR)

Tang dynasty (618–907 C.E.)

Excavated 2009, Tomb M2, Fujiagou Village,

Lingtai County, Gansu Province

Painted and gilt earthenware

65.7 × 30 cm

Lingtai County Museum, Pingliang

镇墓兽（护卫墓碑的野兽）

唐朝（公元前618 – 907年）

2009年出土于甘肃省灵台县富家沟村古墓M2

烤漆镀金陶器

65.7 x 30 厘米

灵台县博物馆，平凉

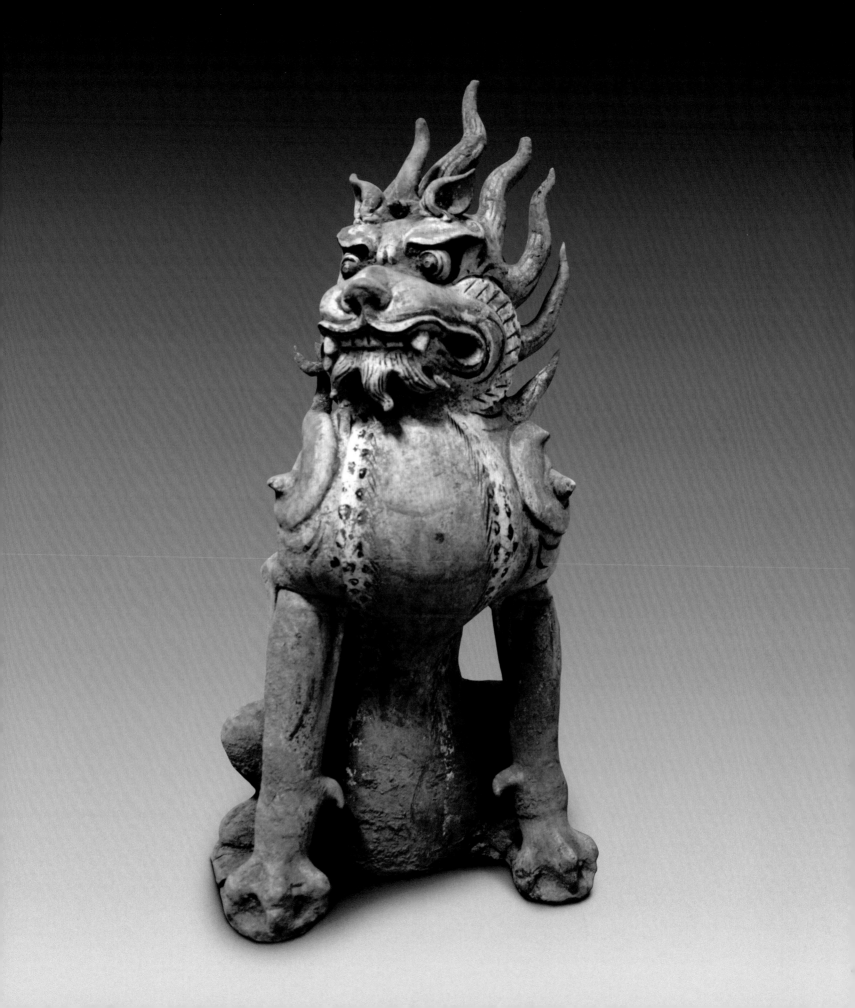

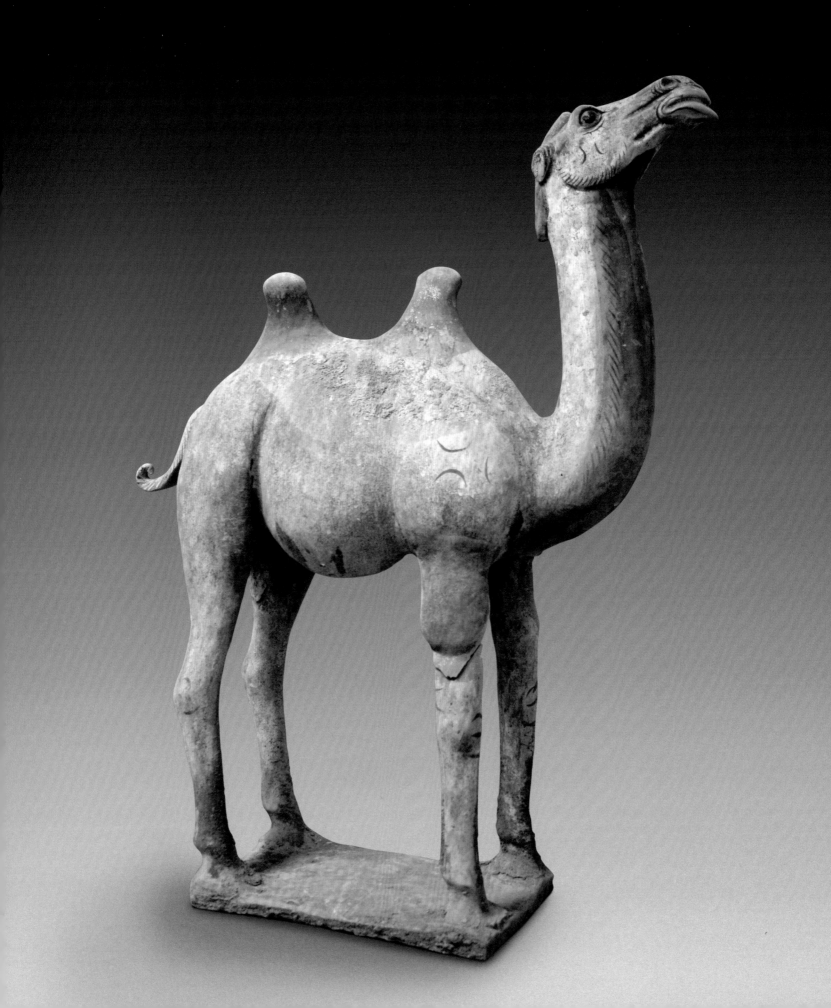

15. CAMEL

Tang dynasty (618–907 C.E.)

Excavated 2009, Tomb M2, Fujiagou Village,

Lingtai County, Gansu Province

Painted earthenware

72 × 58 cm

Lingtai County Museum, Pingliang

———

骆驼

唐朝（公元前618 – 907年）

2009年出土于甘肃省灵台县富家沟村古墓M2

烤漆陶器

72 x 58 厘米

灵台县博物馆，平凉

16. GROOM

Tang dynasty (618–907 C.E.)

Excavated 2009, Tomb M2, Fujiagou Village,

Lingtai County, Gansu Province

Painted earthenware

Height 57 cm

Lingtai County Museum, Pingliang

———————————

新郎

唐朝（公元前618 – 907年）

2009年出土于甘肃省灵台县富家沟村古墓M2

烤漆陶器

高57厘米

灵台县博物馆，平凉

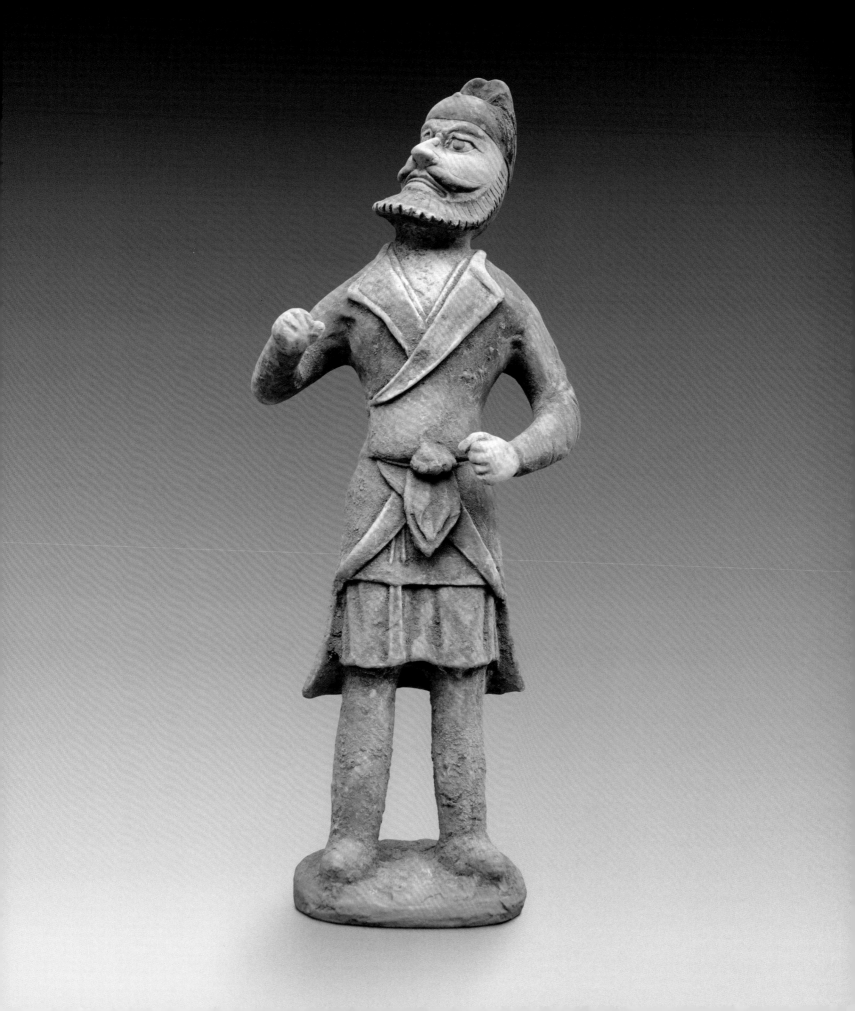

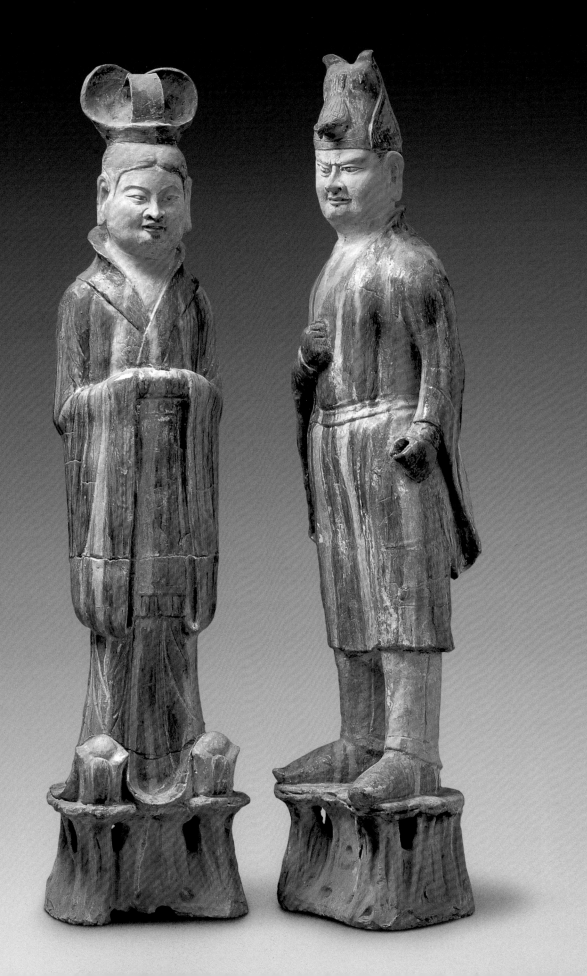

17. CIVIL OFFICIAL AND MILITARY OFFICIAL

Tang dynasty (618–907 C.E.)

Excavated 1965, tomb at Yejiabao, Qin'an County, Gansu Province

Three-color lead-glazed (*sancai*) earthenware

Height 133.5 cm and 135.5 cm

Gansu Provincial Museum, Lanzhou

文官俑和武官俑

唐朝（公元前618 – 907年）

1965年出土于甘肃省秦安县叶家堡

三色彩釉（三彩）陶器

高133.5厘米和135.5厘米

甘肃省博物馆，兰州

18. BUDDHIST RELIQUARY WITH THE PARINIRVANA AND ASCENSION OF THE BUDDHA

Five Dynasties period (907–960 C.E.)

Excavated in Lingtai County, Gansu Province

Painted and gilt stone

35.7 × 45.6 × 19.4 cm

Gansu Provincial Museum, Lanzhou

———————

与圆寂和升天有关的佛教圣物

五代时期 （公元前907 – 960年）

出土于甘肃省灵台县

彩色镀金石

35.7 x 45.6 x 19.4 厘米

甘肃省博物馆，兰州

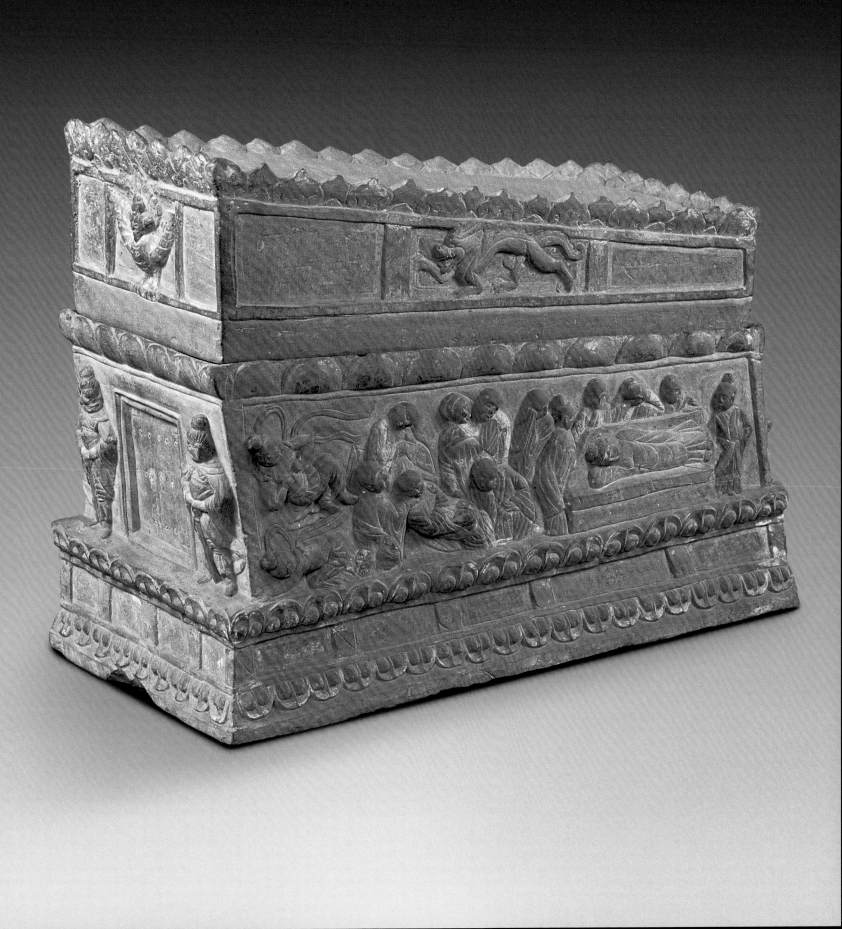

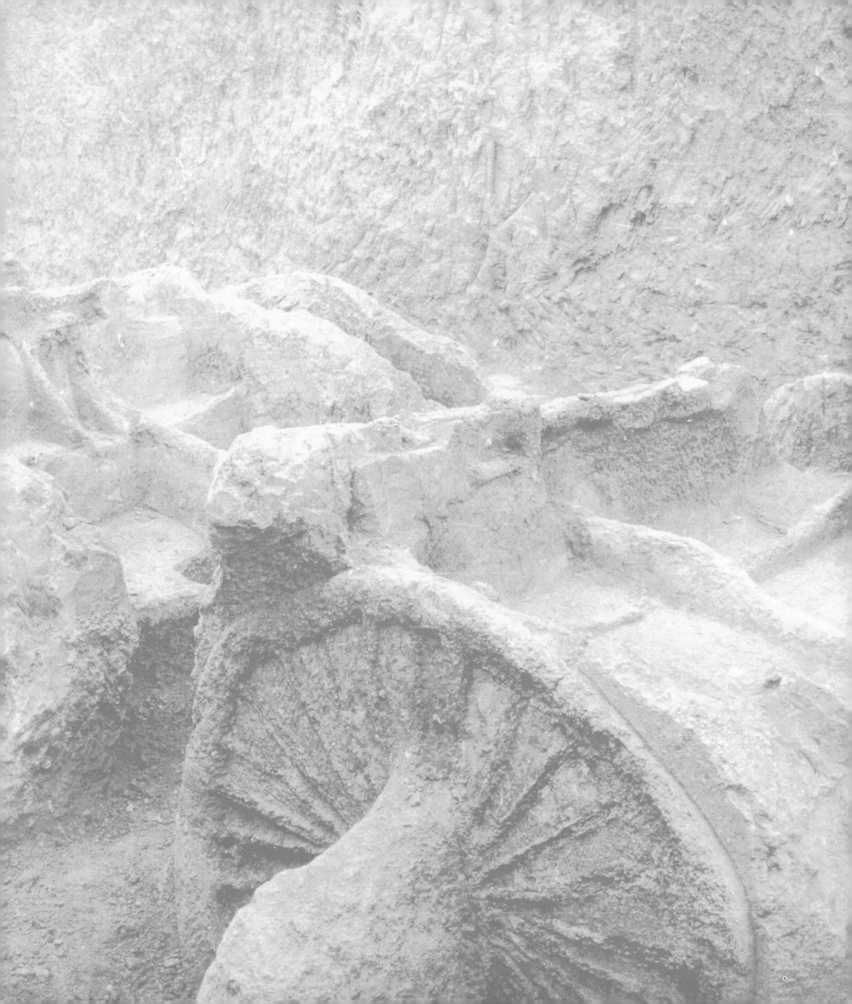

THE DEVELOPMENT OF ARCHAEOLOGY IN CHINA: A NINETY-YEAR JOURNEY

AN JIAYAO

ased on field studies, investigations, and excavations, archaeology emerged early in the twentieth century as a new scientific discipline. For centuries, however, Chinese scholars had pursued interests in studying ancient relics and sites. Epigraphy, the study of inscriptions, was well established in the Northern Song dynasty (960–1126), and centuries later it developed even further during the Qing dynasty (1644–1912). This early work in epigraphy laid the foundations for modern archaeology in China.

In 1898, oracle bones—ancient pieces of inscribed bone or shell used for divination—were found at Xiaotun Village, near Anyang City in Henan province. Two years later, in Gansu province, the caves found at Dunhuang Mogao Buddhist Grottoes attracted the attention of epigraphers when thousands of ancient manuscripts and cultural relics were found in a hidden sutra-storage cave. These two extraordinary discoveries, unprecedented in modern academic history and so close together in time, foreshadowed the birth of modern archaeology in China.

By the end of the nineteenth century, as the Qing dynasty was on the verge of collapse, explorers and expeditions from England, France, Germany, Japan, Russia, and Sweden entered China for many different purposes, including field surveys and excavations at historical sites. With them came knowledge of modern archaeology, and it began to spread throughout China. The Xinhai Revolution in 1911 ended the Qing dynasty and imperial rule in China. During this period, modern biology and geology were established in China, and a number of the members of a new generation of young Chinese scholars even left home to study abroad.

Just prior to 1920, the Chinese government began to invite foreign scholars and institutions to come to China and collaborate on archaeological fieldwork. In 1918, Swedish geologist and archaeologist Johan Gunnar Andersson (1874–1960), already in China as a mining advisor to the government, discussed joining the Chinese National Geological Survey in its work collecting prehistoric vertebrate fossils.

Andersson worked closely with Chinese scholars Ding Wenjiang (1887–1936) and Weng Wenhao (1889–1971). In 1921, Andersson and his Austrian assistant Otto Zdansky (1894–1988) found Dragon Bone Hill (Longgu Shan) at Zhoukoudian, near Beijing, and there they also unearthed a fossil of a humanlike mammal's tooth. That same year, Andersson also found remains of Neolithic-period painted pottery at Yangshao Village in Mianchi county, Henan province. The remains occasioned the naming of Yangshao culture (about 5000–3000 B.C.E.) after the village where they first were excavated. Andersson believed that Yangshao culture existed throughout ancient China and was the precursor of later Chinese culture, and at that time Chinese scholars unanimously confirmed Andersson's findings.

The discovery of Yangshao culture had an enormous impact in China. In 1936, Li Ji (1896–1979), who is considered the founder of modern Chinese archaeology, published "The Past and Future of Archaeology in China," in which he wrote:

> One friend's personal story would give people some background knowledge about the development of Chinese archaeology. My friend was a high school history teacher 10 years ago, at the time that the discovery of Paleolithic and Neolithic sites in Henan was made public. Rather than teaching the Chinese Emperors, my friend began to talk about the Stone Age and Bronze Age cultures in his class. Instead of showing appreciation for his efforts, the students thought he was joking and all laughed at him. Unable to continue his teaching, he quit his job. Ten years later, much had changed, and many grade school students knew and understood the term Stone Age.[1]

With the recognition of Yangshao culture, the origin of ancient Chinese civilization became the most important and hotly debated question for scholars. Andersson continued his field studies and excavations in Henan, Shanxi, Gansu, and Qinghai provinces, with the intention of connecting the Yangshao culture with the Near East and Central Asia. His hypothesis that Yangshao culture came from the West, however, brought him face to face with serious political criticism. Andersson's tremendous contribution to Chinese archaeology was officially recognized in 1985, at the sixty-fifth-anniversary Yangshao Culture Conference held at Mianchi.[2] Then, twenty-six years later, on 6 November 2011, at the opening ceremony of the ninetieth-anniversary conference, statues were unveiled of four famous archaeologists—Andersson, Yuan Fuli (1893–1987), Xia Nai (1910–85), and An Zhimin (1924–2005).

Some scholars date the birth of archaeology in China to either 1926 or 1928. Shortly after Li Ji completed his study of anthropology in the United States and returned to China in 1926, he became the first Chinese leader of a joint Sino-American archaeological project, which was at Xiyin Village, Xia county, Shanxi province. Then, in 1928, the National Academy of Science's Institute of History and Philology was founded, and within it an archaeology research group was established. As the only Chinese scholar equipped with knowledge of modern archaeology and field excavation, Li Ji was appointed director of the institute's archaeology group the following year. In October 1928, Dong Zuobing (1895–1963) was sent to the small village of Xiaotun in Anyang City to conduct a survey and test dig in preparation for a large-scale excavation. Over the following twenty years, Li Ji and Liang Siyong (1904–54) jointly led the archaeology group, which conducted fifteen excavations at the late–Bronze Age capital of the Shang dynasty (about 1500–1050 B.C.E.), Yinxu, Anyang, with a total area of about 114 acres (460,000 sq. m). The group also uncovered and cleaned more than fifty rammed-earth architectural foundations and many tombs and sacrificial burial pits, some of which belonged to the imperial mausoleums of the Shang dynasty. A large number of oracle bones and other cultural relics also were found during this work (fig. 65).

Figure 65 Shang-dynasty Tomb 1001 at Yinxu, Houjiazhuang, Anyang county, Henan province

Liang Siyong had left China in 1923 to study anthropology and archaeology at Harvard University, and when he graduated in 1930, he returned to join the archaeological work recently initiated by the Institute of History and Philology. In 1931, he led the excavation at the Hougang site at Yinxu, where he discovered "three overlaying strata"—the remains of the famous Shang, Longshan (about 3000–1700 B.C.E.), and Shaoyang cultures that actually were layered one on top of the other. This find resolved the relative chronology among these three early cultures and marked the first use of stratigraphy for the study of ancient Chinese culture.[3] Liang Siyong made a great contribution to archaeology in China, but unfortunately he died at an early age, succumbing to the tuberculosis he contracted during his years of rough outdoor working conditions.

On 2 December 1929, archaeologist and anthropologist Pei Wenzhong (1904–82) unearthed a fossilized human skull during an excavation at Zhoukoudian, Beijing (fig. 66). This finding, which became known as Peking man, shocked the entire academic world, and it also came to be considered one of the greatest achievements during the early years of modern archaeology. Another significant contribution made by Pei was the confirmation of Old Stone Age (Paleolithic) wares and the ashen remains of fires at Zhoukoudian. In 1934, Pei published his accounts of the survey and excavation at Zhoukoudian, in which he recorded the details of his archaeological work at that site between 1928 and 1933.[4] Although it was a book of science, Pei also included an introduction to the Zhoukoudian area, in which he described the natural setting, scenery, and climate as well as local transportation, business, and industries. He also expressed his sympathy for the region's poor laborers, saying "their life was in hell."[5]

CHINESE ARCHAEOLOGY'S RAPID DEVELOPMENT, 1950–66

Upon the establishment of the People's Republic of China in 1949, the new government issued laws concerning the protection of antiquities and ancient cultural relics and established government-run organizations charged with working with archaeological study within the country. A branch of the Ministry of Culture, for example, the Bureau of Cultural Relics, was formed to oversee and administer programs whose mission was the protection of cultural relics across the nation. Under the auspices of the Academy of Sciences, the Institute for Archaeology was devoted to research in the discipline. Each administrative area had its own Cultural Property Administrative Committee, which was charged with the care of regional cultural properties and undertaking salvage excavations prompted by

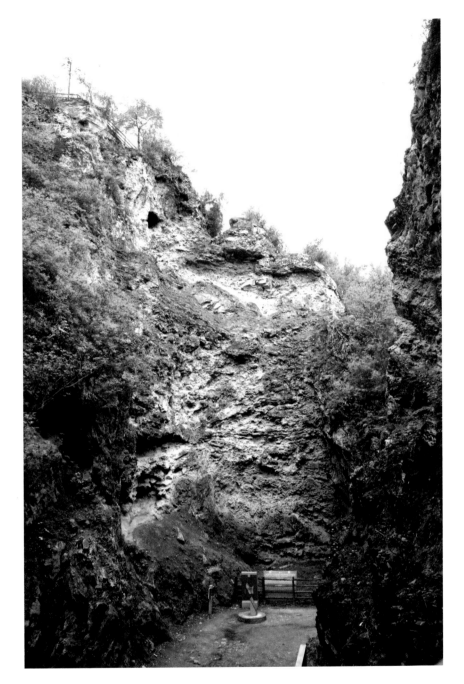

Figure 66 Site at Zhoukoudian, near Beijing, where the fossilized skullcap of what came to be known as "Peking man" was unearthed in the cave

construction projects. New explicit regulations limited excavation work to only those organizations that were deemed suitable for field archaeology and then only after they had obtained approval from both the Ministry of Culture and the Academy of Sciences. Thus, a system was formed aimed at protecting cultural properties and overseeing field archaeology, and this paved the way for future development of archaeological work in the new China.

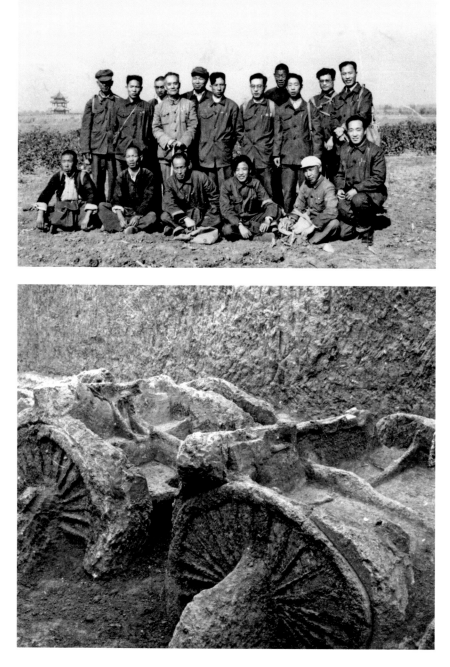

Figure 67 Archaeological team in 1950 at Liulige, a fourth-century B.C.E. site in Hui county, Henan province

Figure 68 Wooden chariots dating to the fourth century B.C.E. or the Warring States period, unearthed in Hui county, Henan province

From 1952 to 1956, three hundred archaeological staff members attended short-term archaeology-training classes presented by the Central Ministry of Culture, the Chinese Academy of Sciences, and Beijing University, which had established its own archaeology major and taken on the mission of training a new generation of specialists. Soon, archaeological science began to develop even more rapidly in China. After having been suspended for about ten years, in 1950 the excavations at Yinxu and Zhoukoudian resumed. In October, Xia Nai led the field excavation at Liulige in Hui county, Henan province (fig. 67). He and his team successfully uncovered the remains of wooden chariots (fig. 68) that dated to the Warring States period (475–221 B.C.E.).[6]

Many of the archaeological excavations in China were undertaken alongside the national infrastructure projects. In October 1955, for example, an archaeology team was formed in conjunction with the water conservancy project to harness and utilize the Yellow River. Xia Nai served as team leader and An Zhimin was vice-leader. A survey of the Sanmenxia area resulted in the discovery of more than 300 ancient ruins, including 211 sites. An Zhimin led his team in a large-scale excavation at Miaodigou site of Shan county in 1956. They unearthed 280 pits over a total of 5,380 square yards (4,480 sq. m; fig. 69). This excavation established the existence of Miaodigou culture II (3000–2500 B.C.E.) and revealed that this site was transitional, which clarified the sequence of development of the earlier Yangshao and later Neolithic Longshan cultures. Consequently, it is ranked among the most important achievements in Chinese archaeology.[7]

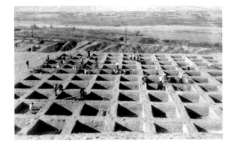

Figure 69 Excavations at the Neolithic site of Miaodigou II (3000–2500 B.C.E.), Shan county, in Henan province, 1956

Of the seventy-five people who participated in the Miaodigou excavation, two-thirds were experiencing their first actual excavation. The excavation sites—which also included Sanliqiao—were on farmland on either bank of the Jian River, not far from the Yellow River. The working conditions were very difficult, but the excavators were enthusiastic and remained upbeat, even making jokes, such as "listening to the roar of the Yellow River by day; hearing the howl of the wild wolves at night." After they had completed this excavation training, most of the team members went on to become leading archaeologists in China. The Miaodigou excavation added a significant chapter to the history of Chinese archaeology, whether from the perspective of the site's large scale, the training of young archaeologists, or the overall scholarly achievement. The report—"Miaodigou and Sanliqiao," first published in 1959, was republished in 2011 in Chinese and English to honor this major archaeological achievement.

From 1951 to 1952, during repair of the Baisha reservoir in Henan province, archaeologists excavated and salvaged ancient sites and tombs situated around the reservoir. The Baisha tombs—three large tombs built in the late Song dynasty (960–1276) for members of the same clan—was an important discovery.

While Tombs 2 and 3 contained no dated inscriptions, based on the two found in tomb 1, it can be dated to 1099, during the Northern Song dynasty (960–1126). A comparison of burial objects among tombs suggests that 2 and 3 were built after Tomb 1, probably during Emperor Huizong's reign (1101–25). The brick murals in the three tombs were quite well preserved, and have the most complicated compositions and richest contents ever found among the many known tombs with brick sculptures and murals. Of the three, Tomb 1—that of Zhao Daweng—was the

best preserved. Brick tombs, a popular form of burial initiated in northern China, evolved after the Tang dynasty (618–907) and the Five Dynasties period (907–60). The archaeological report on the Baisha Song tombs, written by Su Bai and published in 1957, not only is an objective, accurate, and complete excavation report, but it also is a feat of exceptionally fine research.[8] By using text and literature to facilitate and elucidate archaeological research, Su Bai has set an excellent example (fig. 70). His work combines historical texts with the study of archaeological materials, and by linking the two complementary disciplines, he offers an exemplary approach to obtaining information for the study of ancient society.

In the 1950s, the periods targeted for archaeological studies expanded greatly. In addition to continued excavations of prehistoric sites, surveys of many ruins dating to several more recent historical periods, particularly important ancient capital cities, began to be conducted. As political, economic, and military centers, capitals were naturally also the foci for national talent and advanced culture and technology, making them reflections of the highest achievements of a given society and important components of the Chinese cultural heritage. Ancient capitals usually occupied large areas of land ranging in size from less than 1 to nearly 4 square miles (1 to 10 sq. km). Today, these cities usually are buried beneath their modern counterparts that have been built on top, so in surveying an ancient capital, archaeologists start by assessing its overall layout,

Figure 70　The author with Professor Su Bai at the Tallin Pagoda Forest, Changping, Beijing, June 2011

defining the positions of the city wall and its gates. Based on the locations of the gates, one can ascertain placement of the major roads and significant architectural ruins. These surveys have yielded crucial data about the evolution of the city plan at the same time as they have helped plan for the sites' preservation. Among the capital cities surveyed are Fengxi and Zhouyuan in Shaanxi province; six cities that served as capitals during the Warring States period; and those of the Han and the Tang dynasties. In 1961, the state council designated the first group of historical cultural heritage sites, among them the Shang capital at Zhengzhou; the Han-dynasty city of Chang'an (modern-day Xi'an in Shaanxi); Luoyang, Henan province, which was capital for both the Han and Wei dynasties; and the Tang-dynasty Daming Palace outside Xi'an, each of which has received serious archaeological study.

The Han dynasty was one of the most prosperous periods in Chinese history and a formative period for the ethnic-Chinese people. As well as being the political, business, and cultural center of the country during the Han, after Zhang Qian's (200–114 B.C.E.) mission to the West in 139 B.C.E., the capital city Chang'an also became the starting point of the Silk Road. Founded in 202 B.C.E., Chang'an is located just short of 2 miles (3 km) northwest of present-day Xi'an's urban center. Surveys of Chang'an City commenced in 1956 and have revealed its overall layout, the structure of the city walls and moat, the shapes and positions of its gates, and the location of the main streets, market places, and palaces. Chang'an City occupied almost 14 square miles (36 sq. km), with walls made of rammed earth measuring between 39 and 52 feet (12 to 16 m) in width and nearly 40 feet (12 m) in height; outside the wall, the moat was 26 ¼ feet (8 m) wide and close to 10 feet (3 m) deep. Chang'an's perimeter described an irregular square, with three gates on each of the four sides and three entrances at each gate. Eight straight roads crossed the city, and during the second year of the reign of Han Emperor Ping (reigned 1–5 C.E.), the population numbered 246,000.[9]

From 1949 until 1966, Chinese archaeology was internationally engaged. Xia Nai, director of the Institute of Archaeology of the Chinese Academy of Sciences from 1962 to 1982, maintained contact with many archaeologists around the world and kept abreast of the latest technologies, such as radiocarbon dating, which emerged in the early 1950s and was hailed as a revolutionary tool for the study of prehistory.[10] China's first laboratory for carbon dating was established in 1965.

The Cultural Revolution—the damaging political movement launched and led by Mao Zedong—lasted from May 1966 to October 1976, and it resulted in near disaster for China. On many fronts, the movement caused the most severe setbacks and losses since the founding of the People's Republic of China in 1949, and the discipline of Chinese archaeology did not escape harm. Various research projects were suspended, and most of the professional archaeologists were forced to do physical labor in Henan.

In the 1960s, the relationship between the Soviet Union and China deteriorated, and the Soviets reinforced their troops near the Sino-Soviet border. The Chinese army also expedited their defensive preparations and began building military facilities in the mountains, which led to accidental discoveries of ancient tombs. The famous tombs of Mancheng in Hebei province, and those of Mawangdui in Hunan, were uncovered in this way.

On 22 May 1968 soldiers detonated explosives in the Ling Mountains, close to 1 mile (1.5 km) southwest of Mancheng county, and created a huge hole that exposed a large cavern with many artifacts. The military project was halted immediately, and the army reported the finding through the many layers of bureaucracy, finally reaching the central government and the state council in early June. On 18 June, during a break before a state banquet, Premier Zhou Enlai mentioned the Mancheng tomb to Guo Moruo (1892–1978), president of the Chinese Academy of Sciences, and asked him to follow up. Guo was an outstanding scholar, who made considerable contributions in the areas of literature, history, and scripts in ancient writing. He formed an excavation team composed primarily of archaeologists from the academy's Institute of Archaeology, and they went to Mancheng on 25 June, when the excavation led by Lu Zhaoyin (born 1927) began immediately (fig. 71).

In 1968, when some factions in the Baoding area, where Mancheng is situated, became violent, the archaeologists arranged to lodge in the army's headquarters for their own safety. Soldiers took over the responsibilities of safeguarding the site and did all the tedious on-site cleanup work. With the assistance of young, strong soldiers, the excavation moved forward quickly, and afterward, the soldiers who had been involved wrote an article highlighting their role in this important excavation.[11]

Based on the Mancheng tomb structure, artifacts unearthed, and historical texts, the tomb occupant was determined to be Liu Sheng, Prince Jing of Zhongshan of the Western Han dynasty (206 B.C.E.–C.E. 9). Given the Han custom of

joint burials of husband and wife, the archaeologists searched for and found the tomb of Dou Wan (died 104 B.C.E.), Liu's wife, as well, which was located on the south side of the mountain. These two tombs were the largest, best-preserved palacelike mountain burials ever found in China. In 154 B.C.E. Liu Sheng, brother to Emperor Wu (reigned 141–87 B.C.E.) of the Western Han, was given the fief of Zhongshan by his father, Emperor Jing (reigned 156–141 B.C.E.). After 42 years as prince of Zhongshan, Liu Sheng died in 113 B.C.E.

Built into the mountain, both tombs were nearly identical in layout, with covered passageways and southern, northern, central, and rear chambers. The central chambers were furnished with a wood-structure tile house and storehouse, which together formed a functional and elaborate underground palace that housed an extravagant collection of some four thousand objects in gold, silver, jade, stone, bronze, and iron. Among the nineteen bronze lamps found was a Changxin Palace lantern and a gold-inlay, hill-shaped censer. The two complete *Jin Lu Yu Yi* (jade suits sewn with gold thread), the first such discovery in China, are world famous today. The one in Liu Sheng's tomb measures 74 inches (1.88 m) in length and required 2,498 pieces of jade and 1,100 grams of gold thread; Dou Wan's is 67 ¾ inches (1.72 m) long and is made of 2,160 pieces of jade and 600 grams of gold thread.[12]

The discovery of the Mancheng Han tombs was one of the most exciting cultural events in China, and it attracted attention nationwide. Despite his advanced age, Guo Moruo made a special trip to inspect the site, and Premier Zhou asked

the Central News and Documentary Film Studio and Beijing TV to film a documentary at the site (fig. 72).[13]

The Mawangdui tombs in Hunan province were also found by chance. During construction of an underground army hospital at Mawangdui, the structures often collapsed, and malodorous gas leaked from the drilled holes. When ignited, the gas showed a blue flame, bringing the Hunan Provincial Museum in Changsha City to conclude quickly that the site housed an ancient tomb. In January 1972, a joint team of archaeologists from the museum and Chinese Academy of Sciences' Institute of Archaeology began work at Mawangdui. The three early Western Han-dynasty tombs subsequently excavated were those of Prime Minister Daihou Licang (died 186 B.C.E.), his wife (died about 168 B.C.E.), and his son (died 168 B.C.E.). Although buried for more than 2,100 years, the female corpse discovered in Tomb 1 remained in remarkable condition, to the point that some muscles at joints retained elasticity. In addition, most of the more than three thousand precious relics unearthed from the tombs were well preserved. Among them are five hundred refined lacquers, which are magnificently patterned and vibrantly colored; these are the best-preserved lacquers of the Han dynasty and make up the single largest quantity unearthed in China. Also found in Tomb 1 was a variety of finely woven silk fabrics and garments—including gauze, brocade, and damask as well as others—all in excellent condition. One exquisite silk garment was as light as mist and thin as cicada wings. Two silk medical manuscripts and two silk maps were also unearthed from these tombs, a surprisingly important and unexpected trove of ancient manuscripts and classic texts.

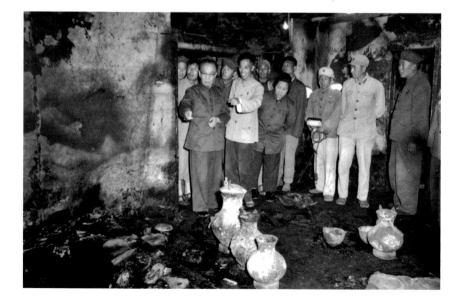

Figure 72 In 1968 Guo Moruo, president of the Chinese Academy of Sciences, visited the excavations at Mancheng; here he is shown a bronze vessel belonging to Liu Sheng and unearthed from Tomb 1

The treasures from the Mancheng and Mawangdui Han tombs instilled great pride of their rich cultural heritage in the Chinese people. The government decided to reinstate publication of three archaeology magazines: *Kaogu* (Archaeology), *Wenwu* (Cultural relics), and *Acta Archaeologica Sinica*. In this barren period in modern-Chinese history, the reinstatement of these journals was received eagerly. *Kaogu* alone printed close to ten thousand copies for each issue.

The discovery of the burial site of Emperor Qin Shihuangdi with his army of terracotta warriors and horses at Xi'an in 1974, followed by the 1976 finding of the tomb of Fu Hao, consort of the Shang-dynasty king, Wu Ding (about 1238–1180 B.C.E.), at Yinxu, Anyang, Henan province, marked the end of the archaeological work accomplished during the Cultural Revolution.

ECONOMIC REFORMS OPEN A NEW ERA IN ARCHAEOLOGY, 1977–2000

Once the Cultural Revolution ended in 1976, economic reforms coupled with a policy of greater openness created opportunities for a new era in Chinese archaeology. About ten colleges and universities instituted concentrations in the discipline. In 1977, the discovery of the Peiligang culture (about 6500–5000 B.C.E.) confirmed the origin of Yangshao culture and reset the previously accepted date for the start of the Neolithic period. In April 1979, the founding of the Chinese Society of Archaeology at Xi'an marked a milestone in the development of Chinese archaeology (fig. 73).

During this period, cooperative and joint research and excavations with non-Chinese archaeologists represented a major shift in the discipline as practiced in China. Due to the previous removal of so many ancient treasures by outsiders in the first half of the century, which badly damaged Chinese self-esteem, starting in 1949 and continuing for nearly thirty years, foreigners had been prohibited

Figure 73 The original officers of the Chinese Society of Archaeology are shown together in this photograph made just before the society's formal establishment (*from left*): President Xia Ding, Vice President Pei Wenzhong, and Secretary General An Zhimin

from joining any archaeological excavations in China. The first joint research began late in the 1970s, when foreign students were first permitted in the archaeological department of Beijing University. These students from Germany, Japan, and the United States were excited beyond words as they—together with Chinese students and the author—participated in an excavation season at Zhucheng Qianzhai of Shandong in 1980. Lothar von Falkenhausen, a professor at the University of California, Los Angeles, and Sugaya Fuminori, director of Japan's Archaeological Institute of Kashihara, in Nara, were among these students. This open policy has encouraged more contacts between Chinese archaeologists and the outside world, including other joint archaeological excavations (fig. 74).

In May 1977, what had been the Department of Philosophy and Social Sciences of the Chinese Academy of Sciences was established as its own entity, which was named the Chinese Academy of Social Sciences (CASS), and the Institute of Archaeology transferred with it. Shortly thereafter, archaeologists from the institute discovered at Shangqiu, Henan province, a large cache of domestic objects and production tools made of stone, pottery, bone, and clamshells dating to the Longshan culture. It indicated that human habitation existed in the Shangqiu area about four thousand years ago.[14] Since the 1990s, archaeologists from the institute and the Peabody Museum of Natural History at Harvard University conducted a nine-year-long archaeological survey and excavation at Shangqiu. Before then, Chinese archaeologists considered the Shang cities in Zhengzhou and Yanshi to have been the capitals of the Shang dynasty, established by Emperor

Figure 74 During his visit to the Institute of Archaeology in 1981, Robert Brill of the Corning Museum of Glass made this photograph of (*from left*) the author, Xia Ding, and Lu Zhaoyin

Figure 75 Harvard's Professor Kwang-chih Chang (*facing camera*) and China's team leader of the Shangqiu excavation, Zhang Changshou (*right*), examine part of the site

Shangtang (died 1588 B.C.E.), but they were not sure of the origins of the Shang culture. Kwang-chih Chang, a Harvard professor, boldly predicted that Shangqiu could be the birthplace of the Shang culture. This Sino-American archaeology team expanded the Shangqiu investigation to excavate the Panmiao site in Shangqiu county, the Mazhuang site in Yucheng county, and the Shantaisi 2 site in Zhecheng county, during which they discovered two rammed-earth architectural sites and other sites and remains from the Longshan culture. They also found the site of the Song capital (fig. 75) of the Eastern Zhou dynasty (770–221 B.C.E.). Because the flooding of the Yellow River had buried the ancient ruins at Shangqiu with a thick layer of earth, ground-penetrating radar was used to assist with the archaeological reconnaissance. This collaboration of Chinese and American archaeologists in this area east of Zhengzhou has yielded important data for the exploration of cultures ranging from the Longshan culture to the Eastern Zhou period.[15]

With origins in the second century B.C.E., the Silk Road connected east and west in trade and cultural interaction for centuries. The point linking the north and south has been situated from ancient times at the crossroads of the Loess (Huangtu) Plateau in Shaanxi, Gansu (Longxi), Guyuan, and Ningxia provinces, and Guyuan became an important meeting place and transfer station on the Silk Road. Since the 1980s, the archaeological department of the Ningxia Hui Autonomous Region has excavated dozens of ancient tombs from the Northern Wei (386–535), Northern Zhou (557–81), Sui (581–618), and Tang dynasties and yielded valuable data.[16]

In July 1995, Chinese and Japanese archaeologists signed an agreement to conduct joint archaeological work at Yuanzhou (the ancient Guyuan), where they intended to excavate one tomb in 1995 and another the following year, with Su Bai, a professor at Beijing University, as an advisor. The archaeological team started their first excavation at a previously robbed site at Xiaomazhuang Village, where they found the epitaph—with a very well-preserved, twelve-character inscription—recording the lives of the tomb's occupants, Shi Daoluo (590–655) and his wife, Kangshi (591–646). Shi's father, Shi Shewu (died 610), a general of the fourth grade who had served the Sui court, was also buried nearby. The two members of the Shi family were descendants of Sogdians, who emigrated from Central Asia. Kangshi, born in Samarkand, was a descendant of the Kang State and also from Central Asia. The tomb chamber yielded almost one hundred objects, including pottery figurines, white porcelain vases and bowls, Eastern Roman (or Byzantine) coins, and bronze mirrors. Two pairs of terracotta guardians flanked the tomb door, each pair including one *zhenmushou* (tomb-guardian beast) and one warrior, both painted with beautiful colors and gilt. These pairs are outstanding examples of terracotta figurines from Sui and Tang tombs.[17]

One year later, the Sino-Japanese archaeological team began excavation of a tomb at Dabao Village, Guyuan county, in Hebei province. Although it also had been robbed, archaeologists once again found the epitaph that identifies the tomb's occupants: Tian Hong (510–75), "Northern Zhou Pillar of State, Grand General, and Governor of Yuanzhou," and his wife. Tian Hong, a very influential person in the Northern Dynasties, was recorded in the *Book of Zhou* and the *History of the Northern Dynasties*. Five Eastern Roman gold coins found in this tomb offered solid evidence of early interaction between the East and the West.[18]

The Sino-Japanese Yuanzhou Joint Excavation Team demonstrated meticulous working methods. They paid close attention to removal of soil and the cavities' refilling afterward, during which they also filled the holes made by the robbers. They were especially cautious in recording ephemeral traces, such as the motifs on the lacquered wooden handle for a gauze crown and a mother-of-pearl screen that were found. As a result of this delicate and careful work, some complete designs could be restored.

Another major initiative, the five-year Xia-Shang-Zhou Chronology Project, began in 1996. This effort to date the three historical Bronze Age periods of the Xia (about 2070–about 1600 B.C.E.), Shang, and Zhou (1050–221 B.C.E.) dynasties adopted methodology that called for work in the natural sciences and liberal arts

as well as collaborations among multiple disciplines. More than two hundred professionals representing nine disciplines and twelve academic majors—including historians, astronomers, and archaeologists—worked together to establish a series of relative dates and phases. Radiocarbon dating, including traditional radioactive decay and accelerator mass spectrometry, was the primary scientific technique employed. The Xia-Shang-Zhou Chronology was published in 2000.[19] Some foreign scholars have issued critical reviews and brought up disputes, but new archaeological discoveries and further research will serve to help perfect the chronology.[20]

MAKING ARCHAEOLOGY ACCESSIBLE TO THE PUBLIC, 2001–12

In times when providing adequate food was a major worry in China, archaeology mattered only to scholars. I attended the thirtieth-anniversary celebration for the discovery of the Neolithic Peiligang culture in Xinzheng, Henan province, in September 2007. There I met with the organizer, Jin Baoqin, director of the Cultural Relics Bureau of Xinzheng, who told me that Peiligang Village was her hometown. She was a little child following the crowds in the late 1970s, when the excavation team was working there. Villagers laughed at the archaeologists, saying, "These archaeologists are fools, digging not for food but for tiles." In the popular view at the time, food was of primary importance. Despite this, however, it was the excavation scenes in Jin's childhood memory that led her to select a major in archaeology when applying to Zhengzhou University.

With the rapid economic development of the twenty-first century, China is no longer a poverty-driven country, and its people have begun to re-explore spiritual and cultural pursuits, as they look for answers to time-honored, contemplative questions such as Who am I? Where did I come from? and Where shall I go? Archaeology, devoted to the mission of revealing and studying the human past, offers some answers.

In 2002 the National Geographic television channel in the United States presented a live program that allowed viewers to witness the opening of a sarcophagus from a pyramid in Egypt. Soon after, similar programs produced by Chinese television studios broadcast live coverage of archaeological excavations in China, including the Leifeng Pagoda of Hangzhou, Zhejiang province; tombs at Jiuliandun, Hubei province; the Daqingdun Han tomb in Jiangsu province; two Zhou-period tombs at Liangdai Village, Hancheng, in Shaanxi; and the Underground Palace of the Grand Bao'en Monastery in Nanjing, Jiangsu province. With the

announcement of major excavations occurring seemingly one right after another, news media have also begun exhibiting a great enthusiasm that never was evident before. Archaeology today is neither the unfamiliar nor strange discipline to the Chinese people it was not so long ago.

The successful 1987 excavation of the Sanxingdui site in Sichuan province and the subsequent discovery of two sacrificial pits opened the door to unearthing the history of the ancient Shu kingdom (about 1046 B.C.E.–about 316 B.C.E.). In the spring of 2001, the discovery of the Jinsha site at Chengdu, Sichuan province, further shortened the perceptual distance separating the modern world from the mysterious ancient realm. The once-elusive Shu Kingdom, with its splendid culture, finally came into historical focus. The cultural relics unearthed at Sanxingdui and Jinsha were of very different styles that revealed the diverse and colorful society of the Shu. These relics and the site became the most attractive cultural highlight in the upper reaches of the Yangzi River as well as among the most distinctive known to date in the history of Chinese civilization.

A visually dynamic gold-foil "Divine Sunbird" (fig. 76)—also called "four birds around the sun"—was discovered at the Jinsha site. Four birds cut out from the foil can be seen to fly around a flaming, whirlpool-like sun. The flying birds on the outer rim and the spinning sun in the center represent the ancient Shu people's worship of the Divine Sunbird and the Sun God. This unique motif was chosen by the State Bureau of Cultural Relics to be the logo of China Cultural Heritage. On 10 June 2006—China's first Cultural Heritage Day—CCTV ran exclusive live coverage of the re-excavation of the Jinsha site, celebrating the first and most important archaeological find of the twenty-first century in China.

Underwater archaeology in China has only been practiced since the late 1980s, when the country began salvaging its ancient shipwrecks. Most remarkable was the salvage of the sunken *Nanhai* No. 1, a wooden ship of the early Song dynasty found in the southwest coastal area of Yangjiang, Guangdong province. Eight season underwater archaeological surveys that began in 1989 and continued through 2004 concluded that the ship was about 100 feet (30.4 m) long by 32 feet (9.8 m) wide and close to 14 feet (4.2 m) high. Submerged 79 feet (24 m) below sea level, it was covered with between 3 ¼ to 5 feet (1 to 1.5 m) of mud. The hull was very well preserved, and below decks was almost completely intact. The cabin held a quantity of goods in porcelain, metal, and lacquer. Since 2002, the Institute of Archaeology of Guangdong Province and the Guangzhou Salvage Bureau collaborated on devising the strategy for salvaging and protecting the complete ancient

Figure 76 The Divine Sunbird, a gold-foil disc unearthed at the Jinsha site, Chengdu, Sichuan province

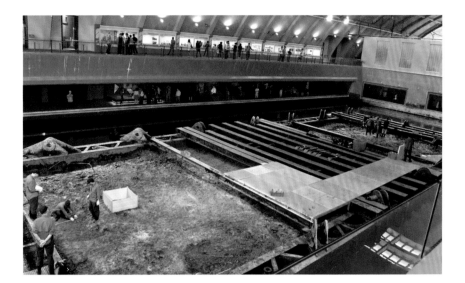

Figure 77 Excavation display of the Song-dynasty wooden ship *Nanhai* No. 1 at China's Marine Silk Road Museum in Yangjiang

ship. Eventually, the entire *Nanhai* No.1 had been salvaged and in December 2007 it safely was moved into China's Marine Silk Road Museum in Yangjiang.

At that time, the salvage and preservation of the *Nanhai* became the focus for all Chinese news media. More than eighty outlets competed for the release of excavation reports, interviews, and commentaries. After vanishing for eight hundred years, the *Nanhai* No. 1 became a "star" known to everyone. In the museum, a virtual water palace built for the ship replicated its original environmental conditions, water quality, and temperature. For months archaeologists continued work on the vessel inside the museum (figs. 77, 78). Today, through its observation corridor and underwater archaeology showcases, visitors have access to every step of the salvage process.[21]

Figure 78 News media view the ongoing archaeological study of the *Nanhai* No. 1

In 2006 the Yinxu ruins were successfully designated a UNESCO World Heritage Site, which greatly encouraged the Chinese government to protect many other historical sites in China, and local governments are exploring new solutions that will permit them to pursue urbanization and protect important cultural sites at the same time. In October 2010, twelve National Archaeology Site Parks were established. While protecting and showcasing the original archaeological locations and their surrounding environments, National Archaeology Site Parks have become multifunctional, providing public city spaces for education, research, tourism, and leisure.

Daming Palace, the principal royal residence of the Tang emperors, who lived and dealt with state affairs within its precincts, was one of the first places to receive designation as a National Archaeology Site Park. Built in 663 B.C.E. and destroyed at the end of the Tang dynasty, for more than two hundred years Daming Palace was symbolic of China and its government center. In 1957, a group of archaeologists led by Ma Dezhi (born 1923) began the archaeological survey and ascertained the scale and area of the palace: It occupied a huge area of about 1 ¼ square miles (3.2 sq. km), making it about four and a half times the size of the Forbidden City in Beijing. I personally joined this project and led several excavations: the main palace, Hanyuan Hall (figs. 79, 80), from 1995 to 1996; Taiyechi Pool, from 2001–2005; and, also in 2005, the south gate, known as the Danfeng gate (fig. 81).

Figure 79 Bird's-eye view of the excavation site at the Hanyuan Hall of the Tang-dynasty Daming Palace, near Xi'an, Shaanxi province

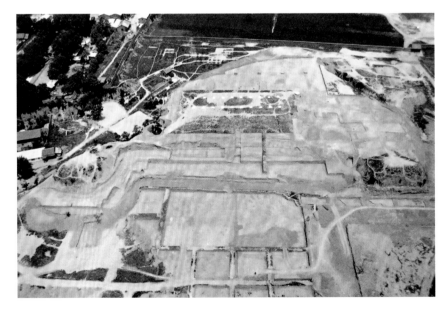

The Daming Palace was an incredible achievement in scale, layout, and refined architectural craftsmanship. But today, it is surrounded by the modern city of Xi'an, and it lies north of the train station, which added to logistical difficulties for the excavation. Poor peasants from the countryside moved into dilapidated houses built on top of the site, which also lacked proper city infrastructure. Poverty and substandard living conditions led to increasing damage to the site. In 2007, Xi'an's city government launched a campaign to convert the Daming Palace site into a National Archaeology Site Park. By employing a new mode of collaboration support from the city, public, and business communities, about one hundred thousand residents were relocated successfully. The Daming Palace National Archaeology Site Park opened in October 2010. This project has achieved its goals for protecting the site, upgrading the living conditions of people formerly residing there, improving the city environment, and pursuing city modernization. The discovery and protection of the Daming Palace site has become a fine example of how archaeology can enhance the lives of the people who live on and around sites.

Undertaking this type of work inside archaeological parks provides them with an important rationale for their continued creation. The archaeological work

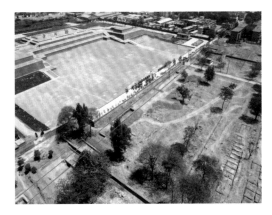

Figure 80 *Longshou qu* (dragon-head channel) unearthed in front of Hanyuan Hall at Daming Palace

Figure 81 The protection center at Danfeng gate of the Daming Palace National Archaeology Site Park, Xi'an, Shaanxi province

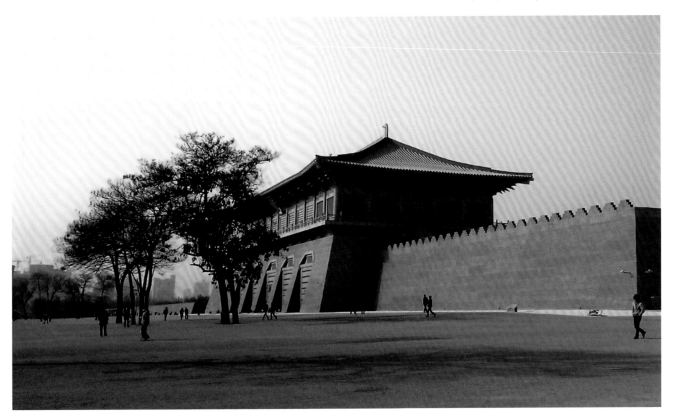

done here is conducted in public, and as people follow the excavation's on-site progress, they will acquire a better understanding of both past and present.

CURRENT ISSUES AND FUTURE CHALLENGES

The ongoing pursuit of archaeology as a science in China faces many challenges, the most urgent of which is the lack of Chinese professional archaeologists. China is a vast, ancient country with an uninterrupted history under which countless treasures remain buried, but presently fewer than 1,700 archaeologists are qualified to lead archaeological fieldwork. Each year, the State Bureau of Cultural Relics grants approval to approximately eight hundred archaeological projects, 80 percent of which are necessitated by impending construction. With thousands of new construction projects undertaken every year, only a small number of major undertakings see that archaeological analysis is done before construction begins. This means a large number of ancient sites and relics have been completely destroyed by bulldozers.

Grave robbery, long a serious problem in China, has increased in frequency since the 1970s, as the wave of economic reform and open policy have instilled in people a yearning and search for wealth deemed possible by robbing tombs, but this just causes greater damage, even disasters. In regions rich in cultural relics, such as Henan, Shaanxi, and Shanxi provinces, a popular saying was "Want to be rich, try grave robbing, and become a millionaire overnight." With the media reporting frequently on the dramatically increasing prices of ancient artifacts at auction, people have become increasingly irrational about buying and collecting them, which has led to grave robbery becoming more rampant, almost out of control.

In 1956, after the excavation of the Dingling mausoleum—the tomb of Emperor Wan Li (1573–1620) and one of the thirteen Ming-dynasty imperial tombs located in a northern suburb of Beijing—the Chinese government began to discourage any digs at the tombs of emperors and other famous historical figures. The State Bureau of Cultural Relics permitted such work only when it was no longer possible to protect the relics otherwise—a practice called "salvage excavation." For example, the discovery in December 2009 and the subsequent official excavation of a Xigaoxue tomb near Anyang, Henan province, started after robbers had already looted the tomb many times by means of a hole dug by local brick workers. Under these circumstances, an archaeological team stepped in. Based on the carved inscriptions on several stone objects referring to "Wei Wu Wang" (King

Wu of Wei)—a title given to a general and king of the Kingdom of Wu before his death—the scale of the tomb, and information from historical texts, the archaeological team concluded that this could be the tomb of General Cao Cao (155–220), a skilled general, warlord, and politician who built the strongest and most prosperous Wei Kingdom (208–80) in northern China. Another example was the Dayunshan Han tomb from Xuyi, Jiangsu province, which had been discovered in September 2009. The decision to excavate was made only after four robbers died in a collapse of the tomb caused by the holes they dug to enter it. Incredible discoveries were made at this tomb, among them a jade garment composed of plaques sewn together with fine gold wire, a jade coffin, and many precious relics. Based on inscriptions on the artifacts and the size of the tomb, it was concluded that this was the tomb of Liu Fei, half-brother of Liu Che, Emperor Wu of the Western Han (reigned 156-87 B.C.E.).

Another challenge that Chinese archaeology now faces is misunderstanding by the public. People often fail to distinguish between archaeology and antiquarian studies, becoming confused about the differences between excavation and treasure hunting. Intense media coverage has only made the situation worse. In recent years, prices for antiquities skyrocketed, and more and more counterfeits appeared on the market, causing problems in collecting and authentication. Archaeological finds have become a way to attract tourism, and local governments are very enthusiastic about developing a tourist economy. In this context, people have become increasingly skeptical about the archaeological yields or certain "discoveries." A case in point was the public's initial flurry of questions concerning the identification of the tomb as that of Cao Cao.

Archaeology, a discipline of discovery, can be defined as the scientific study of past human culture and behavior, primarily through controlled discoveries. China's long and ancient history and its vast territory provide fertile ground for new archaeological discoveries that continue to surprise the world. With the country's continued economic development, the desire of its people for a rich cultural life will expand, support from the government as well as nongovernmental organizations toward preserving cultural heritage will increase, and the contingent of professional archaeologists will grow. With more planned archaeological surveys and excavations coupled with the comprehensive multidisciplinary study of cultural relics and ancient sites, the historical evolution of Chinese civilization will be presented to an eager world with increasing clarity.

ENDNOTES

1. Li Ji, "Zhongguo kaogu xue zhiguoqu yu jianglai" (The past and future of archaeology in China), in *Li Ji kaoguxue lunwen ji* (Collection of essays on archaeology by Li Ji), ed., Zhang Guangzhi and Li Guangmo (Beijing: Wenwu chubanshe, 1990), 46.

2. Yan Wenming, "Yangshao wenhua yanjiu zhong jige zhide zhongshi de wenti" (Issues worth attention in the study of Yangshao Culture), in Hunan sheng Kaoguxue Hui and Mianchi xian Wenwu Baohu Guanli Weuyuan Hui Bian, *Lun Yangshao wenhua* (On the study of Yangshao Culture). *Zhongyuan Wenwu* (1987; special issue): 18–21.

3. An Zhimin, "Liang Siyong xiansheng he Zhongguo jindai kaoguxue" (Liang Siyong and Chinese [modern] archaeology). *Wenwu Tiandi* 1 (1990): 2–6.

4. Pei Wenzhong, *Zhoukoudian dongxue ceng caijue ji* (Accounts of the survey and excavation at Zhoukoudian cave stratum). Originally published in *Dizhi* 7 (1934) by the Geology Survey administered by the Ministry of Industry and National Geology Research Institute. (Reprint ed. Beijing: Dizhen chubanshe, 2001).

5. Ibid., 4.

6. Zhongguo Shehui Kexueyuan Kaogu Yanjiu Suo bianzhu, *Huixian fajue baogao* (Hui county excavation report). Special Publication on Archaeology, type D, no. 1 (Beijing: Kexue chubanshe, 1956).

7. Zhongguo Shehui Kexueyuan Kaogu Yanjiu Suo bianzhu, *Miaodigou and Sanliqiao: Archaeological Excavations at the Yellow River Reservoirs, Report.* Special Publication on Archaeology, type D, no. 9 (Beijing: Kexue chubanshe, 1959); republished in Chinese and English (Beijing: Wenwu chubanshe, 2011).

8. Su Bai, *Baisha Song mu* (Song-dynasty Baisha tomb) (Beijing: Wenwu chubanshe, 1957).

9. Wang Zhongshu, *Han Civilization*, trans. K. C. Chang (New Haven, CT: Yale University Press, 1982); and Wang Zhongshu, *Handai kaoguxue gaishuo* (Summary of Han-dynasty archaeology) (Beijing: Zhonghua shuju, 1984).

10. Chen Xingcan, "Jingen shijie xueshu chaoliude Xia Nai xiansheng yixie zai Xia Nai riji ban zhi ji" (Xia Nai closely follows world academic trends: On the occasion of publishing his diary). *Zhongguo Wenwu* (5 August 2011): 8.

11. 4749 Budui Liu Liandang Zhibu, "Women canjia le Xi Han gumu de fajue" (We took part in the excavation of the Western Han tomb). *Wenwu* 1 (1972): 3–5.

12. Zhongguo Shehui kexueyuan Kaogu Yanjiu Suo he Hebei sheng Wenguanhui bian zhu, *Mancheng Hanmu fajue baogao* (Excavation report on the Han tombs at Mancheng) (Beijing: Wenwu chubanshe, 1980).

13. Lu Zhaoyin, *Zhongguo zhongda kaogu fajue ji: Mancheng Hanmu* (Record of the major archaeological finds: Han tombs at Mancheng) (Beijing: Sanlian shudian, 2005).

14. Zhongguo Shehui Kexue Yuan Kaogu Yanjiu suo Henan er dui and Shangqiu Wenguan Hui, "1977 nian Yu Dong Kaogu Jiyao" (Essential accounts of archaeological work in the area east of Zhengzhou of Henan province in 1977). *Kaogu* 5 (1981): 385–97.

15. Zhang Changshou and K. C. Chang, "Henan Shangqiu diqu Yin-Shang wenming diaocha fajue chubu baogao" (An initial report on the survey of Yin-Shang Culture in the Shangqiu area of Henan province). *Kaogu* 4 (1997): 24–31.

16. Luo Feng, *Guyuan nan jiao Sui Tang mu di* (Graveyard of Sui and Tang dynasties in the south suburbs of Guyuan) (Beijing: Wenwu chubanshe, 1996).

17. Yuanzhou lianhe kaogu dui, *Tang Shidaoluo mu:Yuanzhou kaogu diaocha baogao zhi yi* (Tang tomb of Shi Daoluo: First report on the archaeological survey of Yuanzhou) (Tokyo: Bensei Chuppan, 1999).

18. Yuanzhou lianhe kaogu dui, *Bei Zhou Tian Hong mu:Yuanzhou kaogu diaocha baogao zhi er* (Northern Zhou tomb of Tian Hong: Second report on the archaeological survey of Yuanzhou) (Beijing: Wenwu chubanshe, 2009).

19. Xia-Shang-Zhou Duandai gongcheng Zhuanjia zu, *Xia-Shang-Zhou Duandai gongcheng 1996–2000 nian jiduan chengguo baogao (jianben)* (Report on the Xia-Shang-Zhou Chronology Project: 1996–2000 phase [abridged version]) (Beijing: Shijie tushu chuban gongsi, 2000).

20. Bruce Gilley, "China: Nationalism Digging into the Future." *Far Eastern Economic Review* (20 July 2000); Erik Eckholm, "In China, Ancient History Kindles Modern Doubts." *New York Times* (10 November 2000). www.nytimes.com/2000/11/10/world/in-china-ancient -history-kindles-modern-doubts.html

21. Guangdong sheng Wenwu Kaogu Yanjiu Suo, *2011 nian Nanhai 1 hao de kaogu shijue* (Trial excavation of the Song-dynasty sunken ship *Nanhai* No. 1 in 2011) (Beijing: Kexue chubanshe, 2011).

FURTHER READING

Abramson, Marc S. *Ethnic Identity in Tang China*. Philadelphia: University of Pennsylvania Press, 2008.

An, Jiayao. "When Glass Was Treasured in China." In *Nomads, Traders, and Holy Men along China's Silk Road: Papers Presented at a Symposium at the Asia Society in New York, November 9–10, 2001,* edited by Annette L. Juliano and Judith A. Lerner, 79–94. Turnhout, Belgium: Brepols, 2002.

Beningson, Susan L., and Cary Y. Liu. *Providing for the Afterlife: "Brilliant Artifacts" from Shandong.* New York: China Institute Gallery, 2005.

Berger, Patricia. "Body Doubles: Sculpture for the Afterlife." *Orientations* 29, no. 2 (February 1998): 46–53.

Bower, Virginia L. *From Court to Caravan: Chinese Tomb Sculptures from the Collection of Anthony M. Solomon.* Cambridge, MA: Harvard University Art Museums; New Haven: Yale University Press, 2002.

DeFrancis, John. *The Chinese Language: Fact and Fantasy*. Honolulu: University of Hawai'i Press, 1984.

Dien, Albert E. *Six Dynasties Civilization*. New Haven: Yale University Press, 2007.

Eberhard, Wolfram. *A Dictionary of Chinese Symbols: Hidden Symbols in Chinese Life and Thought.* London: Routledge and Kegan Paul, 1986.

Eckfeld, Tonia. *Imperial Tombs in Tang China, 618–907: The Politics of Paradise*. London: RoutledgeCurzon, 2005.

Fan, Jinshi. *The Caves of Dunhuang*. Dunhuang: Dunhuang Academy; Hong Kong: London Editions, 2010.

Fisher, Robert E. *Buddhist Art and Architecture*. London: Thames and Hudson, 1993.

Foltz, Richard C. *Religions of the Silk Road: Overland Trade and Cultural Exchange from Antiquity to the Fifteenth Century*. New York: St. Martin's Press, 1999.

Fontein, Jan, and Wu Tung. *Unearthing China's Past.* Boston: Museum of Fine Arts, 1973.

Juliano, Annette L. *Art of the Six Dynasties: Centuries of Change and Innovation.* New York: China Institute, 1975.

———. *Treasures of China*. New York: Richard Marek Publishers, 1981.

———. "Hidden Treasures: Little-known Buddhist Cave Temples from Northwest China, 5th to 7th Centuries." *Orientations* 32, no. 8 (October 2001): 62–71.

———. *Buddhist Sculpture from China: Selections from the Xi'an Beilin Museum, Fifth through Ninth Centuries*. New York: China Institute Gallery, 2007.

Juliano, Annette L., and Judith A. Lerner. *Monks and Merchants: Silk Road Treasures from Northwest China, Gansu, and Ningxia, 4th–7th Century.* New York: The Asia Society; Abrams, 2001.

———. "The Miho Couch Revisited in Light of Recent Discoveries." *Orientations* 32, no. 8 (October 2001): 54–61.

Kim, Hyun Jin. *Ethnicity and Foreigners in Ancient Greece and China.* London: Duckworth, 2009.

Knauer, Elfriede Regina. *The Camel's Load in Life and Death: Iconography and Ideology of Chinese Pottery Figurines from Han to Tang and Their Relevance to Trade along the Silk Routes.* Zurich: Akanthus, 1998.

Ledderose, Lothar. *Ten Thousand Things: Module and Mass Production in Chinese Art.* Princeton: Princeton University Press, 2000.

Lewis, Mark Edward. *China between Empires: The Northern and Southern Dynasties.* Cambridge, MA: Belknap Press of Harvard University Press, 2009.

———. *China's Cosmopolitan Empire: The Tang Dynasty.* Cambridge, MA: Belknap Press of Harvard University Press, 2009.

Li Jian, ed. *The Glory of the Silk Road: Art from Ancient China.* Dayton, OH: Dayton Art Institute, 2003.

Liu, Xinru. *Ancient India and Ancient China: Trade and Religious Exchanges, AD 1-600,* 2nd rev. ed. London: Oxford University Press, 1999.

Loewe, Michael. *Ways to Paradise: The Chinese Quest for Immortality.* London: George Allen & Unwin, 1979.

———. *Chinese Ideas of Life and Death: Faith, Myth, and Reason in the Han Period (202 BC– AD 220).* London: George Allen & Unwin, 1982.

Los Angeles County Museum of Art. *The Quest for Eternity: Chinese Ceramic Sculptures from the People's Republic of China.* Los Angeles: Los Angeles County Museum of Art; San Francisco: Chronicle Books, 1987.

Paludan, Ann. *The Chinese Spirit Road: The Classical Tradition of Stone Tomb Statuary.* New Haven: Yale University Press, 1991.

Pirazzoli-t'Serstevens, Michèle. *The Han Dynasty.* Translated by Janet Seligman. New York: Rizzoli, 1982.

Rawson, Jessica. "Thinking with Pictures: Tomb Figures in the Chinese View of the Afterlife." *Transactions of the Oriental Ceramic Society* 61 (1996/97): 19–37.

Schafer, Edward H. *The Golden Peaches of Samarkand: A Study of T'ang Exotics.* Berkeley: University of California Press, 1985.

Sensabaugh, David. "Guardians of the Tomb." *Yale University Art Gallery Bulletin* (2001): 57–65.

So, Jenny F., and Emma C. Bunker. *Traders and Raiders on China's Northern Frontier.* Washington, D.C.: Arthur M. Sackler Gallery, Smithsonian Institution; Seattle: University of Washington Press, 1995.

Sullivan, Michael. *The Arts of China,* 5th rev. ed. Berkeley: University of California Press, 2008.

Valenstein, Suzanne. *Cultural Convergence in the Northern Qi Period: A Flamboyant Chinese Ceramic Container; a Research Monograph.* New York: Metropolitan Museum of Art, 2007.

Watt, James C. Y., An Jiayao, Angela F. Howard, Boris I. Marshak, Su Bai, and Zhao Feng. *China: Dawn of the Golden Age, 200–750 AD.* New York: Metropolitan Museum of Art; New Haven: Yale University Press, 2004.

White, Julia M., Emma C. Bunker, and Chen Peifen. *Adornment for Eternity: Status and Rank in Chinese Ornament.* Denver, CO: Denver Art Museum; Woods Publishing Company, 1994.

Whitfield, Susan. *Life along the Silk Road.* Berkeley: University of California Press, 1999.

———. *The Silk Road: Trade, Travel, War, and Faith.* Chicago: Serindia Publications, 2004.

Wriggins, Sally Hovey. *Xuanzang: A Buddhist Pilgrim on the Silk Road.* Boulder, CO: Westview Press, 1996.

Wright, Arthur F. *Buddhism in Chinese History,* rev. ed. Stanford, CA: Stanford University Press, 1971.

Wright, Arthur F., and Denis Twitchett, eds. *Perspectives on the T'ang.* New Haven: Yale University Press, 1973.

Wu, Hung. *The Art of the Yellow Springs: Understanding Chinese Tombs.* Honolulu: University of Hawai'i Press, 2010.

Zhang Qingjie. "New Archaeological and Art Discoveries from the Han to the Tang Period in Shanxi Province." *Orientations* 34, no. 5 (May 2002): 54–60.

INDEX

Numbers in italics refer to pages with images of the subject.

IMAGE CREDITS

The images in this catalogue are reproduced from the following sources:

Along the Ancient Silk Routes: Central Asian Art from the West Berlin State Museums (New York: Metropolitan Museum of Art, 1982): fig. 4

Archives of the Chinese Society of America 18 (1964): fig. 44

Courtesy of An Jiayao: figs. 65–81

Bei Qi Dong'an Wang Lou Rui Mu (Beijing: Cultural Relics Publishing House, 2006): figs. 14, 28(middle), 36–42

Changsha Mawangdui yihao Han mu (Beijing: Wenwu chubanshe, 1973): fig. 16

Clark, Robert Sterling, and Arthur de C. Sowerby. *Through Shên-kan: The Account of the Clark Expedition in North China, 1908–9* (London: T. Fisher Unwin, 1912): fig. 5

Dunhuang Institute, ed. *Zhongguo shiku: Dunhuang Mogao ku* (Beijing: Wenwu chubanshe, 1987): figs. 57, 58

E Jun, ed. *Gansu Sheng Bowuguan wenwu jingpin tuji* (Xi'an: San Qin Publishing House, 2006): fig. 63

Gansu Provincial Museum, Lanzhou: pls. 17, 18

Courtesy of the Gansu Cultural Relics Bureau: figs. 48–55

Courtesy of Perry Hu: figs. 62, 64

I-nan gu huaxiang shimu fajue baogao (Shanghai: Beijing: Wenhua bu wenwu guanliju, 1956): fig. 17

Courtesy of Annette L. Juliano: figs. 2, 3(right), 6, 12, 18, 19, 32(bottom), 59

Juliano, Annette. *Treasures of China* (New York: Richard Marek Publishers, 1981): fig. 46

Juliano Annette L., and Judith A. Lerner. *Monks and Merchants: Silk Road Treasures from Northwest China, Gansu, and Ningxia, 4th–7th Century* (New York: The Asia Society; Abrams, 2001): figs. 15, 20, 60, 61

Lingtai County Museum, Pingliang: pls. 11–16

Liu Junxi, ed. *Datong Yanbei Yuan Bei Wei muqun* (Beijing: Wenwu chubanshe, 2008): figs. 21, 22, 24–27, 28(top), 29–31, 32(top), 33(top), 34(left), 35

Courtesy of Walter Rous: fig. 6

Courtesy of the Shanxi Provincial Museum, Taiyuan: figs. 13, 23, 44; pls. 1–10

Smithsonian Institution Archive, Washington, D.C.: fig. 1

Stein, M. Aurel. *Ruins of Desert Cathay: Personal Narrative of Explorations in Central Asia and Westernmost China* (London: Macmillan, 1912): fig. 3

Taiyuan City Archaeological Research Institute. *Bei Qi Xu Xianxiu mu* (Beijing: Wenwu chubanshe, 2005): fig. 28(bottom)

Tang Chang'an chengjiao Sui Tang mu (Beijing: Wenwu chubanshe, 1980): fig. 56

Courtesy of the late Guy Weill: fig. 47

Wenwu 1 (1964): fig. 45

Wenwu 3 (1972): fig. 34(right)

Wenwu 8 (1983): fig. 11

Xia Mingcai. *Qingzhou Longxingsi fojiao zaoxiang jiaocang* (Beijing: Shenghuo, dushu, xinhe sanlian shudian, 2004): fig. 43

Zhongguo Meiyi quanji. *Yungang shiku diaoku* (Beijing: Wenwu chubanshu, 1998): fig. 33(bottom)